LONGMAN

Photo Dictionary
of American English

Longman

NEW

CONTENTS

CONTENTS

1 one	**2** two	**3** three	**4** four	**5** five	**6** six	**7** seven	**8** eight	**9** nine
10 ten	**11** eleven	**12** twelve	**13** thirteen	**14** fourteen	**15** fifteen	**16** sixteen	**17** seventeen	**18** eighteen
19 nineteen	**20** twenty	**21** twenty-one	**30** thirty	**40** forty	**50** fifty	**60** sixty	**70** seventy	**80** eighty

90 ninety **100** one hundred

× times/multiplied by

− minus

÷ divided by

+ plus

= equals

101 one hundred and one

1,000 one thousand

10,000 ten thousand

100,000 one-hundred thousand

1,000,000 one million

100% — 100 one hundred percent
— 90
— 80
— 70
— 60
50% — 50 fifty percent
— 40
— 30
20% — 20 twenty percent
10% — 10 ten percent
— 0

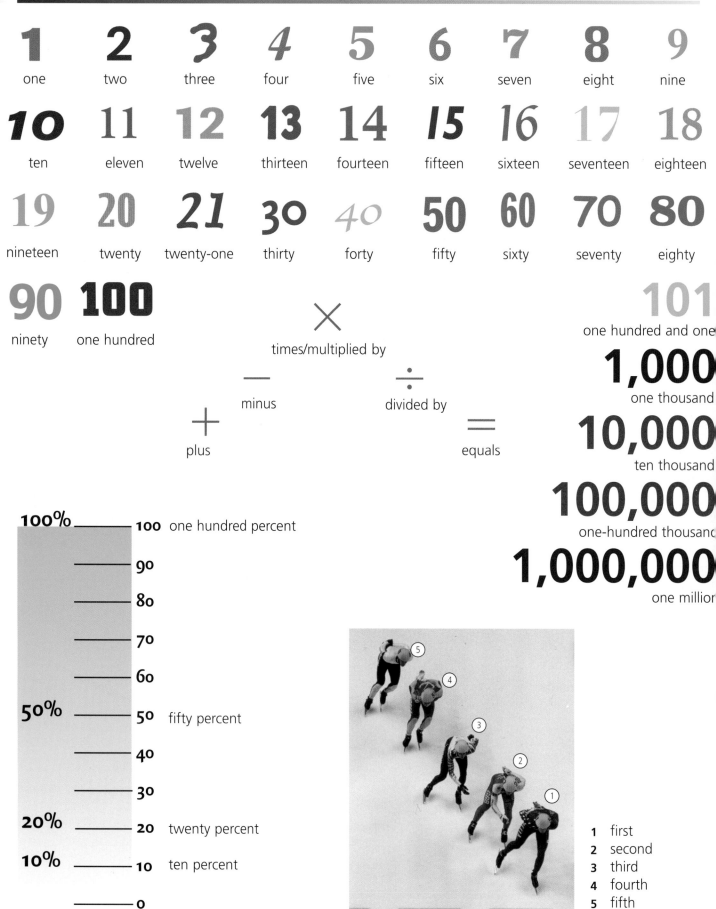

1 first
2 second
3 third
4 fourth
5 fifth

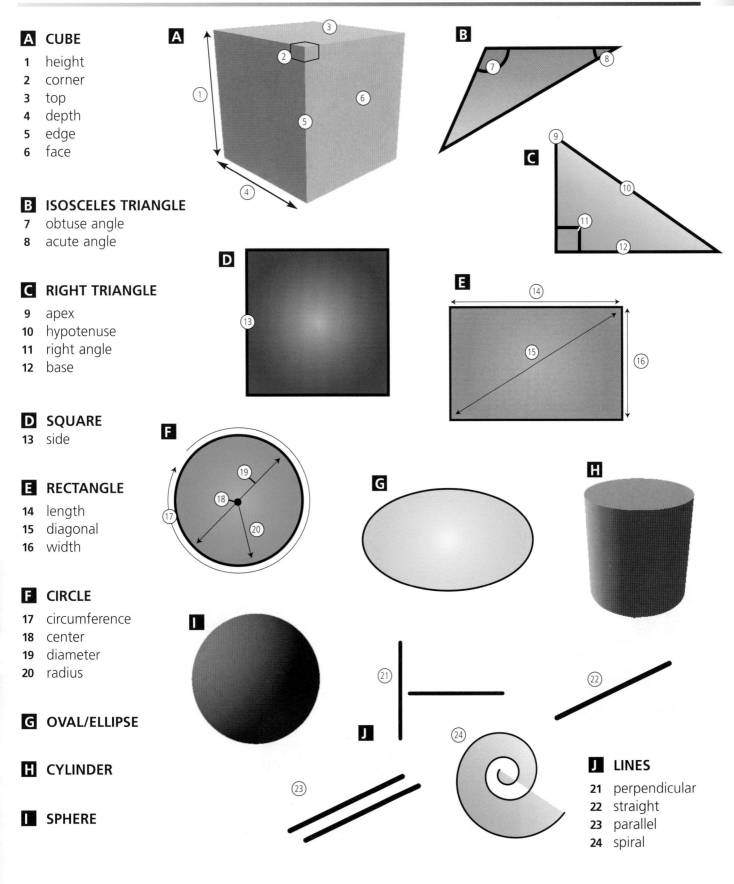

A CUBE

1 height
2 corner
3 top
4 depth
5 edge
6 face

B ISOSCELES TRIANGLE

7 obtuse angle
8 acute angle

C RIGHT TRIANGLE

9 apex
10 hypotenuse
11 right angle
12 base

D SQUARE

13 side

E RECTANGLE

14 length
15 diagonal
16 width

F CIRCLE

17 circumference
18 center
19 diameter
20 radius

G OVAL/ELLIPSE

H CYLINDER

I SPHERE

J LINES

21 perpendicular
22 straight
23 parallel
24 spiral

Discussion

1 Give your partner instructions to draw a shape.
2 Find things that are shaped like a triangle, a square, a rectangle, and a cylinder.

A MONTHS

JANUARY	FEBRUARY	MARCH	APRIL	MAY	JUNE
S M T W T F S	S M T W T F S	S M T W T F S	S M T W T F S	S M T W T F S	S M T W T F S
1 2 3 4 5 6	1 2 3	1 2 3	1 2 3 4 5 6 7	1 2 3 4 5	1 2
7 8 9 10 11 12 13	4 5 6 7 8 9 10	4 5 6 7 8 9 10	8 9 10 11 12 13 14	6 7 8 9 10 11 12	3 4 5 6 7 8 9
14 15 16 17 18 19 20	11 12 13 14 15 16 17	11 12 13 14 15 16 17	15 16 17 18 19 20 21	13 14 15 16 17 18 19	10 11 12 13 14 15 16
21 22 23 24 25 26 27	18 19 20 21 22 23 24	18 19 20 21 22 23 24	22 23 24 25 26 27 28	20 21 22 23 24 25 26	17 18 19 20 21 22 23
28 29 30 31	25 26 27 28	25 26 27 28 29 30 31	29 30	27 28 29 30 31	24 25 26 27 28 29 30

JULY	AUGUST	SEPTEMBER	OCTOBER	NOVEMBER	DECEMBER
S M T W T F S	S M T W T F S	S M T W T F S	S M T W T F S	S M T W T F S	S M T W T F S
1 2 3 4 5 6 7	1 2 3 4	1	1 2 3 4 5 6	1 2 3	1
8 9 10 11 12 13 14	5 6 7 8 9 10 11	2 3 4 5 6 7 8	7 8 9 10 11 12 13	4 5 6 7 8 9 10	2 3 4 5 6 7 8
15 16 17 18 19 20 21	12 13 14 15 16 17 18	9 10 11 12 13 14 15	14 15 16 17 18 19 20	11 12 13 14 15 16 17	9 10 11 12 13 14 15
22 23 24 25 26 27 28	19 20 21 22 23 24 25	16 17 18 19 20 21 22	21 22 23 24 25 26 27	18 19 20 21 22 23 24	16 17 18 19 20 21 22
29 30 31	26 27 28 29 30 31	23 24 25 26 27 28 29	28 29 30 31	25 26 27 28 29 30	23 24 25 26 27 28 29
		30			30 31

B DAYS OF THE WEEK

October

Sunday	Monday	Tuesday	Wednesday	Thursday	Friday	Saturday
	1	2	3	4	5	6
7	8	9	10	11	12	13
14	15	16	17	18	19	
	22	23	24	25	26	
29	30	31				

C HOLIDAYS

1 Easter* (April)
2 Mother's Day* (May)
3 Memorial Day* (May)
4 Father's Day* (June)
5 Independence Day/Fourth of July (July 4th)
6 Halloween (October 31st)
7 Thanksgiving (Day)* (November)
8 Christmas (Day) (December 25th)
9 New Year's Eve (December 31st)
10 Valentine's Day (February 14th)

* the exact date changes from year to year

When's Valentine's Day?
It's on February fourteenth.

When's Christmas Day?
It's in December.

A: **When's Halloween?**
B: .. .

A: **When's** ?
B: It's on (date)./It's in (month).

Discussion

1 Which of these are religious holidays?
2 Which holidays do you celebrate in your own country? When are they?

1 clock
2 hour hand
3 minute hand
4 second hand
5 face
6 (digital) watch
7 (analog) watch
8 twelve o'clock (midnight)
9 twelve o'clock (noon/midday)
10 seven (o'clock)
11 seven oh five/five after seven
12 seven ten/ten after seven
13 seven fifteen/(a) quarter after seven
14 seven twenty/twenty after seven
15 seven thirty/half after seven

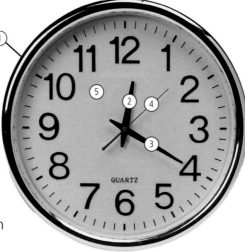

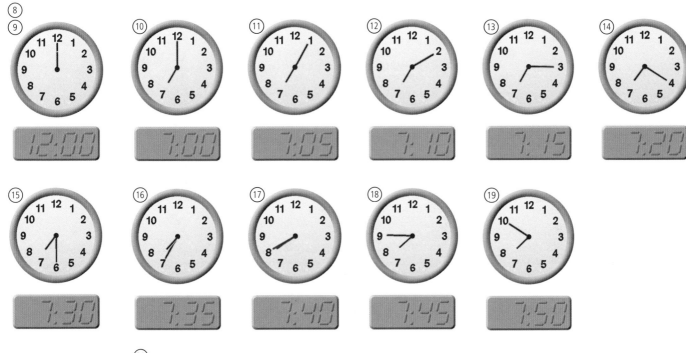

16 seven thirty-five/twenty-five to eight
17 seven forty/twenty to eight
18 seven forty-five/(a) quarter to eight
19 seven fifty/ten to eight
20 seven fifty-five/five to eight
21 eight a.m./eight (o'clock) in the morning
22 eight p.m./eight (o'clock) in the evening

What time is it?
It's ten ten./It is ten after ten.

A: **What time is it?**
B: It is .. .

Discussion
1 What time is it?
2 What time do you get up/ go to bed?

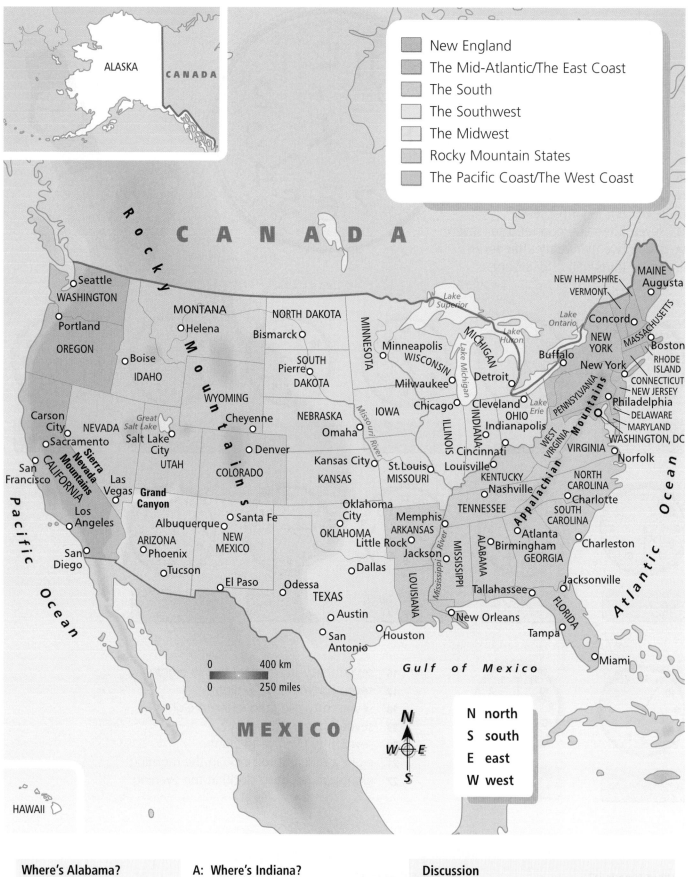

New England
The Mid-Atlantic/The East Coast
The South
The Southwest
The Midwest
Rocky Mountain States
The Pacific Coast/The West Coast

ALASKA
CANADA

CANADA

Rocky Mountains

Seattle
WASHINGTON
Portland
OREGON
Boise
IDAHO
MONTANA
Helena
NORTH DAKOTA
Bismarck
Lake Superior
MINNESOTA
Minneapolis
WISCONSIN
MICHIGAN
Lake Huron
Lake Ontario
NEW HAMPSHIRE
VERMONT
MAINE
Augusta
Concord
NEW YORK
MASSACHUSETTS
Boston
RHODE ISLAND

Pierre
SOUTH DAKOTA
Milwaukee
Lake Michigan
Detroit
Buffalo
New York
CONNECTICUT
NEW JERSEY

WYOMING
Cheyenne
NEBRASKA
Omaha
IOWA
Chicago
ILLINOIS
Cleveland
Lake Erie
OHIO
Indianapolis
INDIANA
PENNSYLVANIA
Appalachian Mountains
Philadelphia
DELAWARE
MARYLAND
WASHINGTON, DC

Carson City
NEVADA
Sacramento
Great Salt Lake
Salt Lake City
UTAH
Denver
COLORADO
Kansas City
KANSAS
St. Louis
MISSOURI
Cincinnati
Louisville
KENTUCKY
WEST VIRGINIA
VIRGINIA
Norfolk

San Francisco
CALIFORNIA
Sierra Nevada Mountains
Las Vegas
Grand Canyon
Nashville
TENNESSEE
NORTH CAROLINA
Charlotte
SOUTH CAROLINA

Los Angeles
Albuquerque
Santa Fe
Oklahoma City
OKLAHOMA
Memphis
ARKANSAS
Little Rock
Atlanta
Birmingham
GEORGIA
Charleston

San Diego
ARIZONA
Phoenix
NEW MEXICO
Jackson
MISSISSIPPI
ALABAMA

Tucson
Dallas
Mississippi River
Tallahassee
Jacksonville
FLORIDA

El Paso
Odessa
TEXAS
LOUISIANA
New Orleans
Tampa

Austin
San Antonio
Houston
Gulf of Mexico
Miami

Pacific Ocean

Atlantic Ocean

0 400 km
0 250 miles

MEXICO

N north
S south
E east
W west

N
W ⊕ E
S

HAWAII

Where's Alabama?
It's east of Mississippi and west of Georgia.

Where's Kansas?
It's south of Nebraska and north of Oklahoma.

A: **Where's Indiana?**
B: It's ..

A: **Where's?**
B: It's of
and of

Discussion

1 Which states are on the Atlantic Ocean? the Pacific Ocean? the Gulf of Mexico?

2 Which states are next to Canada? Mexico?

Application Form

Please complete all of the items on this form. Use blue or black ink only.

Application for _Design Manager_

Last/Family Name _Edwards_

First Name _Susan_ Middle Initial _C_

Date of Birth _04/24/66_ Place of Birth _New York_

Country of Birth _USA_

Emergency Contact _Paul Edwards_

Address _734 Center Drive, Suite 103_
La Mesa, California
USA
 Zip Code _91652_

E-Mail Address _susan.edwards@uol.com_

Previous Employment
Hart Design, New York 1998–present
JPB Design Associates 1993–1998

1 single
2 couple
3 married
4 divorced

5 widow
6 widower
7 girl
8 boy
9 baby
10 child
11 toddler
12 man
13 woman
14 teenager
15 adult
16 senior citizen

What's your address?
It's 63 Maple Street.

What's your marital status?
I'm married./I'm a widow.

A: What's your marital status?
B: I'm

A: What's your ?
B: It's/I'm (a) ..

Discussion
1 Give the personal data of someone you know.
2 Give the personal data of a famous person.

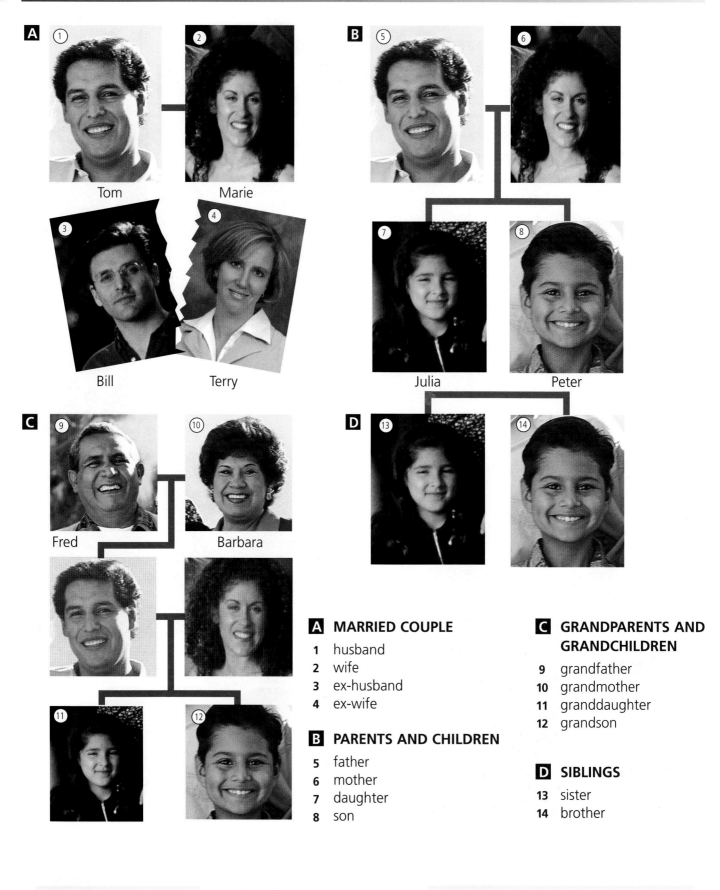

Tom · Marie · Bill · Terry · Julia · Peter · Fred · Barbara

A **MARRIED COUPLE**

1 husband
2 wife
3 ex-husband
4 ex-wife

B **PARENTS AND CHILDREN**

5 father
6 mother
7 daughter
8 son

C **GRANDPARENTS AND GRANDCHILDREN**

9 grandfather
10 grandmother
11 granddaughter
12 grandson

D **SIBLINGS**

13 sister
14 brother

Who's she?
She's Julia's mother.

Who's he?
He's Tom's son.

A: Who's she?
B: ...

A: Who's he/she?
B: He/She's 's
... .

Discussion

1 Which of these words can be used only for women? only for men? both men and women?

2 Draw your family tree and describe it.

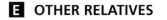

E OTHER RELATIVES

15 aunt
16 uncle
17 niece
18 nephew
19 cousins

Sue Josh

Emily Jason

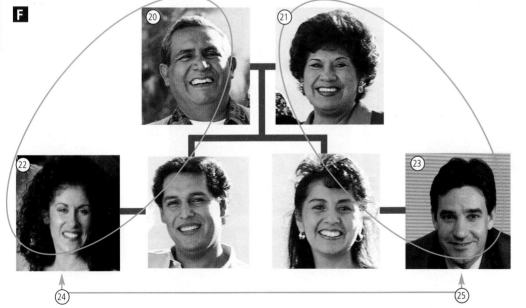

F IN-LAWS

20 father-in-law
21 mother-in-law
22 daughter-in-law
23 son-in-law
24 sister-in-law
25 brother-in-law

1 wake up
2 get up
3 wash your face
4 rinse your face
5 dry your face/yourself
6 brush your teeth
7 take a shower
8 shave
9 get dressed
10 comb your hair
11 put on make-up
12 eat breakfast
13 have a cup of coffee
14 go to work

15 watch (TV)
16 read (the paper)
17 listen to the radio
18 take a bath
19 brush your hair
20 go to bed
21 sleep

Is she getting up?
Yes, she is.

Is he taking a shower?
No, he isn't. He's watching TV.

A: **Is she listening to the radio?**
B:

A: **Is he/she** ?
B: Yes, he/she is./No, he/she isn't.

Discussion
1 Which of these things do you do in the morning? In what order?
2 Which of these things do you do in the evening? In what order?

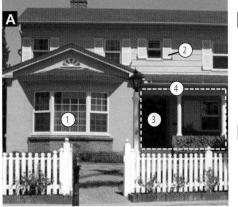

A **HOUSE**
1 window
2 shutter
3 (front) door
4 (front) porch

B **DUPLEX**
5 (front) yard
6 walkway
7 screen door

C **RANCH HOUSE**
8 gutter
9 drainpipe
10 fence
11 driveway
12 roof
13 mailbox
14 garage
15 chimney
16 satellite dish
17 TV antenna

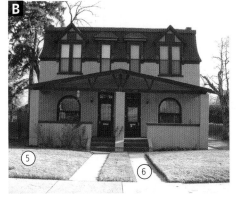

D **FRONT DOOR**
18 knocker
19 doorbell
20 intercom
21 doorknob

11018

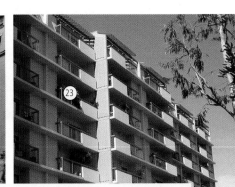

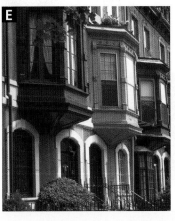

E **TOWNHOUSE**

F **APARTMENT BUILDING**
22 fire escape
23 balcony

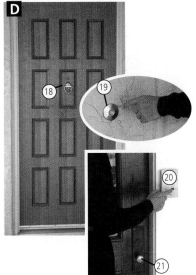

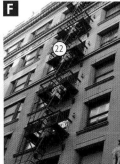

Does this house have a front porch?
No, it doesn't.

Does this house have a chimney?
Yes, it does.

A: Does this house have a(n)
.. ?
B: Yes it does./No, it doesn't.

A: Does this **have a(n)**
.. ?
B: Yes, it does./No, it doesn't.

Discussion
1 What kinds of places to live are there in your city?
2 Where do you live? Describe your home.

1 freezer
2 refrigerator
3 faucet/tap
4 counter/counter top
5 sink
6 cupboard/cabinet
7 stove
8 oven
9 burner
10 dishwasher
11 microwave (oven)

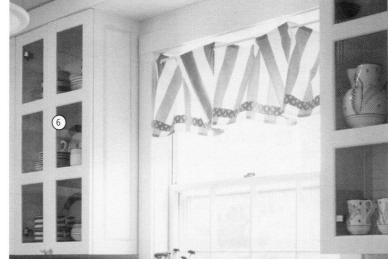

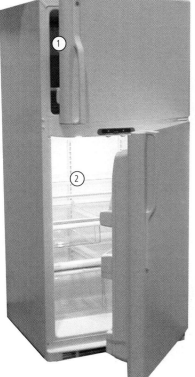

12 cookbook
13 storage jar
14 spices
15 spice rack
16 dishwashing liquid
17 scouring pad
18 trash can/garbage can

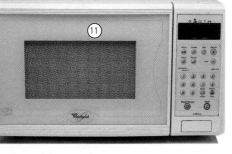

Is this the microwave?
Yes, it is.

Is this the stove?
No, it isn't. It's the oven.

A: **Is this the** ?
B: Yes, it is./No, it isn't. It's the
.. .

Discussion

1 Which of these things do you have in your kitchen?
2 Which of these things do you need?

1 wok
2 ladle
3 pot
4 toaster
5 pot holder
6 cookie sheet
7 egg beater
8 tea kettle
9 knife
10 cutting board
11 food processor
12 roasting pan
13 blender
14 peeler
15 garlic press
16 can opener
17 rolling pin
18 sifter/sieve
19 colander
20 steamer

21 measuring spoons
22 grater
23 (mixing) bowl
24 whisk
25 measuring cup
26 (electric) mixer

27 bottle opener
28 coffee maker
29 handle
30 saucepan
31 lid
32 frying pan

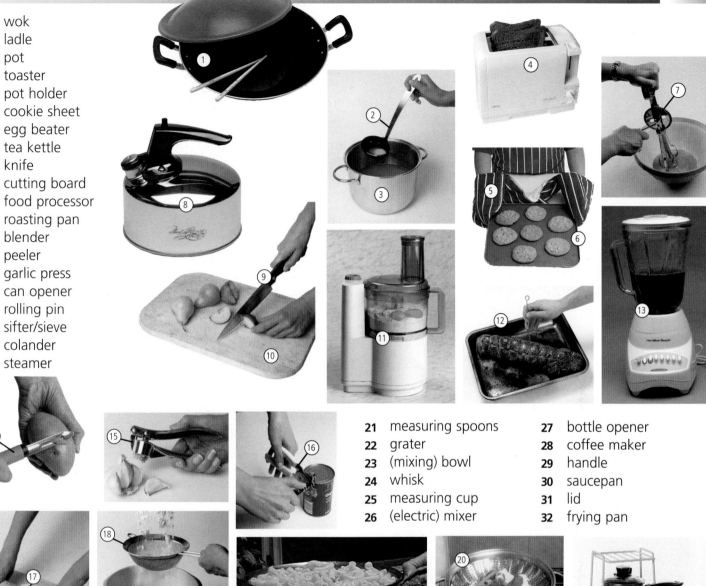

What do you do with a tea kettle?
You boil water in it.

What do you do with a wok?
You stir-fry vegetables in it.

A: What do you do with a(n)
..................................... ?
B: You
in/ with it.

Discussion
1 Which of these things do you have in your kitchen?
2 Which things would you like to have? Why?

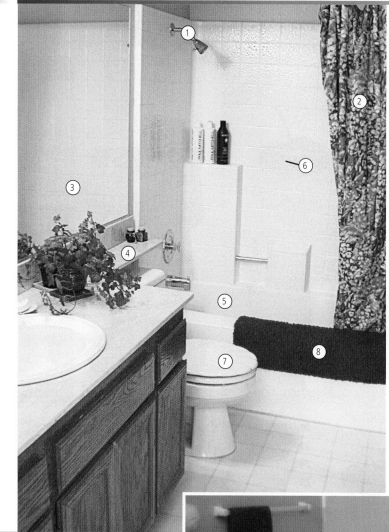

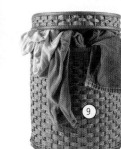

1 shower
2 shower curtain
3 mirror
4 shelf
5 bathtub
6 tile
7 toilet
8 bath mat
9 laundry basket/hampe~

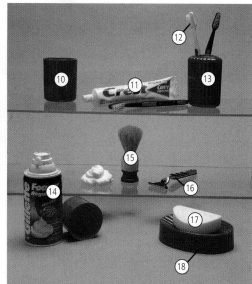

10 cup
11 toothpaste
12 toothbrush
13 toothbrush holder
14 shaving cream
15 shaving brush
16 razor
17 soap
18 soap dish
19 medicine cabinet
20 towel rack
21 wash cloth
22 hand towel
23 bath towel
24 hot water faucet
25 cold water faucet
26 sink
27 toilet paper
28 box of tissues

What color is the bath mat?
It's red.

What color are the tiles?
They're white.

A: What color is/are the?
B: It's/They're

Discussion

1 Which of these things do you have in your bathroom? Which would you like to have?

2 Do you prefer taking a bath or a shower? Why?

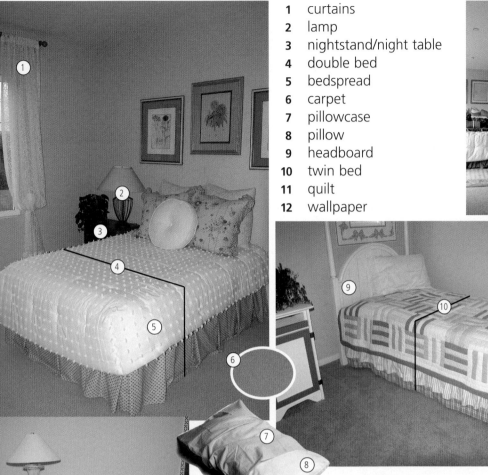

1 curtains
2 lamp
3 nightstand/night table
4 double bed
5 bedspread
6 carpet
7 pillowcase
8 pillow
9 headboard
10 twin bed
11 quilt
12 wallpaper

13 closet
14 dresser/chest of drawers
15 drawer
16 handle
17 comforter

18 (flat) sheet
19 (fitted) sheet
20 mirror
21 dressing table
22 alarm clock
23 mattress
24 dust ruffle/bedskirt

Where's the lamp?
It's on the nightstand.

Where's the bedskirt?
It's under the mattress.

A: **Where's the flat sheet?**
B: It's the

A: **Where's the** ?
B: It's on/under the

Discussion
1 What do you have in your bedroom?
2 Which of these things would you like to have?

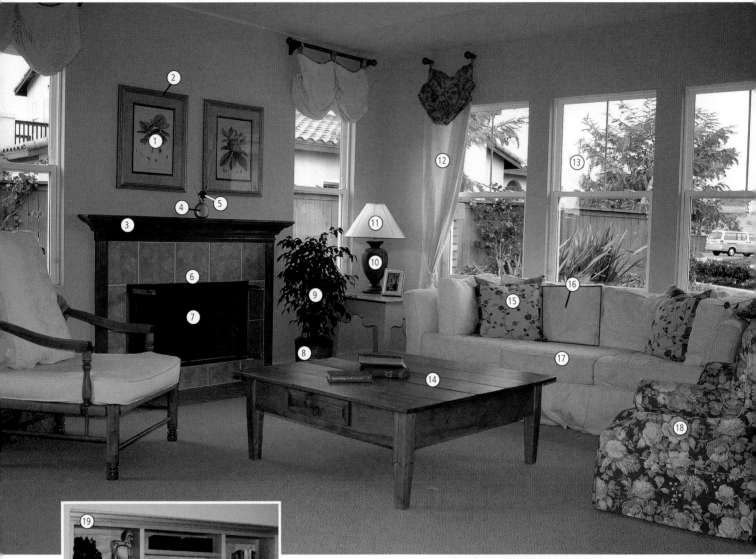

7 (fireplace) screen
8 planter
9 plant
10 lamp
11 lampshade

1 picture
2 picture frame
3 mantel(piece)
4 vase
5 flowers
6 fireplace

12 drape
13 window
14 coffee table
15 throw pillow
16 cushion
17 sofa/couch
18 armchair
19 wall unit
20 desk
21 bookcase
22 books

Where's the vase?
It's on the mantel.

Where are the books?
They're in the bookcase.

A: **Where's the lamp?**
B: It's the

A: **Where's/Where are the**
... ?
B: It's/They're

Discussion

1 What do you have in your living room?
2 Do you like this living room? Why or why not?

1 sideboard
2 mirror
3 chandelier
4 (dining room) table
5 chair
6 teapot
7 pepper shaker
8 salt shaker
9 napkin
10 napkin ring
11 place mat
12 glass
13 pitcher

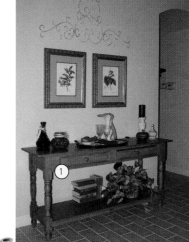

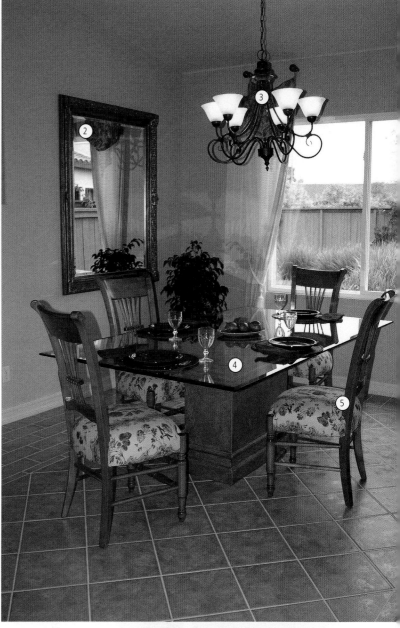

A DISHES
14 wine glass
15 bowl
16 plate
17 cup
18 saucer
19 serving dish

B SILVERWARE/CUTLERY
20 fork
21 knife
22 tablespoon
23 teaspoon

Where's the pepper?
It's to the left of the salt.

Where's the knife?
It's to the right of the fork.

A: Where's the ?
B: It's
of the

Discussion
1 Which of these things are used for eating?
2 Which of these things do you use for drinking?

1. diaper
2. changing pad
3. potty chair
4. crib
5. stuffed animal
6. teddy bear
7. baby clothes
8. high chair
9. bib
10. pacifier
11. baby wipes
12. spill-proof cup
13. nipple
14. (baby) bottle
15. sterilizer

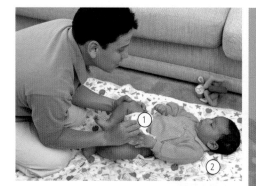

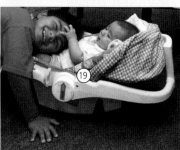

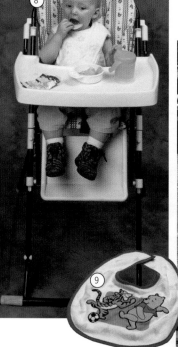

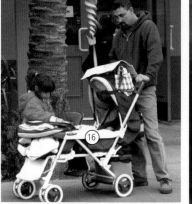

16. baby carriage
17. stroller
18. intercom
19. baby carrier
20. car seat

Where's the baby?
He's in his car seat.

Where's the baby?
She's in her crib.

A: **Where's the baby?**
B: He's/She's in/on his/her
.. .

Discussion

1 Which of these things are used for taking a baby outside?

2 Which of these things are used for feeding a baby?

1 clothesline
2 clothespin
3 socket
4 plug
5 iron
6 washing machine
7 (tumble) dryer
8 dustcloth
9 vacuum cleaner
10 ironing board
11 sponge mop
12 broom
13 hanger

14 laundry detergent
15 mop
16 bucket
17 laundry basket
18 dustpan
19 brush
20 scrub brush
21 clothes rack

Where's the clothespin?
It's on the clothesline.

Where's the laundry?
It's in the laundry basket.

A: **Where's the laundry detergent?**
B: It's the

A: **Where's the** ?
B: It's in/on the

Discussion
1 Which of these things do you have in your home?
2 How often do you use these things?

1 umbrella
2 patio
3 (patio) table
4 (patio) chair
5 flowers
6 flowerbed
7 lawn
8 barbecue
9 yard
10 hedge
11 bush
12 tree
13 vegetable garden
14 lounge chair

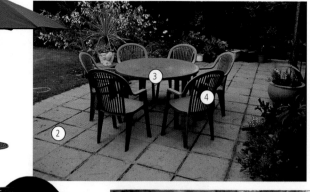

15 daffodil
16 hyacinth
17 daisy
18 tulip
19 orchid
20 rose

Do you like roses?
Yes, I do.

Do you like hyacinths?
No, I don't.

A: **Do you like** ?
B: Yes, I do./No, I don't.

Discussion

1 Do you have a yard? a patio? Describe it.
2 Do you like to work with plants? What kind?

1 seeds
2 seedling tray
3 shed
4 compost
5 rake
6 fork
7 shovel/spade
8 planter
9 hose

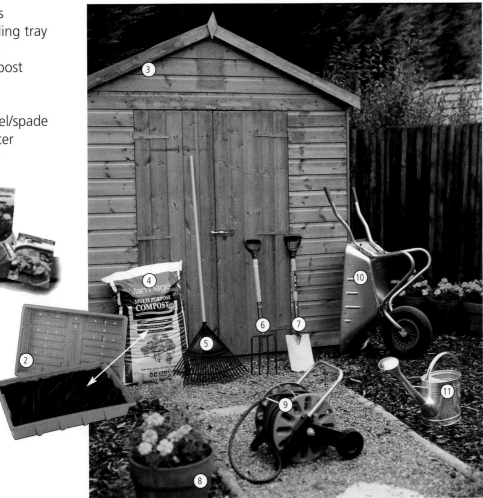

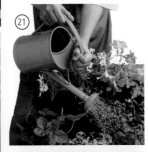

10 wheelbarrow
11 watering can
12 garden shears
13 sprinkler

14 clippers
15 garden gloves
16 trowel
17 lawn mower

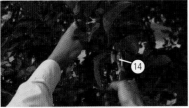

ACTIONS

18 mow the lawn
19 plant flowers
20 rake (the) leaves
21 water the plants
22 dig the soil

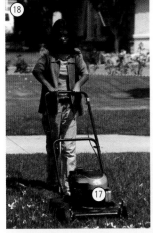

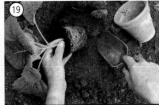

A: **I want to water the garden.**
B: You need a watering can or a sprinkler.

A: **I want to mow the lawn.**
B: You need a lawn mower.

A: **I want to**
B: You need a(n)
and/or (a/an)

Discussion

1 Do you like gardening?
2 Which of these things do you do?

1 attic
2 second floor
3 staircase
4 bannister
5 hallway
6 first floor
7 stair
8 basement/cellar

9 ceiling
10 window
11 window frame
12 window pane
13 screen
14 shutter
15 wall
16 floor

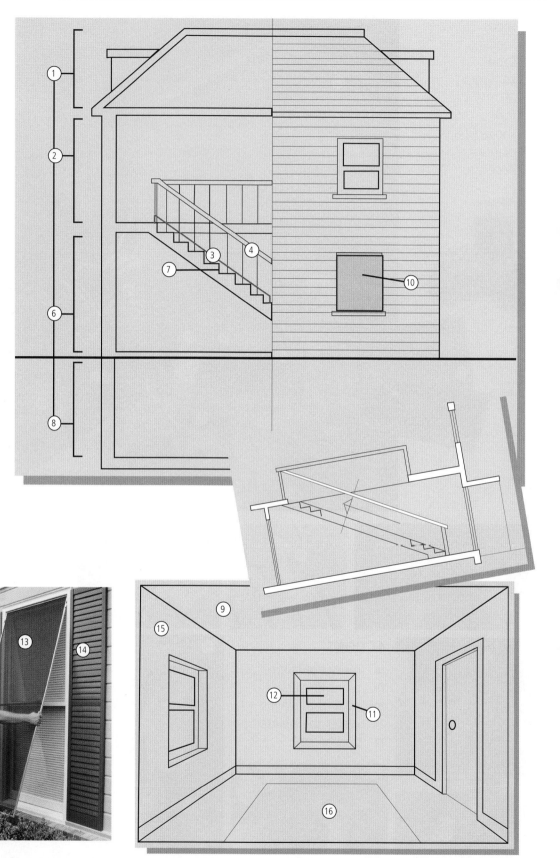

Does your home have a dining room?
No, it doesn't.

Does your home have stairs?
Yes, it does.

A: **Does your home have a(n)**
.. ?
B: Yes, it does./No, it doesn't.

Discussion

1 Which of these things do you have in your home?

2 Are there many two-story houses in your city?

1 make the bed
2 make breakfast/lunch/dinner
3 take the children to school
4 walk the dog
5 take the bus to school
6 make a sandwich
7 load the dishwasher

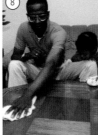

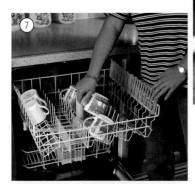
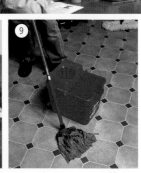

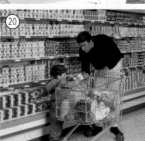

8 dust
9 mop the floor
10 wash the dishes
11 feed the baby
12 sweep the floor
13 vacuum the house
14 feed the dog
15 do homework

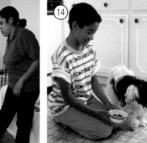
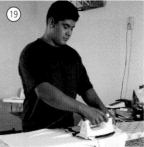
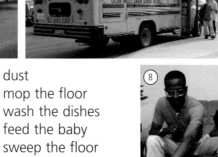

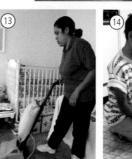

16 pick up the children
17 do the laundry
18 study
19 iron the clothes
20 go shopping

Did you make dinner yesterday?
Yes, I did.

Did you do the laundry yesterday?
No, I didn't.

A: Did you go shopping yesterday?
B: ...

A: Did you yesterday?
B: Yes, I did./No, I didn't.

Discussion
1 Which of these activities do you do every day?
2 Which activities do you like/dislike?

1 application form
2 résumé
3 cover letter
4 job interview
5 job candidate
6 interviewer
7 job announcement board
8 classifieds

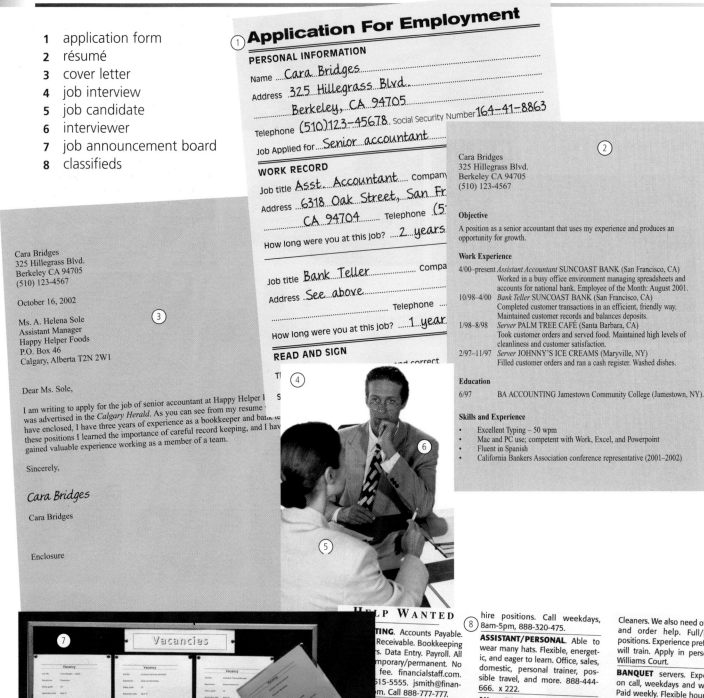

① **Application For Employment**

PERSONAL INFORMATION

Name Cara Bridges
Address 325 Hillegrass Blvd.
Berkeley, CA 94705
Telephone (510)123-45678 Social Security Number 164-41-8863
Job Applied for Senior accountant

WORK RECORD

Job title Asst. Accountant Company
Address 6318 Oak Street, San Fr.
CA 94704 Telephone (5
How long were you at this job? 2 years

Job title Bank Teller Compa
Address See above
Telephone
How long were you at this job? 1 year

READ AND SIGN

② Cara Bridges
325 Hillegrass Blvd.
Berkeley CA 94705
(510) 123-4567

Objective

A position as a senior accountant that uses my experience and produces an opportunity for growth.

Work Experience

4/00–present *Assistant Accountant* SUNCOAST BANK (San Francisco, CA)
Worked in a busy office environment managing spreadsheets and accounts for national bank. Employee of the Month: August 2001.

10/98–4/00 *Bank Teller* SUNCOAST BANK (San Francisco, CA)
Completed customer transactions in an efficient, friendly way. Maintained customer records and balances deposits.

1/98–8/98 *Server* PALM TREE CAFÉ (Santa Barbara, CA)
Took customer orders and served food. Maintained high levels of cleanliness and customer satisfaction.

2/97–11/97 *Server* JOHNNY'S ICE CREAMS (Maryville, NY)
Filled customer orders and ran a cash register. Washed dishes.

Education

6/97 BA ACCOUNTING Jamestown Community College (Jamestown, NY).

Skills and Experience

- Excellent Typing – 50 wpm
- Mac and PC use; competent with Work, Excel, and Powerpoint
- Fluent in Spanish
- California Bankers Association conference representative (2001–2002)

③ Cara Bridges
325 Hillegrass Blvd.
Berkeley CA 94705
(510) 123-4567

October 16, 2002

Ms. A. Helena Sole
Assistant Manager
Happy Helper Foods
P.O. Box 46
Calgary, Alberta T2N 2W1

Dear Ms. Sole,

I am writing to apply for the job of senior accountant at Happy Helper [Foods?]
was advertised in the *Calgary Herald*. As you can see from my resume
have enclosed, I have three years of experience as a bookkeeper and bank te
these positions I learned the importance of careful record keeping, and I hav
gained valuable experience working as a member of a team.

Sincerely,

Cara Bridges

Cara Bridges

Enclosure

④ ⑥ ⑤

⑦ Vacancies

Vacancy	Vacancy	Vacancy

HELP WANTED

...TING. Accounts Payable. Receivable. Bookkeeping s. Data Entry. Payroll. All mporary/permanent. No fee. financialstaff.com. 15-5555. jsmith@finan-m. Call 888-777-777.

...TING/ADMINISTRATOR ... degree. Responsibilities ...nancial statements, bud-...ecasting. Must be com-y. P.O.S. system knowl-...lpful. Good salary, ...efits. Apply in person, ...uare, Irish Pub & Grill, ...enue, San Diego or fax ...8-444-1233.

...ING CLERKS needed ...y for year-end work. ...will go through mid-...st have 2 years experi-...payables and receiv-...uld be famili....with

⑧ hire positions. Call weekdays, 8am-5pm, 888-320-475.

ASSISTANT/PERSONAL. Able to wear many hats. Flexible, energetic, and eager to learn. Office, sales, domestic, personal trainer, possible travel, and more. 888-444-666. x 222.

AU PAIR COORDINATOR. Promote cultural exchange in your community. Support local host families and au pairs participating in live-in childcare/cultural exchange program. Responsibilities include: Market-ing/networking, screening/interviewing host families, monthly au pair meeting. Openings in San Diego, South County, Temecula and surrounding areas. Work at home, flexible hours, compensation per family plus incentive program. Call 888-222-222 or visit www.aupair.org

Cleaners. We also need office en and order help. Full/part-tim positions. Experience preferred b will train. Apply in person, 092 Williams Court.

BANQUET servers. Experience on call, weekdays and weekend Paid weekly. Flexible hours. Pleas call Staffing, 8am-5pm, 888-222 0444.

BIKE CAB DRIVER. independen contractors. Male, female, full/pa time. Driver's license. Trai Monday, Tuesday or Thursday 12.15pm, 646 19th Street, 888 949-0220.

BILINGUAL INTERVIEWERS Spanish and English. No sales Start your career in the interesting world of marketing research, conducting nationwide telephone surveys and opinion polls! Paid training. Full/part time. PM shifts, 7 days. Week-ends enc...

Discussion

1 What should you include in a résumé?
2 What information does a job application ask for?
3 Where can you look for a job?

1 farmer
2 baker
3 mechanic
4 electrician
5 painter
6 truck driver
7 gardener
8 florist
9 window cleaner

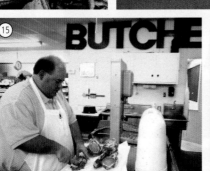
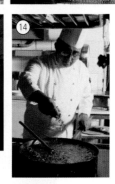

10 fisherman
11 sanitation worker/garbage collector
12 waiter/waitress/server
13 carpenter
14 chef/cook
15 butcher
16 plumber
17 grocery clerk
18 bagger
19 taxi driver
20 bricklayer

BUTCHE

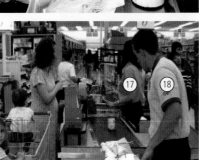

DRIVING FOR AMERICAN'S FAMILIES
www.caregivercredit.org

What does she do?
She's a florist.

What does he do?
He's a waiter.

A: **What does he/she do?**
B: He's/She's a(n)

Discussion
1 Have you ever done any of these jobs?
2 Which of these jobs would you like to try?

1 veterinarian/vet
2 nurse
3 doctor
4 pharmacist
5 scientist
6 dentist
7 police officer
8 teacher
9 judge
10 lawyer
11 mail carrier
12 firefighter
13 professor, lecturer

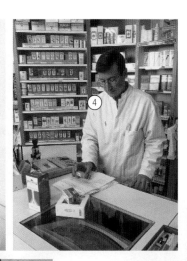

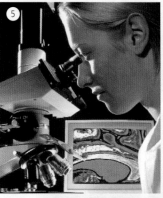
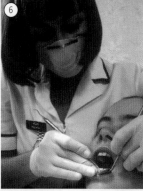
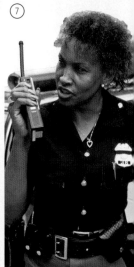

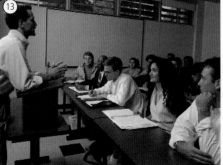

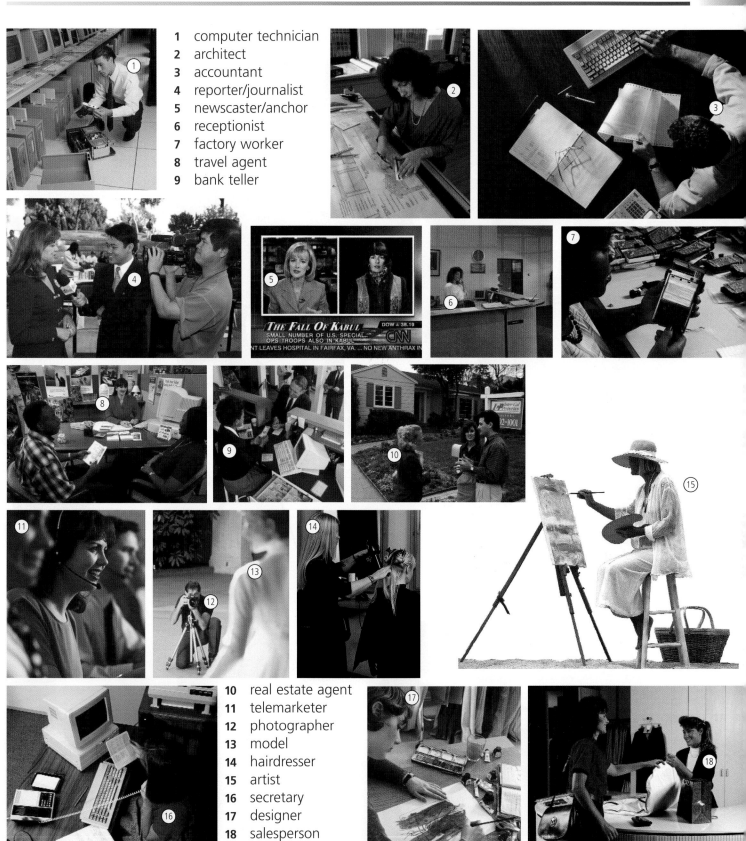

1 computer technician
2 architect
3 accountant
4 reporter/journalist
5 newscaster/anchor
6 receptionist
7 factory worker
8 travel agent
9 bank teller

10 real estate agent
11 telemarketer
12 photographer
13 model
14 hairdresser
15 artist
16 secretary
17 designer
18 salesperson

Would you like to be a photographer?
Yes, I would./No, I wouldn't.

A: **Would you like to be a newscaster?**
B:

A: **Would you like to be a(n)**
... ?
B: Yes, I would./No, I wouldn't.

Discussion
Which of the jobs on the last three pages:
1 are very difficult?
2 are fun?

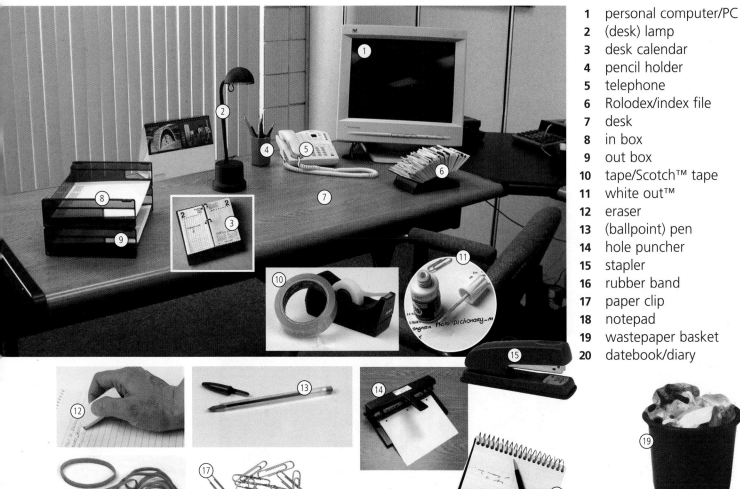

1 personal computer/PC
2 (desk) lamp
3 desk calendar
4 pencil holder
5 telephone
6 Rolodex/index file
7 desk
8 in box
9 out box
10 tape/Scotch™ tape
11 white out™
12 eraser
13 (ballpoint) pen
14 hole puncher
15 stapler
16 rubber band
17 paper clip
18 notepad
19 wastepaper basket
20 datebook/diary

21 pencil
22 filing cabinet
23 fax machine
24 photocopier

Do you ever use a PC?
Yes, I do.

Do you ever use paper clips?
No, I don't.

A: **Do you ever use** ?
B: .. .

Discussion
1 Which of these things do you have at school?
2 Which of these things do you have at home?

1 greet visitors
2 print a copy
3 work on a computer
4 answer the phone
5 conduct a meeting
6 participate in/attend a meeting
7 file papers

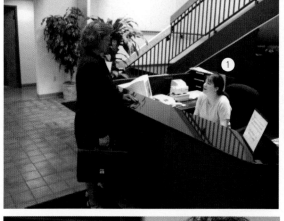

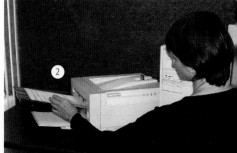

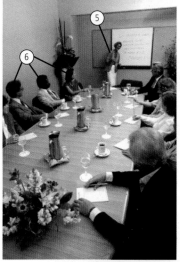

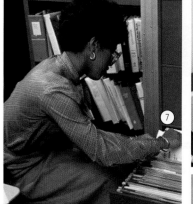

8 send a fax/fax a document
9 send an e-mail
10 photocopy a letter
11 staple documents together
12 fill in a form
13 sign a letter

What's she doing?
She's answering the phone.

What's he doing?
He's sending a fax.

A: What's he doing?
B: He's

A: What's he/she doing?
B: He's/She's

Discussion
1 Which of these activities are interesting?
2 Which of these activities are boring?

1	box cutter
2	toolbox
3	tape measure
4	saw
5	hammer
6	nail
7	power saw
8	plane
9	workbench
10	power/electric drill
11	(drill) bit
12	screwdriver
13	screw
14	hook
15	vise
16	sandpaper
17	pliers
18	wrench
19	ax/axe
20	paintbrush
21	(paint) can
22	(paint) tray
23	(paint) roller
24	paint

What's this?
It's a power drill.

What are these?
They're hooks.

A: What's this?/ What are these?
B: It's a(n)/They're

... .

Discussion
1 Which of these things do you use?
2 Which of these things do you need?

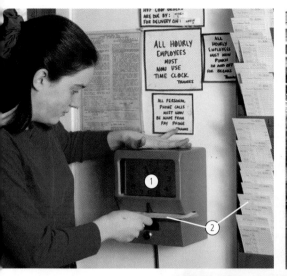

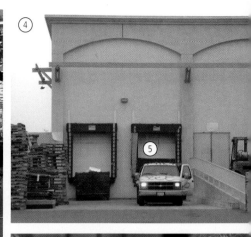

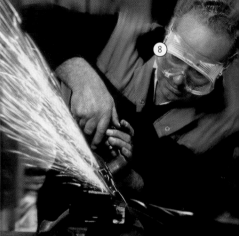

1. time clock
2. time cards
3. machine
4. warehouse
5. loading dock
6. freight elevator
7. conveyor belt
8. safety glasses/
 safety goggles

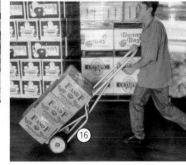

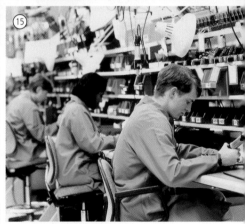

9. fire extinguisher
10. first-aid kit
11. pallet
12. forklift
13. foreman
14. worker
15. work station
16. dolly

Can you tell me where the loading dock is?
Sure. It's right over there.

Can you tell me where the goggles are?
Sure. They're right over there.

A: **Can you tell me where the .. is/are?**
B: Sure. right over there.

Discussion

1. Which of these things do you have at your job?
2. Which of these things are necessary for safety?

1 construction site
2 crane
3 scaffolding
4 ladder
5 construction worker
6 hard hat
7 walkie-talkie
8 wheelbarrow
9 tool belt
10 girder
11 hook
12 excavation site
13 dump truck
14 ear protectors
15 jackhammer

16 cement mixer
17 cement
18 backhoe
19 front-end loader
20 sledge hammer
21 brick
22 trowel
23 level
24 pickaxe
25 shovel

Have you ever used a pickaxe?
Yes, I have.

Have you ever used ear protectors?
No, I haven't.

A: **Have you ever used a(n)**
... ?
B: Yes, I have./No, I haven't.

Discussion
1 Which of these things do people drive?
2 Which of these things make a lot of noise?
3 Which of these things could a person carry?

1 hotel
2 checking in
3 front desk
4 checking out
5 receptionist/desk clerk
6 guest
7 bellhop
8 suitcase
9 restaurant
10 conference room
11 elevator
12 maid/housekeeper
13 bar
14 lobby/foyer
15 bathroom
16 room key
17 single (room)
18 double (room)
19 room service

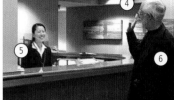

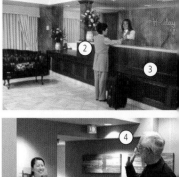

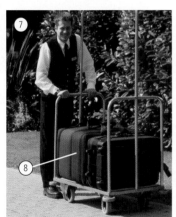

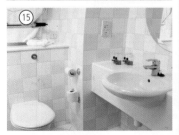

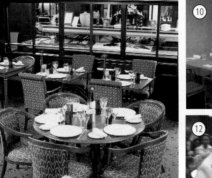

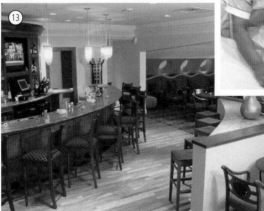

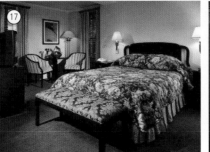

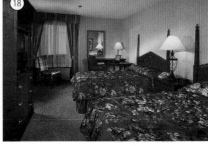

Is this a bar or a restaurant?
It's a bar.

Is she a receptionist or a housekeeper?
She's a housekeeper.

A: **Is this a(n)** **or a(n)** **?**
B: It's a(n) .. .

A: **Is he/she a(n)** **or a(n)** **?**
B: He's/she's a(n)

Discussion

What is the difference between:

1 checking in and checking out?
2 a single room and a double room?

35

1 suspect
2 police officer
3 handcuffs
4 jail/prison
5 prison officer
6 inmate
7 courtroom
8 prosecuting attorney
9 jury
10 defense attorney
11 court reporter
12 witness
13 judge
14 evidence
15 bailiff
16 defendant

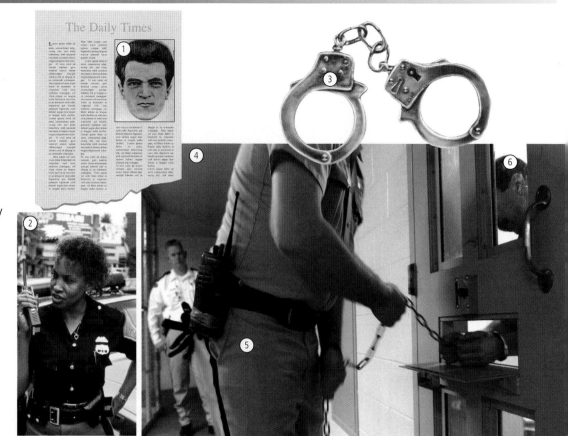

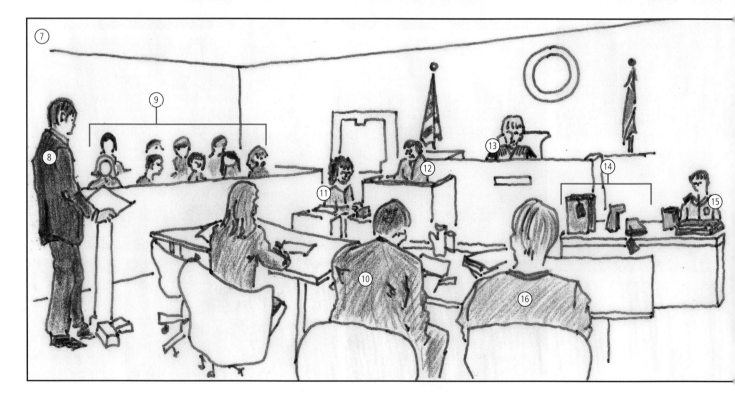

Is this the prosecuting attorney or the defense attorney?
It's the defense attorney.

Is this the witness or the defendant?
It's the witness.

A: **Is this the lawyer or the court reporter?**
B: It's the

A: **Is this the or the ?**
B: It's the

Discussion

1 Have you ever been a witness to a crime?

2 Do you watch any crime series on TV?

1 head
2 arm
3 back
4 waist
5 buttocks/ backside
6 leg
7 face
8 chest
9 stomach
10 hip
11 hand
12 foot
13 eye
14 eyebrow
15 nose
16 mouth
17 chin
18 hair
19 ear
20 lips
21 neck

22 nail
23 thumb
24 finger
25 wrist

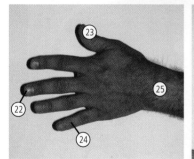

26 palm
27 shoulder
28 forearm
29 upper arm
30 elbow

31 knee
32 thigh
33 shin
34 calf
35 ankle
36 heel
37 toe

What's right above the eye?
The eyebrow.

What's right below the nose?
The mouth.

A: What right above/below the
... ?

B: The

Discussion
What are the parts of the:
1 hand?
2 leg?

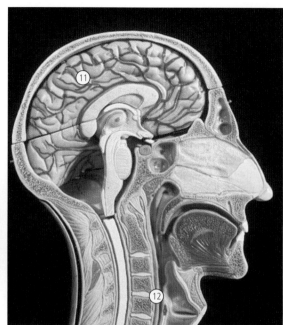

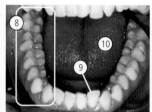

1 forehead
2 temple
3 eyebrow
4 eyelid
5 eyelash
6 pupil
7 cheek

8 teeth
9 tooth
10 tongue

11 brain
12 throat
13 vein
14 artery
15 lung
16 liver
17 stomach
18 large intestine
19 small intestine
20 muscle
21 lung
22 heart

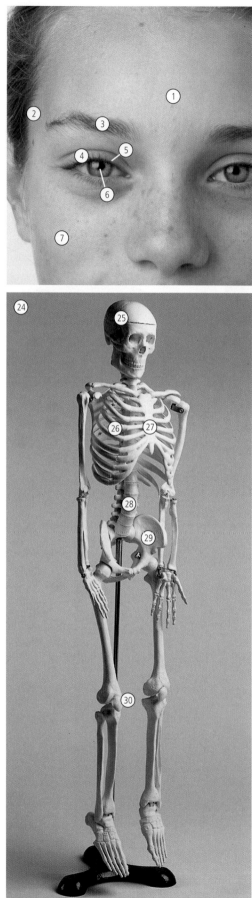

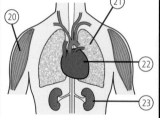

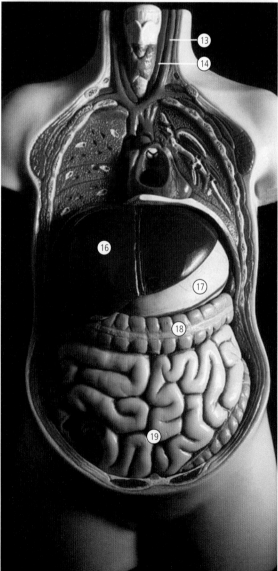

23 kidney
24 skeleton
25 skull
26 ribs
 breastbone/
27 sternum
28 spine/backbone
29 pelvis/hip-bone
 kneecap

1 blond/light hair
2 red hair
3 brown/dark hair
4 black hair

5 long hair
6 shoulder-length hair
7 short hair

8 part
9 bangs
10 braid
11 pony tail
12 curly hair
13 straight hair
14 wavy hair

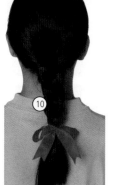
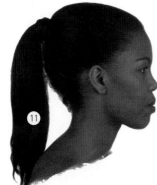
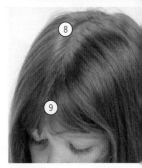

15 bald
16 stubble
17 mustache
18 beard
19 sideburns
20 goatee
21 short
22 tall
23 slim/thin
24 heavy

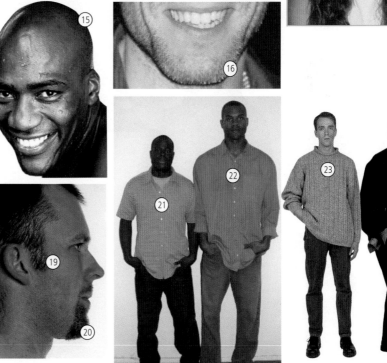

What does he look like?
He's thin, and he has short brown hair.

What does she look like?
She has curly, shoulder length hair.

A: **What does she look like?**
B: She .. .

A: **What does he look like?**
B: He .. .

Discussion
1 What do you look like?
2 What do members of your family look like?

1 fall
2 talk/speak
3 carry
4 stand
5 touch
6 point
7 shake hands
8 sit
9 push
10 pull

11 laugh
12 hug
13 wave
14 lie down
15 cry

16 frown 19 smile
17 sing 20 kiss
18 clap 21 dance

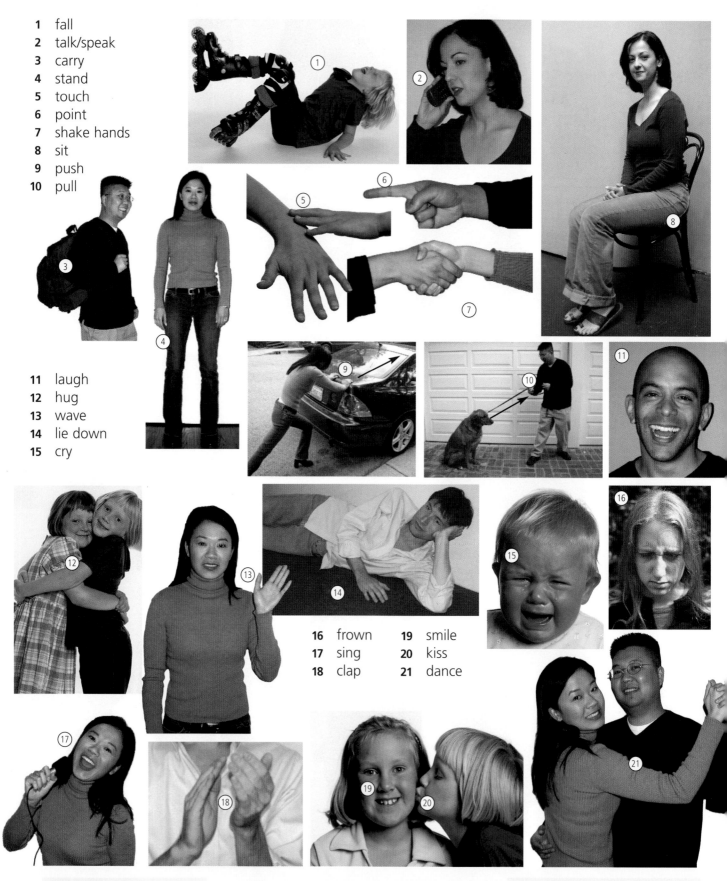

What's she doing?
She's waving.

What are they doing?
They're hugging.

A: **What's he/she doing?/ What are they doing?**
B: He's/She's/They're

Discussion
What do you do when you're:

1 happy?

2 sad?

3 tired?

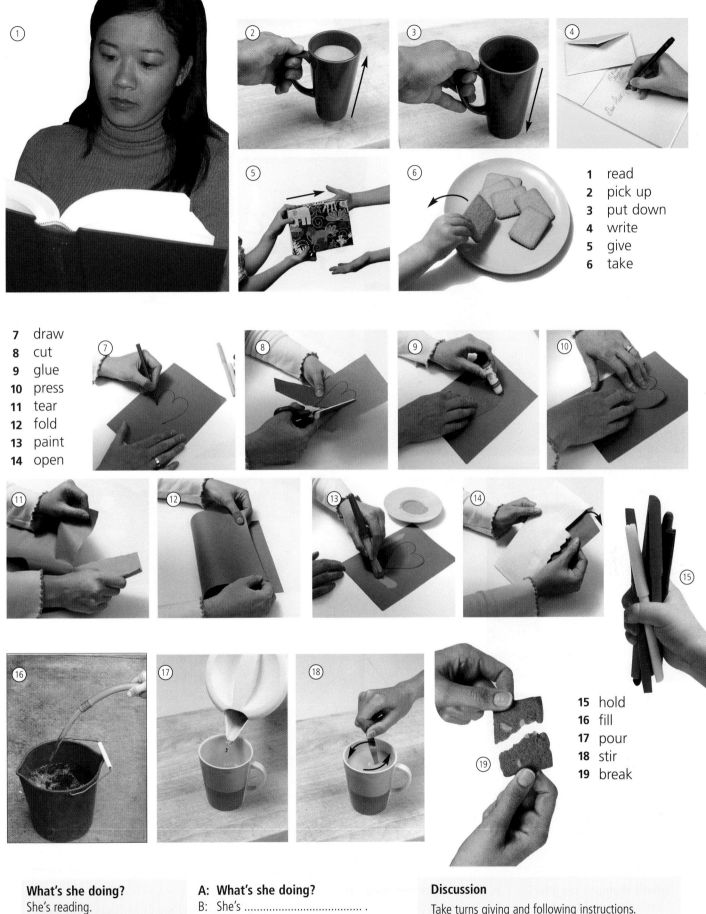

1 read
2 pick up
3 put down
4 write
5 give
6 take

7 draw
8 cut
9 glue
10 press
11 tear
12 fold
13 paint
14 open

15 hold
16 fill
17 pour
18 stir
19 break

What's she doing?
She's reading.

What's she doing?
She's tearing paper.

A: **What's she doing?**
B: She's

Discussion
Take turns giving and following instructions.

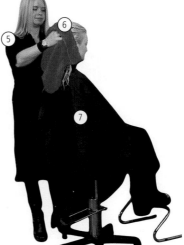

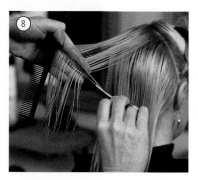

1 wash/shampoo
2 shampoo
3 sink
4 rinse

5 hairdresser
6 towel dry
7 cape
8 cut

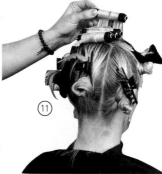

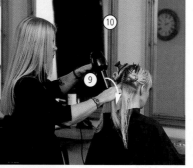

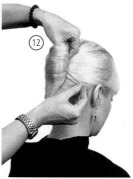

9 blow-dry
10 mirror
11 perm
12 style
13 highlights
14 roller/curler

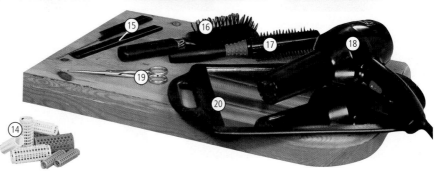

15 comb
16 (hair)brush
17 styling brush
18 hairdryer
19 scissors
20 hand mirror

21 hairdresser's chair
22 footrest

23 massage
24 beautician
25 facial
26 towel

What's shampoo used for?
It's used for washing hair.

What are scissors used for?
They're used for cutting hair.

A: **What are curlers used for?**
B: They're used for

A: **What's (a/an)** **used for?**
B: It's/They're used for........................... .

Discussion
1 What does the hairdresser usually do to your hair?
2 Which of these things do you have at home?

A COSMETICS/MAKE-UP

1 moisturizer
2 blush/rouge
3 brush
4 foundation/base
5 eye shadow
6 mascara
7 lipstick
8 eyeliner
9 eyebrow pencil

B MANICURE ITEMS

10 nail clippers
11 nail scissors
12 nail file
13 emery board
14 nail polish

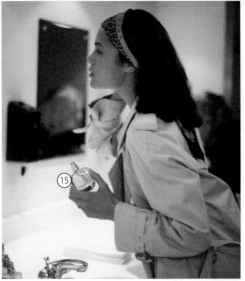

C TOILETRIES

15 perfume
16 cologne
17 shaving cream
18 aftershave
19 razor
20 razor blade
21 electric shaver
22 tweezers
23 brush
24 comb
25 hairdryer

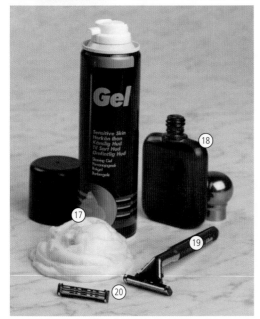

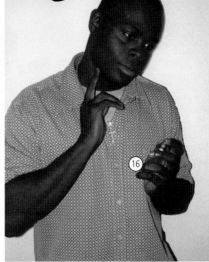

How often do you use mascara?
I sometimes use mascara./I never use mascara.

How often do you use an emery board?
I often use an emery board.

A: **How often do you use (a/an)**
.. ?
B: I never/rarely/sometimes/often/always use (a/an) .. .

Discussion
1 Which of these things are commonly used only by women? only by men? by both men and women?
2 Which of these things usually smell nice?

1 She has a **toothache**.

2 She has a **stomachache**.
3 antacid
4 Alka Seltzer™

5 He has a **headache**.
6 painkiller/pain reliever
7 aspirin
8 pills/tablets

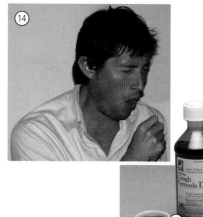

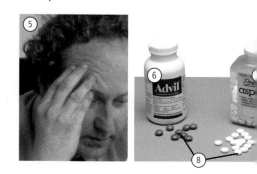

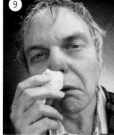

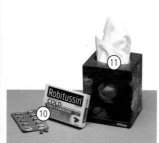

9 He has the **flu/a cold**.
10 cold medicine
11 tissues

12 He has a **sore throat**.
13 throat lozenges

14 He has a **cough**.
15 cough syrup

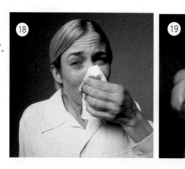

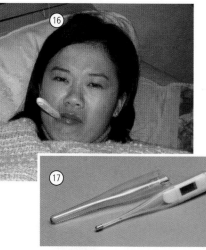

16 She has a **temperature/fever**.
17 thermometer

18 She has a **nosebleed**
19 He has a **backache**
20 He has a **broken leg**

What's the matter with her?
She has a fever.
What's wrong with him?
He has a broken leg.

A: What's the matter/ What's wrong with him/her?
B: He/she has

Discussion

1 What do you take for a stomachache? a cold? a sore throat? a cough?

2 When is the last time you were sick? What was the matter?

21 She **fell down**.

22 He **hurt his hand**.

23 He **sprained his ankle**.

24 bruise
25 sunburn
26 cut
27 scratch
28 bump

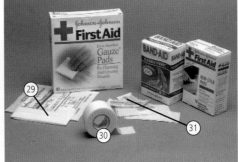

29 gauze (pad)
30 adhesive tape
31 adhesive bandage/Band-Aid™

32 blood
33 black eye
34 scar

35 insect/bug bite
36 insect repellent
37 cream

38 rash

What happened to her?.
She fell down.

What happened to him.
He got a bump.

A: What happened to him/her?
B: He/She .. .

Discussion

1 Which of these remedies do you have at home?

2 What are some ways people can get a bruise? a sunburn? a cut? a bump?

MEDICAL CARE

THE DOCTOR'S OFFICE

1. height chart
2. patient
3. doctor/physician
4. examination table
5. X-ray
6. blood pressure gauge
7. scale
8. prescription
9. medical records
10. stethoscope

Feet
—7
—6
—5
—4

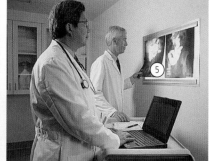

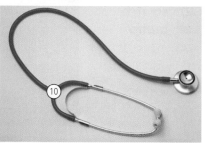
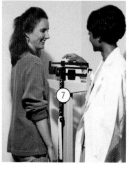
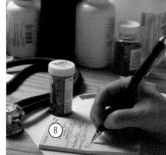
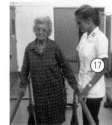
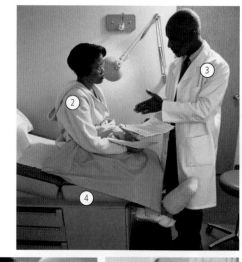
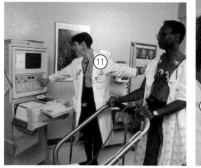

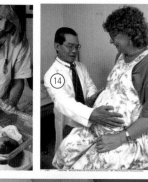
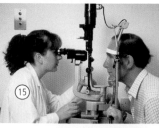
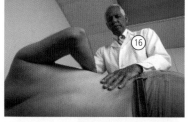

MEDICAL SPECIALISTS

11. cardiologist
12. ear, nose, and throat (ENT) specialist
13. pediatrician
14. obstetrician/gynecologist
15. ophthalmologist
16. osteopath
17. physiotherapist/physical therapist
18. counselor/therapist

What's this?
It's an x-ray.

Who's she?
She's a physical therapist.

A: **What's this** ?
B: It's a(n) .. .

A: **Who's he/she** ?
B: He's/She's a(n)

Discussion

1. Do you always go to the doctor when you're sick?
2. Have you ever visited any of these specialists?

HOSPITAL WARD

1 consultant
2 nurse
3 patient
4 orderly
5 gurney
6 stitches
7 operation/surgery
8 mask
9 surgeon
10 surgical gloves
11 anesthetist
12 give a shot
13 syringe
14 needle
15 cast
16 wheelchair
17 crutches
18 waiting room
19 surgical collar
20 sling
21 scalpel

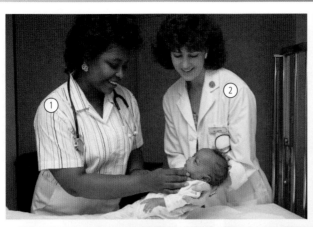

Is this a cast or a surgical collar?
It's a surgical collar.

Is she a nurse or an orderly?
She's an orderly.

A: Is this a(n)
 or a(n) .. ?
B: It's a(n)

A: Is she/he a(n)
 or a(n) .. ?
B: She's/He's a(n)

Discussion

1 Have you ever been in the hospital? Why were you there?

2 Do you like to visit people in the hospital?

47

DENTAL AND EYE CARE

A DENTAL CARE

1 dentist
2 drill
3 dental assistant
4 patient
5 (dental) hygienist
6 lamp
7 orthodontist
8 braces
9 dental floss
10 back teeth
11 front teeth
12 filling
13 gum
14 tooth
15 dentures
16 mirror

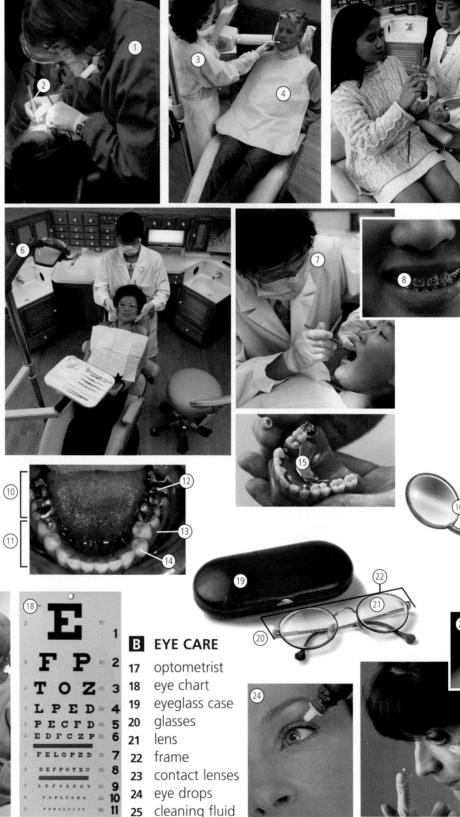

B EYE CARE

17 optometrist
18 eye chart
19 eyeglass case
20 glasses
21 lens
22 frame
23 contact lenses
24 eye drops
25 cleaning fluid

Who's this?
It's the dentist.

What's this?/What are these?
It's a filling./They're glasses.

A: Who's/What's this?
B: It's the/a(n)

A: What are these?
B: They're

Discussion
1 Do you like to go to the dentist?
2 Do you wear eyeglasses/contact lenses?

OUTDOOR CLOTHING

1 rain hat
2 cap
3 hat
4 umbrella
5 raincoat
6 jacket
7 coat
8 gloves

SWEATERS

9 turtleneck
10 V-neck sweater
11 cardigan
12 crewneck sweater

FOOTWEAR

13 shoes
14 sneakers
15 boots
16 sandals
17 pumps

NIGHTCLOTHES

18 pajamas
19 slippers
20 nightgown/nightie
21 bathrobe

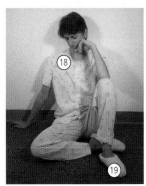

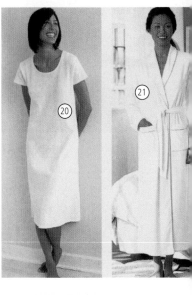

Do you prefer coats or jackets?
I prefer jackets.

Do you prefer sandals or boots?
I prefer sandals.

A: **Do you prefer** or
.. ?
B: I prefer .. .

Discussion

1 Which of these things do you need in wet or cold weather?

2 Which of these things do you only wear at home?

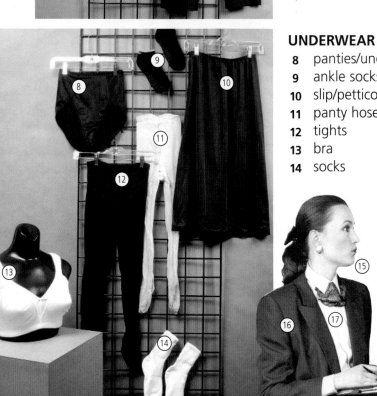

CASUAL WEAR

1 pants/slacks
2 sweatshirt
3 T-shirt
4 shorts
5 jeans
6 blazer
7 overalls

UNDERWEAR

8 panties/underwear
9 ankle socks
10 slip/petticoat
11 panty hose/stockings
12 tights
13 bra
14 socks

FORMAL WEAR

15 suit
16 jacket
17 blouse
18 skirt
19 dress
20 evening gown

What color is the T-shirt?
It's white.

What color are the tights?
They're black.

A: **What color is/are the**
.. ?
B: It's/They're (light/dark)
.. .

Discussion

1 Describe the clothes that you usually wear.

2 In your opinion, which type of clothes look best on a woman? on a man?

FORMAL WEAR
1 suit
2 tie
3 tuxedo
4 bow tie
5 vest
6 shirt

CASUAL WEAR
7 sweatshirt
8 jacket
9 shirt
10 pants/slacks
11 T-shirt
12 baseball cap
13 jeans

UNDERWEAR
14 undershirt
15 socks
16 boxer shorts/boxers
17 briefs/jockey shorts

SPORTSWEAR
18 warm-up suit
19 bathing suit/swimsuit
20 sneakers
21 swimming trunks

Do you like this vest?
Yes, I do.

Do you like these socks?
No, I don't.

A: **Do you like this shirt?**
B: .. .

A: **Do you like this/these**
.. ?
B: Yes, I do./No, I don't.

Discussion
1 Describe the clothes that a classmate usually wears.
2 Which of these clothes are commonly used only at night?
only during the day? both at night and during the day?

DESCRIBING CLOTHES

7.2 PARTS OF CLOTHES AND SHOES

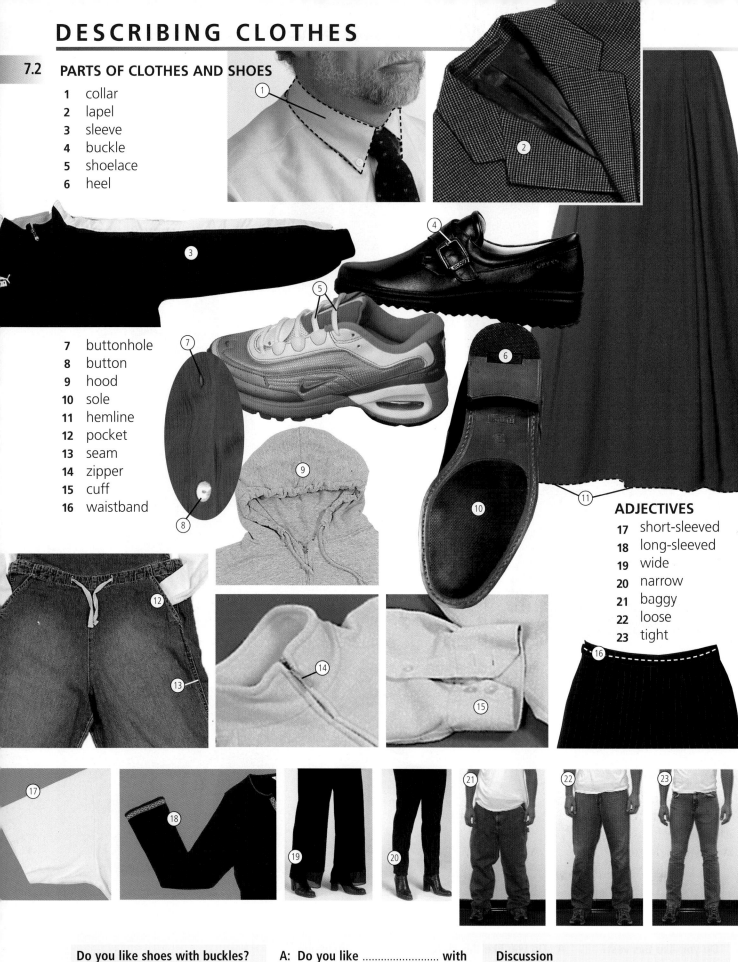

1 collar
2 lapel
3 sleeve
4 buckle
5 shoelace
6 heel

7 buttonhole
8 button
9 hood
10 sole
11 hemline
12 pocket
13 seam
14 zipper
15 cuff
16 waistband

ADJECTIVES

17 short-sleeved
18 long-sleeved
19 wide
20 narrow
21 baggy
22 loose
23 tight

Do you like shoes with buckles?
Yes, I do./No, I don't.

Do you like baggy pants?
Yes, I do./No, I don't.

A: **Do you like** **with**
... ?
B: Yes, I do./No, I don't.

A: **Do you like** ?
B:

Discussion
Who in the class is wearing clothes and shoes with these parts?

COLORS

1 white
2 sky blue
3 yellow
4 navy blue
5 tan
6 pink
7 brown
8 dark green
9 purple
10 beige
11 cream
12 dark blue
13 red
14 gray
15 orange
16 black
17 turquoise

PATTERNS

18 striped
19 polka-dotted
20 patterned
21 solid
22 plaid/tartan
23 checked

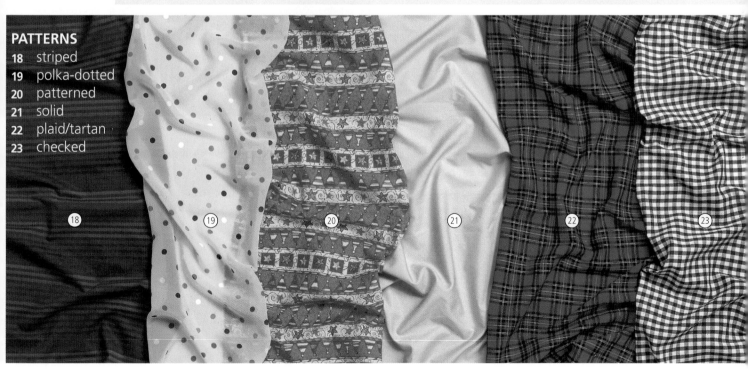

What colors are in the checked pattern?
Navy blue and white.

A: What colors are in the
..................................... **pattern?**
B:

Discussion

1 Which of these colors or patterns do you often wear?

2 Describe what the person next to you is wearing.

1 knitting needle
2 pattern
3 sewing basket
4 hook and eye
5 fastener/snap
6 thread
7 pincushion
8 thimble
9 needle
10 safety pin
11 pin
12 tape measure
13 scissors
14 yarn
15 Velcro™
16 iron-on tape
17 sewing machine
18 dressmaker/seamstress
19 tailor
20 stain

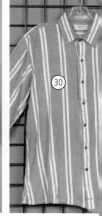

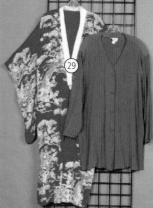

21 rip/tear
22 missing button
23 broken zipper
24 denim
25 wool
26 leather
27 linen
28 polyster
29 silk
30 cotton

Where's the sewing basket?
It's behind the pincushion.

Where are the scissors?
They're in front of the yarn.

A: **Where's/Where are the**
.. ?
B: It's/They're behind/in front of the
.. .

Discussion
1 Which of these things do you have at home?
2 What fabrics are you wearing today?

A JEWELRY

1 watch
2 chain
3 brooch
4 necklace
5 earring
6 cuff link
7 tie clip
8 bracelet
9 barrette
10 pearl
11 ring

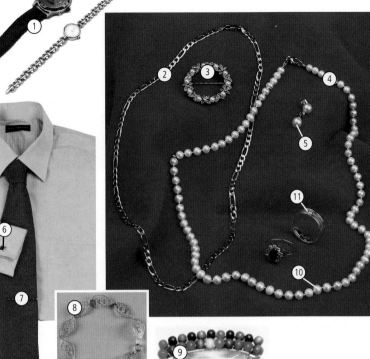

B METALS

12 gold
13 silver

C GEMS

14 diamond
15 emerald
16 ruby
17 amethyst
18 sapphire
19 topaz

D ACCESSORIES

20 daily planner
21 handkerchief
22 wallet
23 change purse
24 scarf
25 make-up bag
26 tote bag
27 clutch (bag)
28 purse/handbag
29 suspenders
30 briefcase
31 belt
32 buckle
33 key ring

What's a nice belt.
I agree./I disagree. I don't like it.

Those are nice earrings?
I agree./I disagree. I don't like them.

A: **That's a nice/Those are nice**
... .
B: I agree./I disagree. I don't like it/them.

Discussion
In your opinion, which of these things:
1 are expensive?
2 are useful?

A SCHOOLS

1 nursery school/pre-school
2 kindergarten
3 elementary school
4 junior high/middle school
5 high school
6 college/university
7 graduates
8 technical/vocational school
9 adult education classes

B THE CLASSROOM

10 teacher
11 blackboard/chalkboard
12 desk
13 textbook
14 student
15 television
16 video cassette recorder
17 cassette/CD player
18 chalk
19 overhead projector
20 bulletin board
21 poster
22 computer
23 whiteboard
24 whiteboard marker

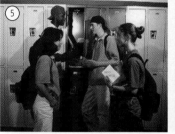

Read chapter one pages 8–13
Write your comments on these pages.
Discussion.
Groups – 2 or 3 people.
Role play.

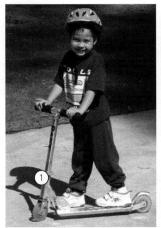

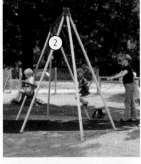

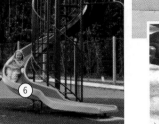

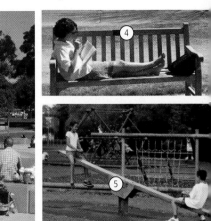

1 scooter
2 swings
3 jungle gym
4 bench
5 seesaw/teeter-totter
6 slide
7 sandbox
8 sand
9 kite
10 skateboard
11 tricycle
12 Rollerblades™
13 roller skates

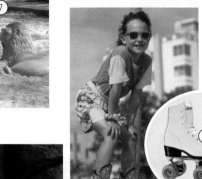

14 easel
15 toys
16 doll
17 book
18 building blocks
19 coloring book
20 crayon
21 paints
22 paintbrush
23 safety scissors
24 jigsaw puzzle
25 glue

What color is the tricycle?
It's red.

What color are the building blocks?
They're yellow, blue, red, and green.

A: What color is/are the
.. ?

B: It's/They're

Discussion

1 Which of these things have wheels?
2 Which of these things did you have when you were a child?

A CLASSROOM OBJECTS

1 triangle
2 ruler
3 protractor
4 compass
5 eraser
6 notebook
7 (ballpoint) pen
8 pencil
9 pencil sharpener
10 calculator

B THE SCIENCE LAB

11 tongs
12 bunsen burner
13 beaker
14 graduated cylinder
15 pipette
16 goggles
17 test tube

C THE GYM

18 mat

D THE COMPUTER LAB

19 screen
20 keyboard

E THE LANGUAGE LAB

21 headphones

F THE CAFETERIA

22 tray

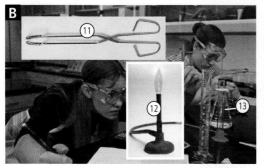

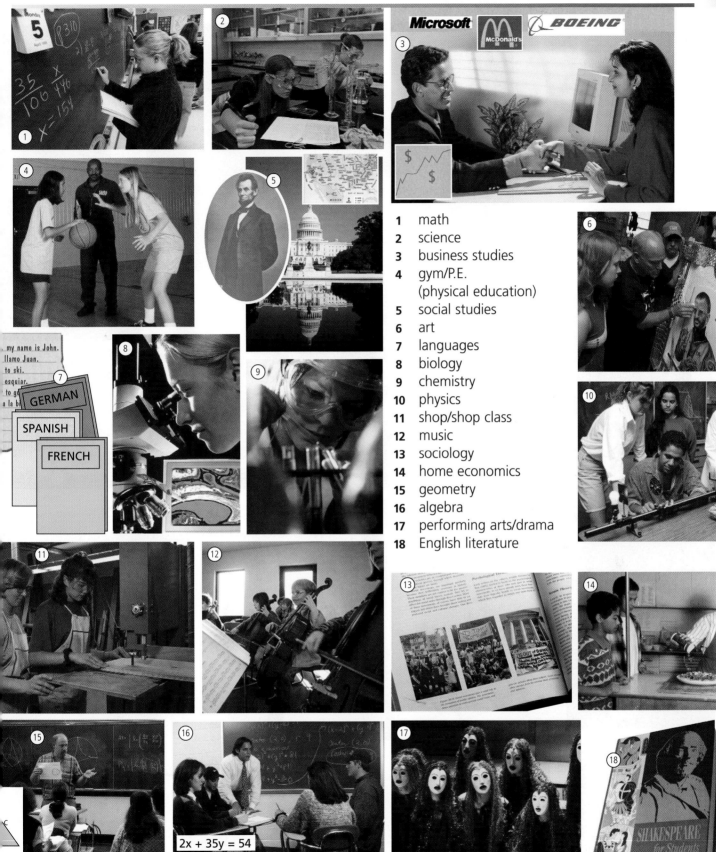

1 math
2 science
3 business studies
4 gym/P.E.
 (physical education)
5 social studies
6 art
7 languages
8 biology
9 chemistry
10 physics
11 shop/shop class
12 music
13 sociology
14 home economics
15 geometry
16 algebra
17 performing arts/drama
18 English literature

What are the students studying here?
They're in biology class.

A: **What are the students studying here?**
B: They're in class.

Discussion
1 Which of these subjects do/did you take?
2 What are/were your favorite subjects in school?

1 librarian
2 checkout desk
3 library card
4 reference section
5 books
6 shelf
7 terminal/computer
8 cart
9 periodical section
10 magazines
11 newspapers
12 information desk

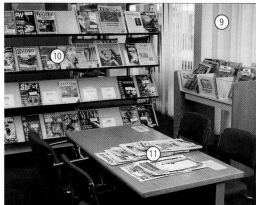

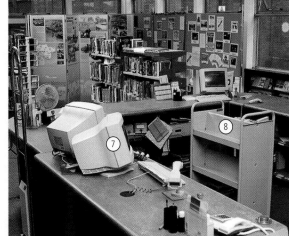

13 storytelling
14 photocopier
15 title
16 author
17 call number
18 dictionary
19 children's section
20 atlas
21 encyclopedia

I need a magazine. Where should I go?
To the periodical section.

I need some information. Where should I go?
To the information desk.

A: **I need a(n)/some**
 Where should I go?
B: To the

Discussion

1 How often do you go to the library?
2 What do you usually do at the library?

1 carrots
2 cabbage
3 cauliflower
4 onion
5 cucumbers
6 broccoli
7 brussel sprouts
8 leek
9 pumpkin

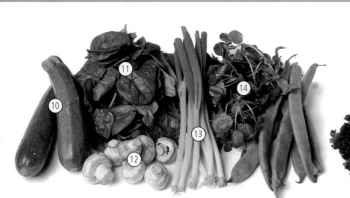

10 zucchini
11 spinach
12 mushrooms
13 green onions
14 watercress

15 asparagus
16 lettuce
17 green beans
18 eggplant
19 peas
20 celery
21 corn (on the cob)
22 potatoes
23 tomatoes
24 garlic
25 green pepper
26 red pepper
27 artichoke

Should we buy cauliflower or broccoli?
Let's buy broccoli.

Should we buy green peppers or red peppers?
Let's buy green peppers.

A: **Should we buy** **or** ?
B: Let's buy .. .

Discussion

1 Do you eat vegetables every day? Which do you eat most often?

2 Which of these vegetables can you eat without cooking them?

1 tangerine
2 grapefruit
3 lemon
4 lime
5 orange
6 grape
7 pineapple
8 banana
9 honeydew melon

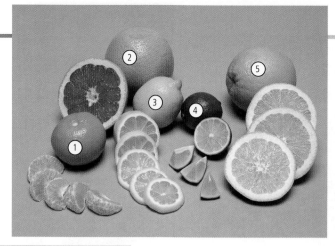

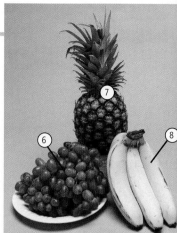

10 avocado
11 kiwi
12 papaya
13 mango
14 apricot
15 star fruit
16 peach

21 apple
22 pear
23 watermelon
24 plum
25 strawberry
26 raspberry
27 blueberry
28 rhubarb
29 cherry

17 raisin
18 fig
19 prune
20 date

NUTS

30 hazelnut
31 walnut
32 coconut
33 Brazil nut
34 pecan
35 peanut
36 cashew

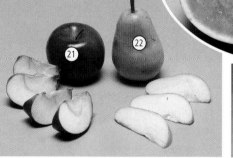

Do you prefer apples or pears?
I prefer pears.

Do you prefer peaches or plums?
I don't like either.

A: **Do you prefer or**
.. ?
B: I prefer/
I don't like either.

Discussion
1 Which of these fruits are common in your country?
2 Which of these fruits do you like?

A CHECK-OUT AREA

1 aisle
2 groceries
3 check-out counter
4 customer/shopper
5 (check-out) cashier
6 conveyer belt
7 (shopping) cart
8 shopping bag

B FROZEN FOODS

C DAIRY PRODUCTS

9 eggs
10 yogurt/yoghurt
11 margarine
12 cheese
13 milk
14 butter

D JARS/CANNED FOOD

15 baked beans
16 tuna fish
17 soup
18 tomatoes
19 honey
20 corn
21 peanut butter
22 jam/jelly

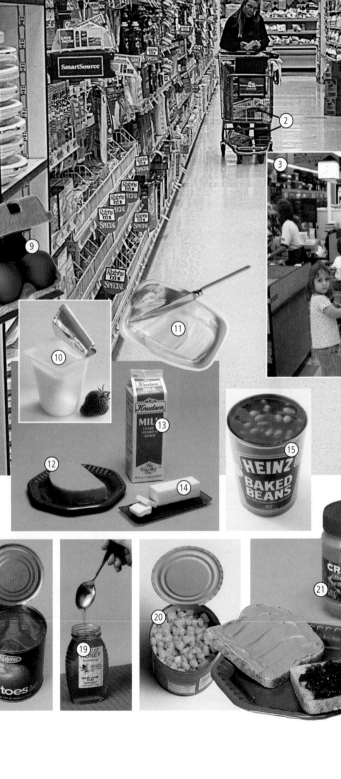

DRY GOODS

1 coffee
2 tea
3 cocoa
4 cereal
5 rice
6 pasta
7 oatmeal
8 flour
9 cookies
10 sugar

CONDIMENTS

11 spices/herbs
12 salt
13 pepper
14 oil
15 vinegar
16 salad dressing
17 ketchup/catsup
18 mustard
19 mayonnaise

DRINKS

20 red wine
21 white wine
22 beer
23 mineral water
24 soft drink/soda
25 juice

HOUSEHOLD PRODUCTS

26 trash bags/garbage bags
27 plastic wrap
28 aluminum foil
29 window cleaner

What do we need today?
We need some coffee and some sugar, but we don't need any cookies.

A: **What do we need today?**
B: We need some, but we don't need any

Discussion
What would you buy to make:
1 breakfast?
2 a quick dinner?

A MEAT

BEEF

1 pot roast
2 steak
3 ground beef
4 liver

PORK

5 pork chops
6 sausage
7 bacon

LAMB

8 leg of lamb
9 lamb chops

CHICKEN

10 chicken

B DELICATESSEN

11 dip
12 coleslaw
13 potato salad
14 ham
15 salami
16 lunchmeat
17 Swiss cheese
18 American cheese
19 cheddar cheese

C FISH AND SEAFOOD

20 whole trout
21 scallops
22 oyster
23 lobster
24 crab
25 shrimp
26 mussels
27 fish fillet
28 salmon steaks

D BAKERY

29 whole wheat bread
30 bagels
31 pita bread
32 French bread
33 cupcakes
34 white bread

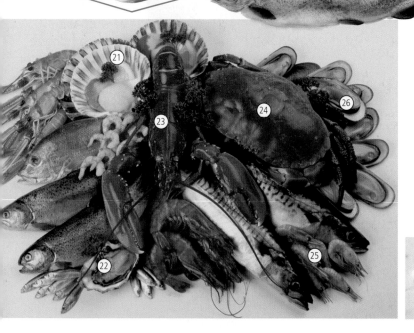

1 waiter
2 menu
3 wine list
4 dessert cart

APPETIZERS/HORS D'OEUVRES

5 shrimp cocktail
6 salad
7 soup

Wine List

White	Per bottle
Australian Chardonnay	$10.99
New Zealand Sauvignon Blanc	$8.99
House White	$6.99
Red	
Australian Shiraz	$10.99
Cotes Du Rhone	$8.99
House Red	$6.99
House Champagne	$22.99

MAIN COURSES

8 roast beef
9 baked potato
10 stuffed peppers
11 pizza
12 lasagna
13 spaghetti
14 fish fillet
15 vegetables
16 rice
17 noodles

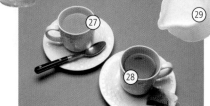

DESSERTS

18 whipped cream
19 ice cream
20 cheesecake
21 pie
22 (chocolate) cake

DRINKS

23 white wine
24 red wine
25 champagne
26 bottled water
27 coffee
28 tea
29 milk

I'd like the lasagna, please.
Certainly.

I'd like the cheesecake, please.
I'm sorry, we don't have any today.

A: **I'd like the ………....…..……… , please.**
B: Certainly./I'm sorry, we don't have any today.

Discussion

What would you like:

1 for dinner?
2 to drink?
3 for dessert?

1 milkshake
2 straw
3 soft drink/soda

4 hamburger
5 hotdog
6 French fries
7 fried chicken
8 sandwich
9 taco
10 potato chips

11 ice cream
12 ice cream cone
13 doughnut
14 muffin

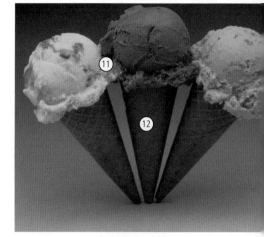

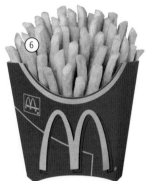

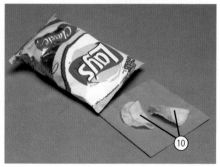

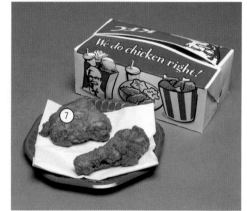

Would you like a hamburger?
Yes, please.

Would you like some doughnuts?
No, thanks.

A: **Would you like some potato chips?**

B: .. .

A: **Would you like a(n)/some**

.. ?

B: Yes, please./ No, thanks.

Discussion

1 How often do you have fast food?

2 What's your favorite fast food restaurant? What do you usually order there?

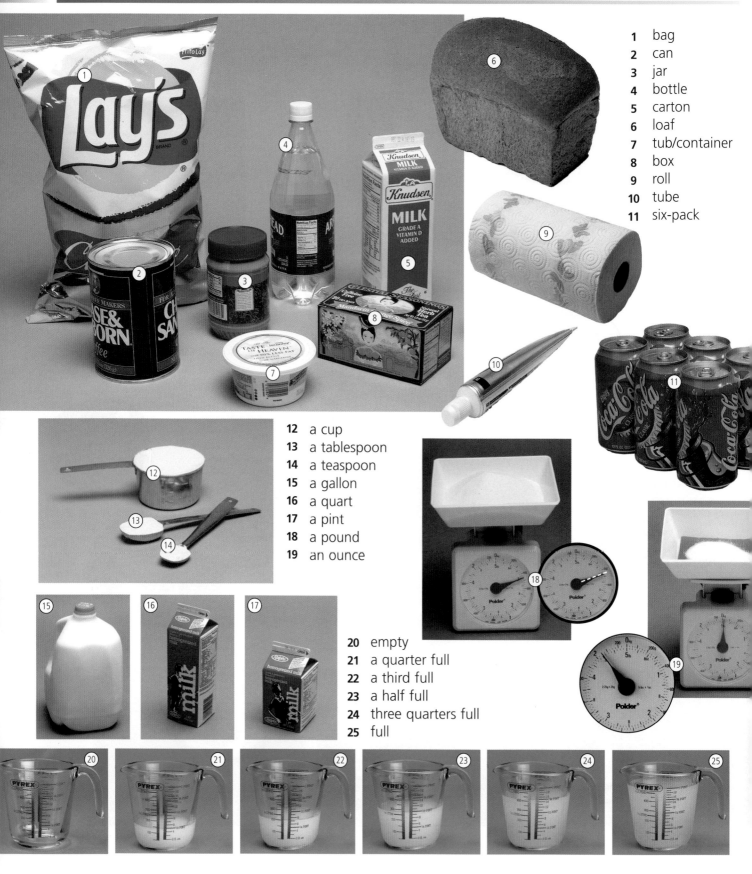

1 bag
2 can
3 jar
4 bottle
5 carton
6 loaf
7 tub/container
8 box
9 roll
10 tube
11 six-pack

12 a cup
13 a tablespoon
14 a teaspoon
15 a gallon
16 a quart
17 a pint
18 a pound
19 an ounce

20 empty
21 a quarter full
22 a third full
23 a half full
24 three quarters full
25 full

How much milk do we want?
Two quarts./ A gallon.

How many cans of soda do we want?
Three.

A: How much do we
 want?/ How many of
 do we want?
B:

Discussion

1 What do you usually buy in these containers (bags, cans, etc.)?

2 How much of these foods do you usually buy: milk, meat, bread, rice, fish?

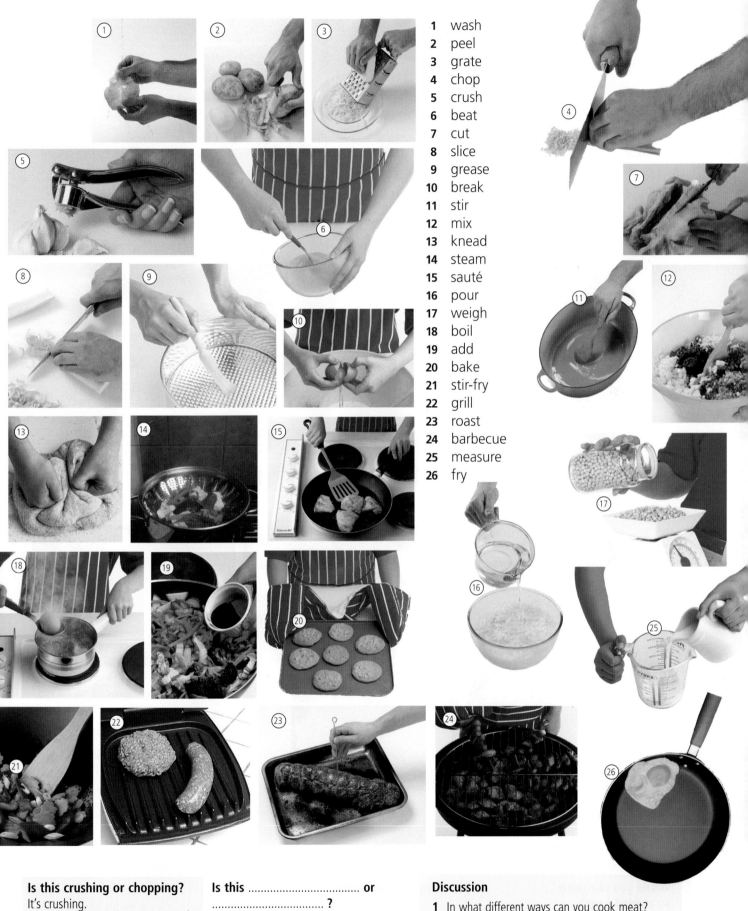

1 wash
2 peel
3 grate
4 chop
5 crush
6 beat
7 cut
8 slice
9 grease
10 break
11 stir
12 mix
13 knead
14 steam
15 sauté
16 pour
17 weigh
18 boil
19 add
20 bake
21 stir-fry
22 grill
23 roast
24 barbecue
25 measure
26 fry

Is this crushing or chopping?
It's crushing.

Is this boiling or frying?
It's frying.

Is this or
................................. ?
B: It's

Discussion

1 In what different ways can you cook meat?
2 Explain how you make one of your favorite dishes.

69

1 grapefruit
2 oatmeal/hot cereal
3 milk
4 cereal
5 orange juice
6 butter
7 toast
8 croissant
9 coffee
10 tea
11 jelly/jam
12 bagel
13 cream cheese

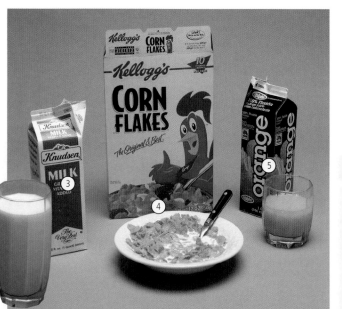

14 soft-boiled egg
15 scrambled eggs
16 omelet
17 fried egg
18 fried egg over easy

Would you like some scrambled eggs?
No, thanks. I'd rather have cereal.

Would you like some toast?
Yes, please.

A: Would you like a(n)/some
............................ ?
B: No, thanks. I'd rather have a(n)/some
...................... ./Yes, please.

Discussion
1 What do you usually eat for breakfast?
2 Which of these foods would you like to try?

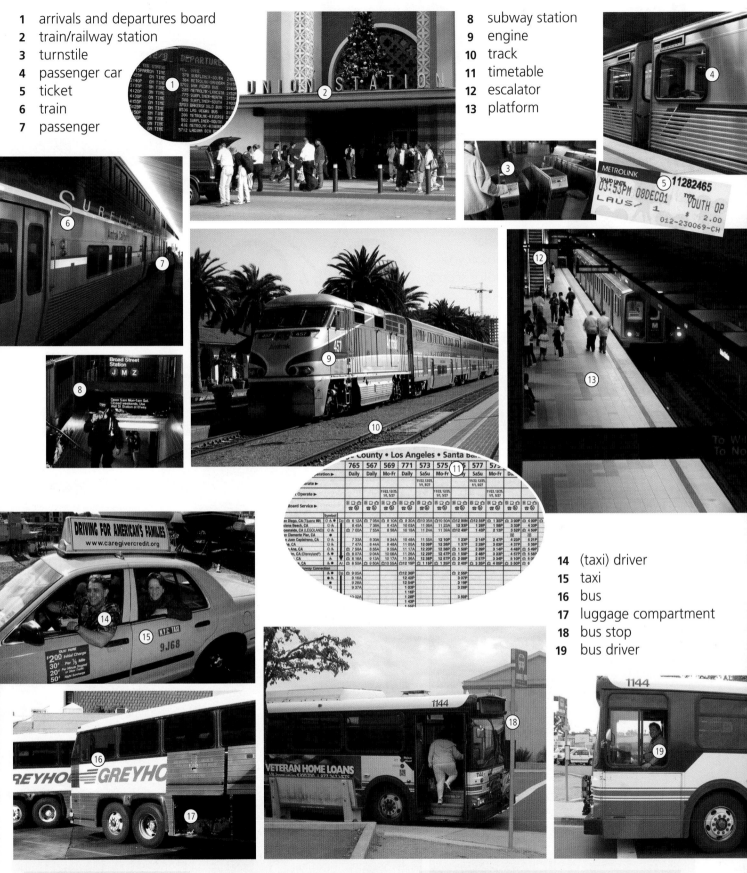

1 arrivals and departures board
2 train/railway station
3 turnstile
4 passenger car
5 ticket
6 train
7 passenger

8 subway station
9 engine
10 track
11 timetable
12 escalator
13 platform

14 (taxi) driver
15 taxi
16 bus
17 luggage compartment
18 bus stop
19 bus driver

Do you want to go by bus?
No. Let's go by taxi.

Do you want to go by subway?
No. Let's go by bus.

A: **Do you want to go by train?**
B: No. Let's go by............................ .

A: **Do you want to go by ?**
B: No. Let's go by............................ .

Discussion

1 Which of these forms of transportation are used in your city?

2 Which of these forms of transportation do you use?

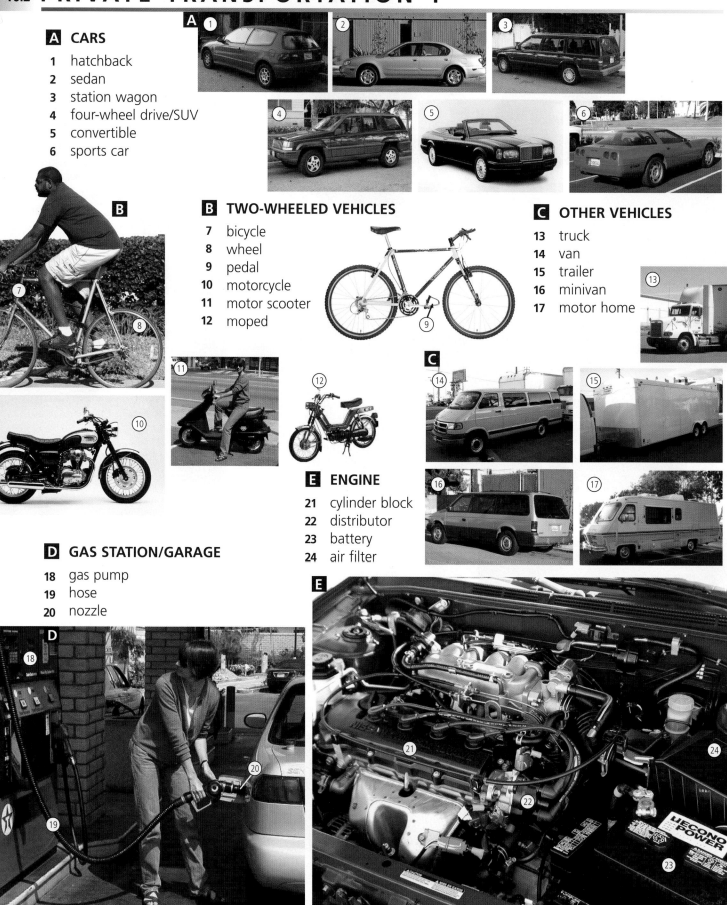

A CARS

1. hatchback
2. sedan
3. station wagon
4. four-wheel drive/SUV
5. convertible
6. sports car

B TWO-WHEELED VEHICLES

7. bicycle
8. wheel
9. pedal
10. motorcycle
11. motor scooter
12. moped

C OTHER VEHICLES

13. truck
14. van
15. trailer
16. minivan
17. motor home

E ENGINE

21. cylinder block
22. distributor
23. battery
24. air filter

D GAS STATION/GARAGE

18. gas pump
19. hose
20. nozzle

1 roof rack
2 windshield
3 hood
4 headlight
5 headrest
6 seat belt
7 door
8 gas cap
9 rear window
10 trunk
11 brake light
12 bumper
13 exhaust pipe
14 license plate
15 windshield wiper
16 side mirror
17 fender
18 hubcap
19 tire

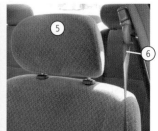

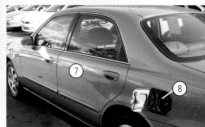

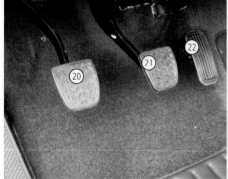

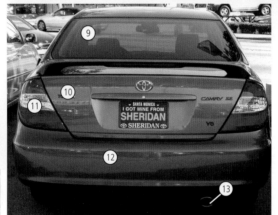

20 clutch
21 brake
22 accelerator
23 rearview mirror
24 dashboard
25 steering wheel
26 turn signal
27 radio/cassette/CD player
28 gear shift

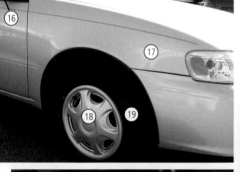

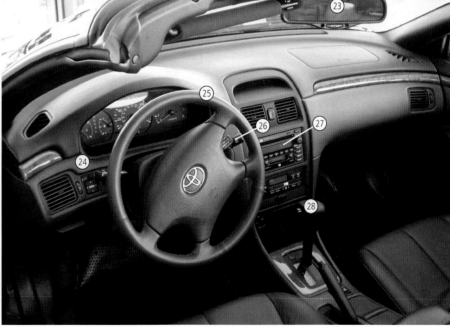

What's this – a van or a motor home?
It's a van.
What's this – the turn signal or the gear shift?
It's the gear shift.

A: **What's this – a(n)/the**
........................... **or a(n)/the**
.. ?
B: It's a(n)/the

Discussion
1 Do you have any of these vehicles?
2 Which are more common in your city: convertibles or station wagons? motorcycles or mopeds?

73

HIGHWAY

1 on-ramp
2 overpass
3 off-ramp/exit
4 street light
5 lane
6 shoulder
7 divider
8 reflector
9 toll booth

INTERSECTION

10 traffic light
11 red light
12 yellow light
13 green light
14 street
15 crosswalk

Is this a street light or a traffic light?
It's a street light.

Is this an on-ramp or an off-ramp?
It's an off-ramp.

A: **Is this a(n) or a(n) ?**
B: It's a(n)

Questions for discussion
1 Do highways in your country look like this?
2 Do you have tollbooths in your country? How much is the toll?

1 bridge
2 railroad crossing
3 barrier

4 cone

5 one-way sign
6 stop sign
7 yield sign
8 railroad crossing sign
9 roadwork sign
10 slippery-when-wet sign
11 steep hill sign
12 no U-turn sign
13 no right turn sign
14 school crossing sign
15 do not enter sign
16 interstate highway sign
17 pedestrian crossing
18 speed limit sign

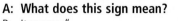

What does this sign mean?
It means "one way."

What does this sign mean?
It means "do not enter."

A: What does this sign mean?
B: It means "................................. ."

Discussion
1 Is there a bridge in your city? a train track?
2 What other road signs have you seen?

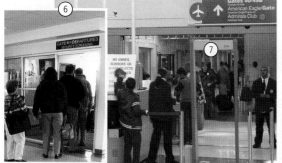

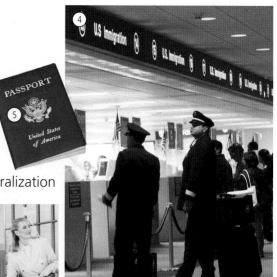

1 airline desk
2 ticket
3 boarding pass
4 immigration and naturalization

5 passport
6 security check
7 metal detector
8 X-ray machine
9 carry-on bag
10 baggage/luggage
11 porter
12 baggage/luggage cart
13 suitcase
14 flight information

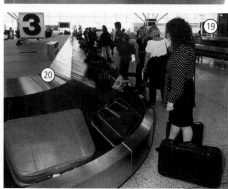

15 departure lounge
16 duty-free shop
17 customs
18 customs officer
19 baggage claim area
20 baggage/luggage carousel

22 cabin
23 window seat
24 middle seat
25 aisle seat
26 flight attendant
27 tray
28 window
29 armrest
30 cockpit
31 pilot/captain
32 instrument panel
33 copilot
34 oxygen mask
35 overhead compartment/bin
36 life jacket
37 takeoff
38 wing
39 runway
40 landing
41 airplane/jet
42 tail
43 air traffic controller
44 baggage cart
45 control tower
46 hangar
47 rotor blade
48 helicopter

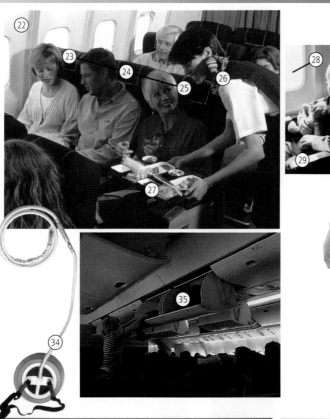

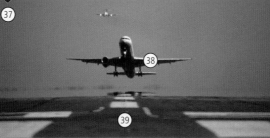

Where's the pilot?
He's in the cockpit.

Where's the plane?
It's on the runway.

A: **Where's the armrest?**
B: It's .. .

A: **Where's the** ?
B: It's/He's/She's in/on the

Discussion

1 Would you like to work at an airport? What job(s) would you like to have?

2 Have you ever flown on a plane? Describe your flight.

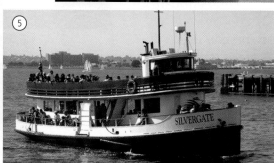

1 lifeboat
2 life jacket
3 cruise ship
4 oil tanker
5 ferry

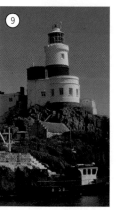

6 sailing ship
7 anchor
8 cable

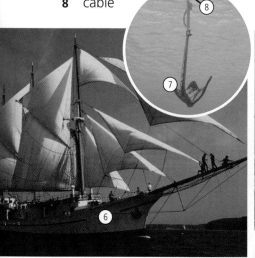

9 lighthouse
10 sailboat
11 marina
12 motorboat/
 speedboat
13 cabin cruiser

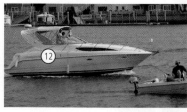

14 rowboat
15 oar

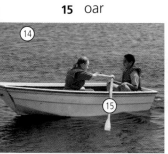

16 cargo ship
17 crane
18 cargo
19 dock

20 yacht
21 deck

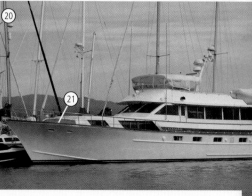

Have you ever been on a ferry?
Yes, I have.

Have you ever been on a yacht?
No, I haven't.

A: Have you ever been on a
... ?
B: Yes, I have./No, I haven't.

Discussion
Which of these boats do you think is:
1 the slowest/fastest?
2 the heaviest?

1 bank
2 bank officer
3 ATM/cash machine
4 credit card
5 ATM/debit card
6 bank teller
7 customer
8 cash drawer

9 traveler's check
10 foreign currency
11 checkbook
12 bank statement
13 withdrawal slip
14 check
15 stub

16 cash
17 dollar coin
18 fifty-cent piece/fifty cents
19 quarter/twenty-five cents
20 dime/ten cents
21 nickel/five cents
22 penny/one cent
23 dollar (bill)/one dollar
24 five (dollar bill)/five dollars
25 ten (dollar bill)/ten dollars
26 twenty (dollar bill)/twenty dollars
27 fifty (dollar bill)/fifty dollars
28 one hundred (dollar bill)/one hundred dollars

Do you have change for a dollar?
Sure. Here are four quarters.

Do you have change for a twenty?
Sure. Here are two fives and a ten.

A: **Do you have change for a five-dollar bill?**
B: Sure. Here are

A: **Do you have change for a ?**
B: Sure. Here are

Questions for discussion

1 What kinds of bills and coins are there in your country?

2 How often do you go to the bank? use an ATM?

1 walk sign	13 parking meter
2 don't walk sign	14 traffic
3 pedestrian	15 traffic lights
4 bus	16 street
5 crosswalk	17 bus lane
6 no parking sign	18 gutter
7 security camera	19 curb
8 department store	20 sidewalk
9 double yellow line	21 handrail
10 bus stop	
11 bus shelter	
12 road sign	

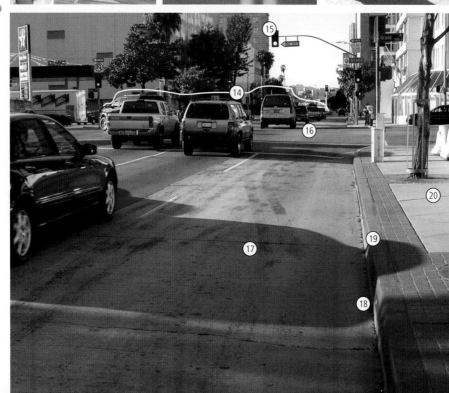

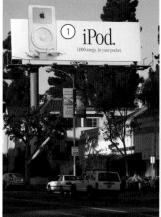

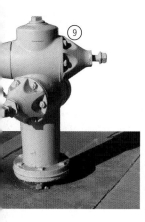

1 billboard

2 skyscraper
3 high-rise building

4 skyline
5 sky

6 manhole
7 manhole cover

8 bridge

9 fire hydrant

10 trash/garbage can

11 subway entrance

12 store/shop

13 vendor
14 magazine stand

Are there trash cans on the sidewalks in your city?
Yes, there are./No, there aren't.

Are there bus lanes on the streets in your city?
Yes, there are./No, there aren't.

A: **Are there on the sidewalks/on the streets in your city?**
B: Yes, there are./No, there aren't.

Discussion

1 Which of these things do you see every day?

2 Which of these things do you wish your city had?

1 mailbox

2 book of stamps
3 envelope
4 postmark
5 airmail letter
6 letter
7 postcard
8 address
9 zip code
10 stamp
11 (birthday) card

12 scale/meter
13 counter
14 postal clerk
15 customer

16 delivery
17 mail/letter carrier

18 mail
19 mail truck/van
20 mailbag
21 collection

22 scissors
23 string
24 package

What's that?
It's a mailbox.

What are those?
They're stamps.

A: What's that?/ What are those?
B: It's a(n) .. ./
They're .. .

Discussion
How would you send these things:

1 a check to someone in another country?

2 a birthday present?

STATIONERY

1 white out™
2 Scotch™ tape
3 thumbtacks
4 pencil
5 eraser
6 string
7 ballpoint pen
8 colored pen
9 (pad of) paper
10 (pack of) envelopes
11 glue stick

PERIODICALS, BOOKS, ETC.

12 ribbon
13 bow
14 matches
15 wrapping paper
16 (roll of) film
17 street map
18 newspaper
19 coloring book
20 paperback/book
21 magazine

CONFECTIONERY

22 (box of) chocolates
23 (bag of) candy
24 (bar of) chocolate
25 (bag of) potato chips
26 (stick of) chewing gum
27 mints
28 lollipops
29 fudge

Can I have one of those maps, please?
Here you are.

Can I have some of that fudge, please?
Here you are.

A: **Can I have one of those/some of that**, **please?**
B: Here you are.

Discussion

1 Where do you usually buy these things?
2 What magazines do you like to read?
3 What kind of candy do you like?

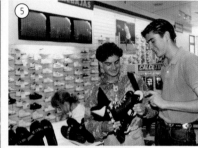

1 music store
2 video store
3 pharmacy/drugstore
4 optician
5 sports store
6 candy store
7 toy store
8 mall

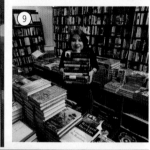

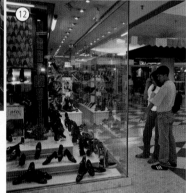

9 bookstore
10 card store
11 escalator
12 shoe store
13 fabric store
14 electronics store
15 clothing store

I need a TV.
Let's go to the electronics store.

I'd like some chocolate.
Let's go to the candy store.

A: I need some tennis balls.
B: Let's go to the

A: I need/I'd like a(n)/some
... .
B: Let's go to the

Discussion:
1 Do you like to shop?
2 Where do you usually shop for clothes? books?
shoes? CDs?

1 police officer
2 police station
3 police car

4 fire station
5 fire extinguisher
6 fire hydrant
7 fire engine
8 hose
9 smoke
10 fire
11 ladder
12 firefighter

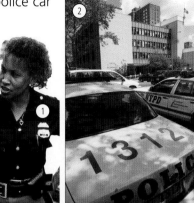

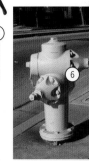
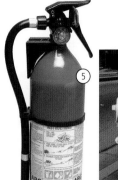

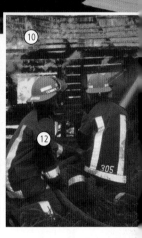

13 ambulance
14 accident
15 (IV/intravenous) drip
16 oxygen mask
17 stretcher
18 accident victim
19 paramedic

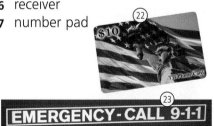

20 roadside help
21 tow truck

22 calling card
23 emergency number
24 pay phone
25 coin slot
26 receiver
27 number pad

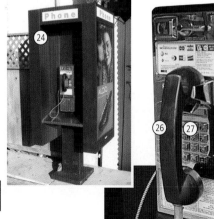

EMERGENCY - CALL 9-1-1

Have you ever been in an accident?
Yes, I have. I was in an accident last year.

Have you ever been in a tow truck?
No, I haven't.

A: **Have you ever been in a(n)**
.. ?
B: Yes, I have. I was in a(n)
....................................... ./No, I
haven't.

Discussion
1 What should you do in an emergency?
2 Would you like to be a police officer? a firefighter? a paramedic?

A FOOTBALL

1 football field
2 goalpost
3 goal line
4 yard line

5 guard
6 football
7 helmet
8 shoulder pads
9 referee
10 tackle

B BASEBALL

11 bat
12 batter
13 crowd/spectators
14 mask
15 home plate
16 catcher
17 pitcher
18 (baseball) glove/mitt
19 pitcher's mound
20 base
21 umpire
22 stadium
23 outfield
24 infield

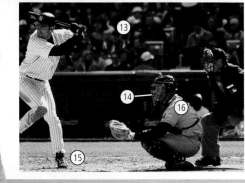

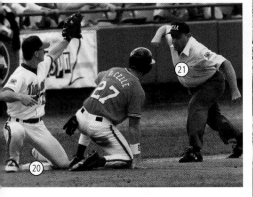

A BASKETBALL

1 backboard
2 basket/hoop
3 net
4 basketball
5 (basketball) court
6 (basketball) player

B VOLLEYBALL

7 volleyball
8 net
9 (volleyball) player

C BOXING

10 boxing glove
11 boxer
12 boxing trunks
13 referee
14 ropes
15 boxing ring

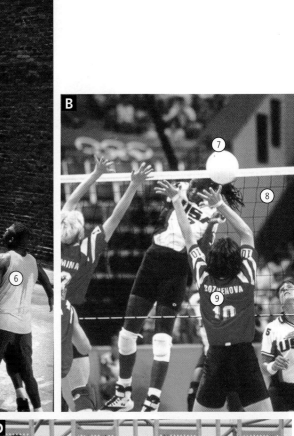

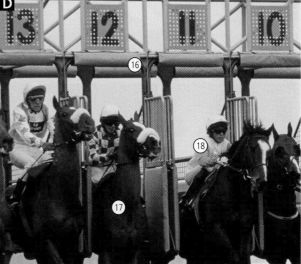

D HORSE RACING

16 gate
17 racehorse
18 jockey

Do they play football in your country?
Yes, they do./No, they don't.

Is boxing popular in your country?
Yes, it is./No, it isn't.

A: **Do they play in your country?**
B: Yes, they do./No, they don't.

A: **Is popular in your country?**
B: Yes, it is./No, it isn't.

Discussion
1 Do you play any of these sports?
2 Do you watch any of these sports on television?

A TENNIS

1 (tennis) racket
2 (tennis) ball
3 (tennis) player
4 baseline
5 court
6 net

B BADMINTON

7 (badminton) racket
8 (badminton) player
9 birdie/shuttlecock

C PING PONG/TABLE TENNIS

10 (ping pong) ball
11 paddle
12 (ping pong) player
13 net
14 (ping pong) table

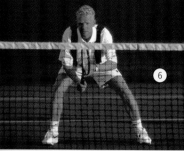

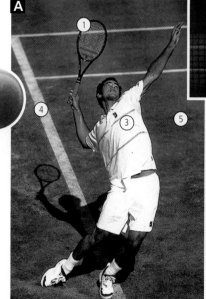

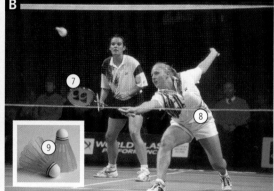

E BOWLING

18 pin
19 bowler
20 (bowling) ball
21 gutter
22 lane

F WRESTLING

23 wrestler
24 mat

D MARTIAL ARTS

15 karate
16 blackbelt
17 judo

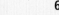

Would you like to try badminton?
Yes, I would./No, I wouldn't.

Would you like to try karate?
I've already tried it.

A: Would you like to try
..?
B: Yes, I would./ No, I wouldn't./ I've already tried it.

Discussion
Who are some famous:

1 tennis players? 4 cyclists?
2 wrestlers? 5 golfers?
3 runners? 6 gymnasts?

A RUNNING
1 runner
2 jogger

B CYCLING
3 helmet
4 cyclist
5 bicycle/bike

C HORSEBACK RIDING
6 rider
7 horse
8 saddle
9 stirrup
10 reins

D GOLF
11 golfer
12 (golf) club
13 (golf) ball
14 tee
15 hole
16 green

E ROLLERBLADING
17 helmet
18 rollerblader
19 elbow pads
20 in-line skate/Rollerblades™

F GYMNASTICS
21 gymnast
22 balance beam

G ROCK CLIMBING
23 climber
24 harness
25 rope

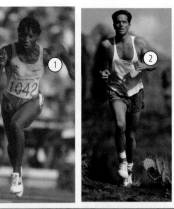

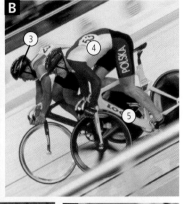
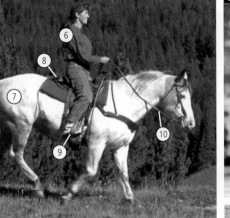
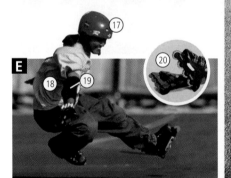
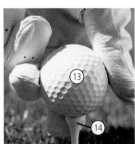
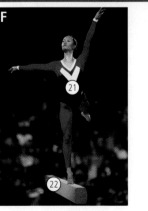
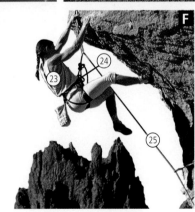

Did you go cycling last weekend?
Yes, I did.

Did you do gymnastics last weekend?
No, I didn't.

A: **Did you go climbing/do gymnastics/play golf last weekend?**
B: Yes, I did./No, I didn't.

Discussion
1 Which of these sports need special clothes?
2 Which of these sports look like fun?

WATER SPORTS

A SWIMMING

1 goggles
2 swimming/bathing cap
3 swimmer
4 swimming pool

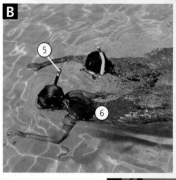

B SNORKELING

5 snorkel
6 snorkeler

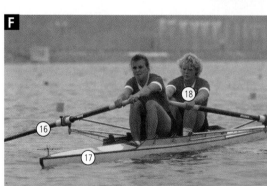

C SCUBA DIVING

7 (air) tank
8 scuba diver
9 mask

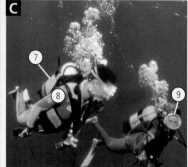

D DIVING

10 diver
11 diving board

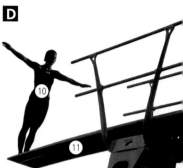

E SURFING AND WINDSURFING

12 surfer
13 surfboard
14 windsurfer
15 sailboard

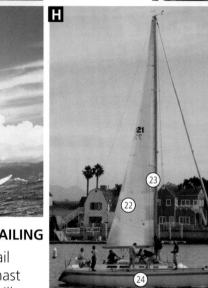

H SAILING

22 sail
23 mast
24 sailboat

I CANOEING

25 paddle
26 canoeist
27 canoe

J WATER-SKIING

28 water-skier
29 water ski
30 motorboat
31 towrope

F ROWING

16 oar
17 boat
18 rower

G FISHING

19 fisherman
20 fishing rod
21 (fishing) line

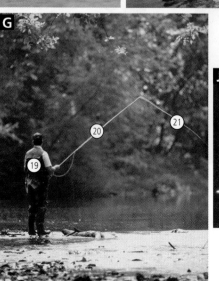

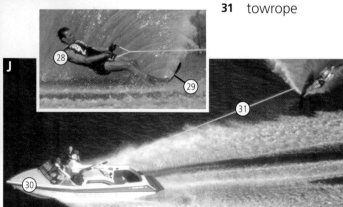

A SLEDDING

1 sled
2 snow

B SKIING

3 downhill skiing
4 pole
5 (ski) boot
6 skier
7 ski
8 cross-country skiing
9 trail
10 snowboard
11 chair lift

C SKATING

12 figure skating
13 figure skater
14 ice skate
15 blade
16 speed skating
17 speed skater
18 ice

D BOBSLEDDING

19 helmet
20 bobsled
21 bobsledder

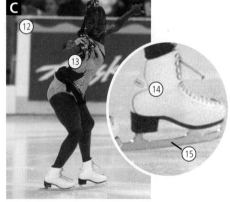

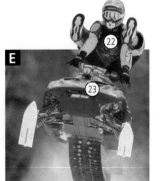

E SNOWMOBILING

22 snowmobiler
23 snowmobile

What are they doing.
They're downhill skiing.

What's she doing?
She's figure skating.

A: **What's he/she doing?**
B: He's/She's

A: **What are they doing?**
B: They're

Discussion

1 Which of these sports are popular in your country?

2 Do any famous skiers, figure skaters, or speed skaters come from your country?

AT THE GYM

1 rowing machine
2 (free) weights
3 mat
4 treadmill
5 exercise bike
6 aerobics class

ACTIONS

7 walk
8 kick
9 bounce
10 throw
11 catch
12 run
13 reach
14 hop
15 lift
16 kneel

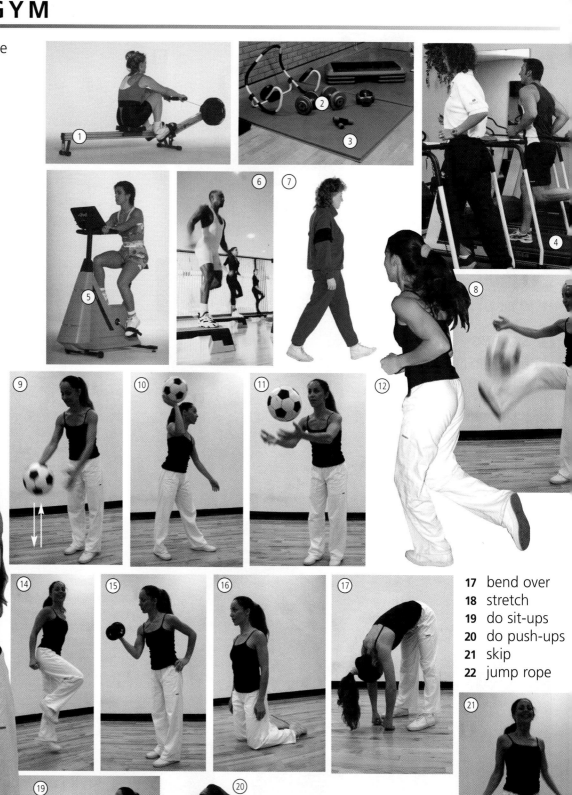

17 bend over
18 stretch
19 do sit-ups
20 do push-ups
21 skip
22 jump rope

What's she doing?
She's stretching.

What are they doing?
They're running on the treadmill.

A: **What's he/she doing?**
B: He's/She's

A: **What's are they doing?**
B: They're

Discussion

1 Do you ever use any of this exercise equipment?
2 Which of these actions do you do when you exercise?

1 concert
2 baton
3 conductor
4 (symphony) orchestra
5 audience

6 ballet
7 ballerina
8 ballet dancer
9 ballet shoes

10 opera
11 singer
12 orchestra pit

13 theater
14 spotlight
15 aisle
16 stage
17 actor
18 actress

19 movie, film
20 (movie) screen
21 movie theater

22 band
23 drummer
24 singer/vocalist
25 guitarist

When did you last go to the theater?
I went two months ago.

When did you last go to the opera?
I've never been.

A: **When did you last go to a(n)/ the................. ?**
B: I went ago./
I've never been.

Discussion

1 What's your favorite form of entertainment? Why do you like it?

2 Who is your favorite entertainer? Why do you like him/her?

93

HOBBIES

1 coin collecting
2 coin
3 stamp
4 stamp collecting
5 magnifying glass
6 (stamp) album
7 baking
8 photography
9 camera
10 astronomy
11 telescope

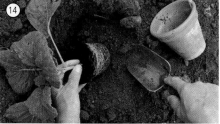

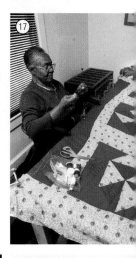

12 bird-watching
13 binoculars
14 gardening

ARTS AND CRAFTS

15 playing music
16 embroidery
17 quilting
18 sewing
19 knitting
20 knitting needle

21 sculpting
22 sculpture
23 painting
24 (paint) brushes
25 pottery
26 potter's wheel
27 woodworking

GAMES

1 video/computer games
2 chess
3 chessboard
4 chesspieces
5 checkers
6 checkerboard
7 dice
8 backgammon
9 cards

Do you like playing chess?
Yes, I do./No, I don't.

Do you like knitting?
I've never tried it.

A: **Do you like painting?**
B: Yes, I do./No, I don't./I've never tried it.

Discussion
1 What are your hobbies?
2 Which of these games can you play?

MUSICAL INSTRUMENTS

STRINGS

1 bow
2 violin
3 viola
4 (double) bass
5 cello
6 piano

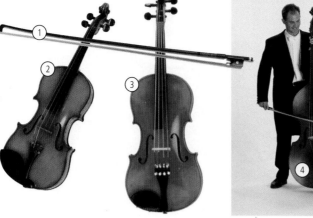

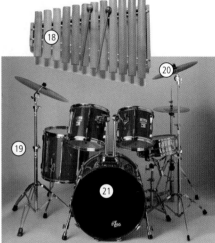

BRASS

7 French horn
8 tuba
9 trumpet
10 trombone

WOODWINDS

11 flute
12 piccolo
13 oboe
14 recorder
15 clarinet
16 saxophone
17 bassoon

PERCUSSION

18 xylophone
19 drum set
20 cymbal
21 drum

ROCK MUSIC

24 mike/microphone
25 (electric) guitar
26 (bass) guitar
27 keyboard
28 amplifier

OTHER INSTRUMENTS

22 accordion
23 harmonica

Which is larger – a double bass or a cello?
A double bass is larger.

Which is smaller – an accordion or a harmonica.
A harmonica is smaller.

A: Which is larger/smaller – a(n)
... or a(n)
... ?

B: A(n) is
larger/smaller.

Discussion

1 Can you play any of these instruments?
2 Which instrument has the nicest sound?
3 Which instruments can be very loud?

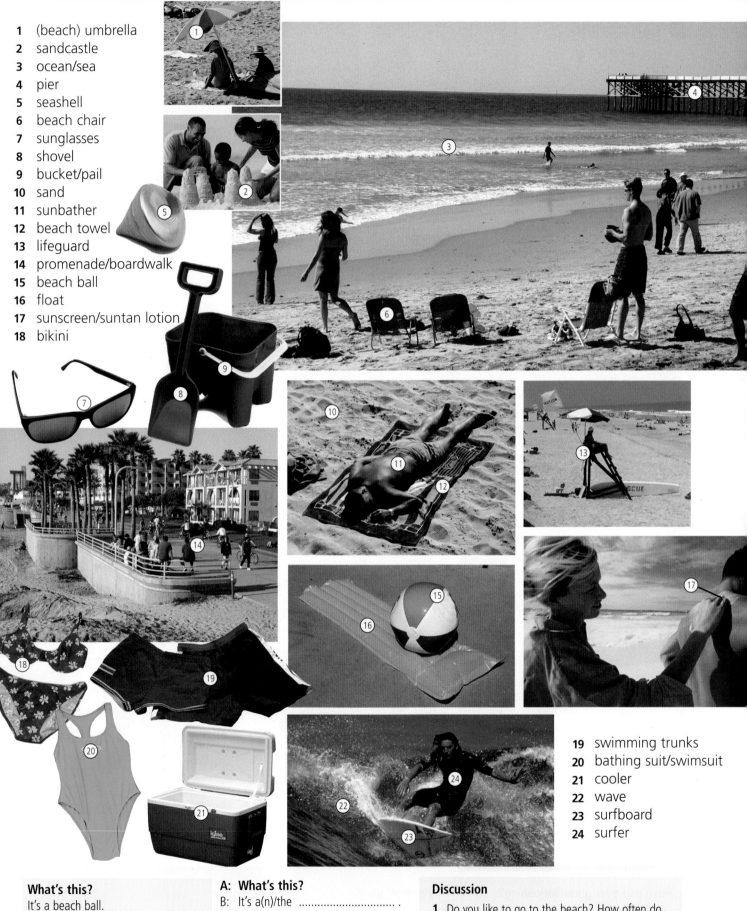

1 (beach) umbrella
2 sandcastle
3 ocean/sea
4 pier
5 seashell
6 beach chair
7 sunglasses
8 shovel
9 bucket/pail
10 sand
11 sunbather
12 beach towel
13 lifeguard
14 promenade/boardwalk
15 beach ball
16 float
17 sunscreen/suntan lotion
18 bikini

19 swimming trunks
20 bathing suit/swimsuit
21 cooler
22 wave
23 surfboard
24 surfer

What's this?
It's a beach ball.

What are these?
They're sunglasses.

A: What's this?
B: It's a(n)/the

A: What are these?
B: They're

Discussion

1 Do you like to go to the beach? How often do you go?

2 Which of these things do you usually take to the beach with you?

A BALLOONING
1 hot-air balloon

B FISHING
2 lake
3 boat
4 fisherman/angler
5 fishing rod
6 fishing hook

C HIKING
7 hiker
8 backpack
9 path
10 signpost

D CAMPING
11 groundsheet
12 sleeping bag
13 recreational vehicle (RV)
14 campsite
15 tent

16 campfire
17 camper
18 picnic table
19 camping stove

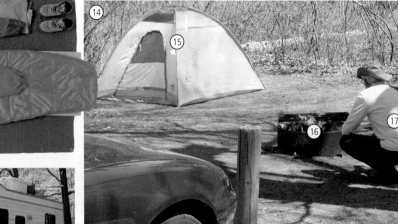

Have you ever gone ballooning?
Yes, I have./No, I haven't.

A: **Have you ever gone**
.. ?
B: Yes, I have./No, I haven't.

Discussion
Which of these activities would you like to try?
Why?

1 botanical garden
2 roller coaster
3 Ferris wheel
4 amusement park
5 zoo

6 fairground
7 exhibition
8 museum
9 park
10 craft fair
11 tour guide
12 tourist
13 historic battlefield
14 national park
15 monument

Would you rather go to an exhibition or a craft fair?
I'd rather go to a craft fair.

Would you rather visit a museum or a park?
Neither. I'd rather visit a zoo.

A: Would you rather go to/visit a(n) or a(n) ... ?
B: I'd rather go to a(n)
................................. ./Neither. I'd
rather go to a(n)

Discussion

1 Which of these places looks the most fun?

2 Are any of these places near your home?

1 cat
2 whiskers
3 fur
4 basket
5 kitten
6 hutch
7 rabbit
8 cage
9 parakeet
10 hamster
11 (goldfish) bowl
12 goldfish
13 aquarium
14 tropical fish

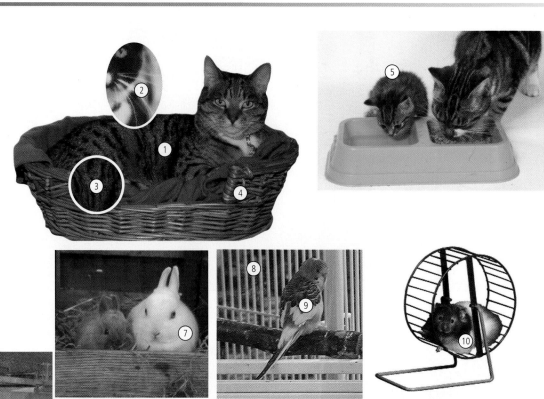
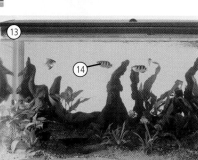

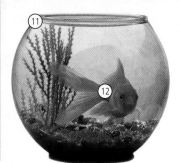

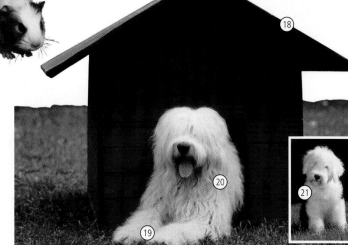

15 gerbils
16 tail
17 guinea pig
18 doghouse
19 paws
20 dog
21 puppy

Do you have any pets?
No, I don't.

Do you have any pets?
Yes, I do. I have a dog and some goldfish.

A: **Do you have any pets?**
B: No, I don't./Yes, I do. I have (a/an)
... .

Discussion
1 Which of these pets need a special "home?"
2 Which of these pets could you keep in an apartment?
3 Which of these pets needs to be outdoors?

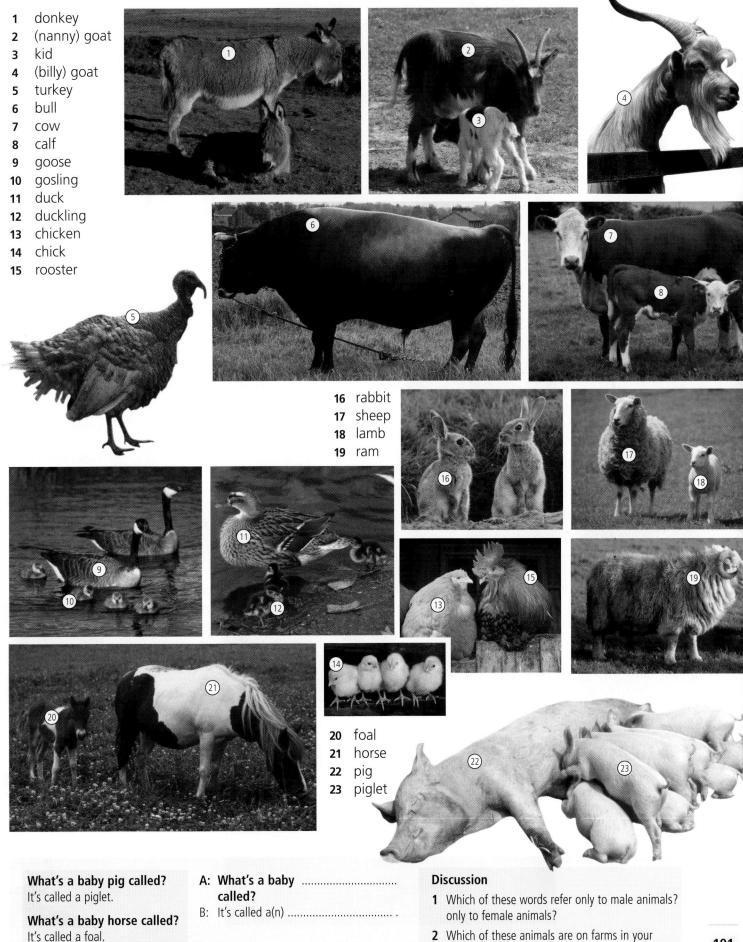

1 donkey
2 (nanny) goat
3 kid
4 (billy) goat
5 turkey
6 bull
7 cow
8 calf
9 goose
10 gosling
11 duck
12 duckling
13 chicken
14 chick
15 rooster

16 rabbit
17 sheep
18 lamb
19 ram

20 foal
21 horse
22 pig
23 piglet

What's a baby pig called?
It's called a piglet.

What's a baby horse called?
It's called a foal.

A: **What's a baby
called?**
B: It's called a(n)

Discussion
1 Which of these words refer only to male animals?
 only to female animals?
2 Which of these animals are on farms in your
 country?

101

WILD ANIMALS

1 elephant
2 tusk
3 trunk
4 lion
5 mane
6 tiger
7 bear
8 rhinoceros
9 horn
10 hippopotamus
11 kangaroo
12 pouch
13 cheetah
14 water buffalo
15 zebra
16 stripes
17 koala bear
18 giraffe
19 leopard
20 spots
21 deer
22 antlers
23 llama

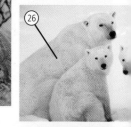

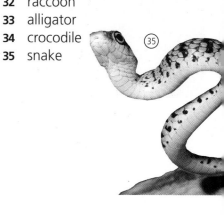

24 gorilla
25 tortoise
26 polar bear
27 camel
28 hump
29 monkey
30 lizard
31 wolf
32 raccoon
33 alligator
34 crocodile
35 snake

FISH

1 shark
2 tail
3 gills
4 fin
5 snout
6 bass
7 trout
8 scales
9 eel
10 angelfish

SEA ANIMALS

11 sea lion
12 killer whale/orca
13 shrimp
14 walrus
15 tusk
16 dolphin
17 flipper
18 crab
19 octopus
20 tentacle
21 clam
22 mussels
23 sea turtle
24 lobster
25 claw
26 starfish
27 jellyfish
28 seahorse

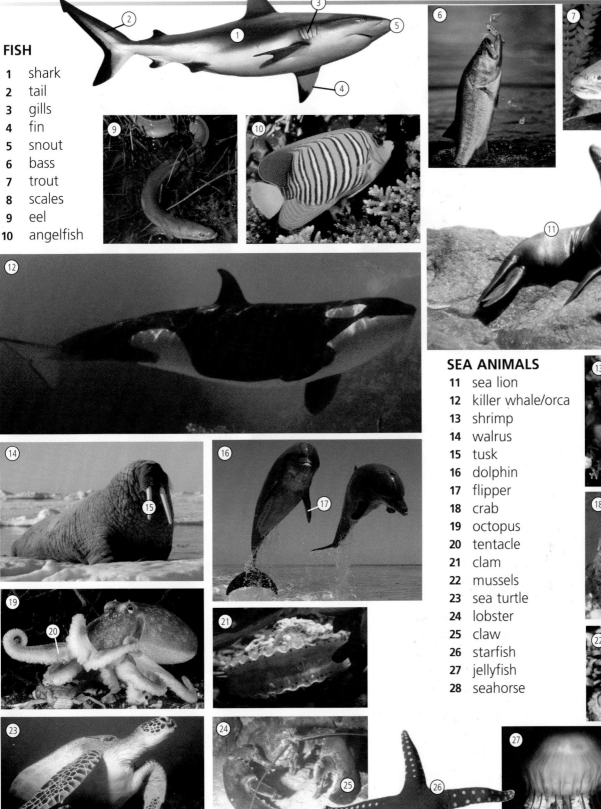

Which is smaller – an octopus or a whale?
An octopus.

Which is friendlier – a dolphin or a shark?
A dolphin.

A: **Which is slower – a shark or a walrus?**

B:

Questions for discussion

1 Which of these fish do people often eat?
2 Which of the sea animals can you sometimes find on land?

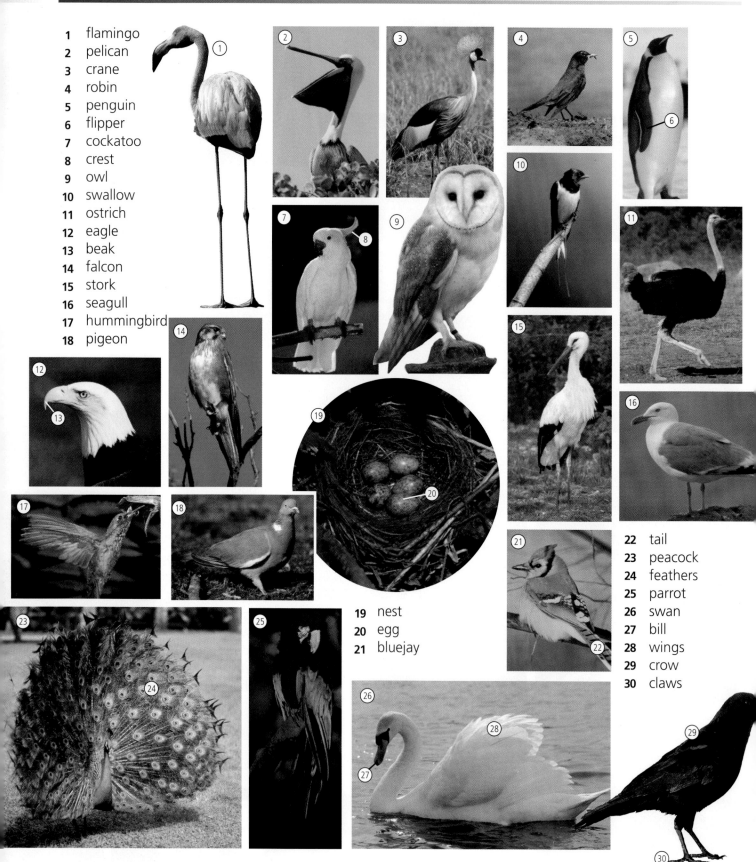

1 flamingo
2 pelican
3 crane
4 robin
5 penguin
6 flipper
7 cockatoo
8 crest
9 owl
10 swallow
11 ostrich
12 eagle
13 beak
14 falcon
15 stork
16 seagull
17 hummingbird
18 pigeon

19 nest
20 egg
21 bluejay

22 tail
23 peacock
24 feathers
25 parrot
26 swan
27 bill
28 wings
29 crow
30 claws

Are parrots prettier than pigeons?
Yes, they are.

Are hummingbirds bigger than robins?
No, they aren't. They're smaller.

A: Are .. prettier/
 bigger than ?
B: Yes, they are./No, they aren't. They're

Discussion
1 Are there a lot of birds in your area?
2 Which of these birds do you see where you live?

INSECTS

1 wasp
2 beehive
3 bee
4 honeycomb
5 ladybug
6 mosquito
7 moth
8 butterfly
9 cockroach
10 dragonfly
11 caterpillar
12 snail
13 grasshopper
14 spider web
15 spider
16 ant
17 fly

SMALL ANIMALS

18 chipmunk
19 rat
20 skunk
21 mole
22 frog
23 mouse
24 groundhog/woodchuck
25 squirrel

Is this a moth?
Yes, it is.

Is this a squirrel?
No, it isn't. It's a chipmunk.

A: **Is this a(n)** ?
B: Yes, it is./No, it isn't. It's a(n)
... .

Discussion

1 Which of these insects and animals are dangerous?

2 Which of these insects and animals can you sometimes find inside?

1 peak
2 mountain
3 lake
4 cactus
5 meadow
6 hill
7 valley
8 palm tree
9 desert
10 (sand) dune
11 reservoir
12 dam
13 pond
14 woods
15 pine cone
16 pine tree
17 forest
18 island
19 coastline
20 river
21 stream/brook
22 waterfall

23 rock
24 cliff
25 beach
26 cave
27 grass
28 field
29 tree
30 swamp

Is there a hill near your home?
Yes, there is.

Are there any fields near your home?
No, there aren't.

A: **Is there a(n)/Are there any**
.. **near**
...?
B: Yes, there is/are./No, there isn't/aren't.

Discussion
1 How many of these things are in your country?
2 What are the names of some famous mountains? lakes? islands? rivers?

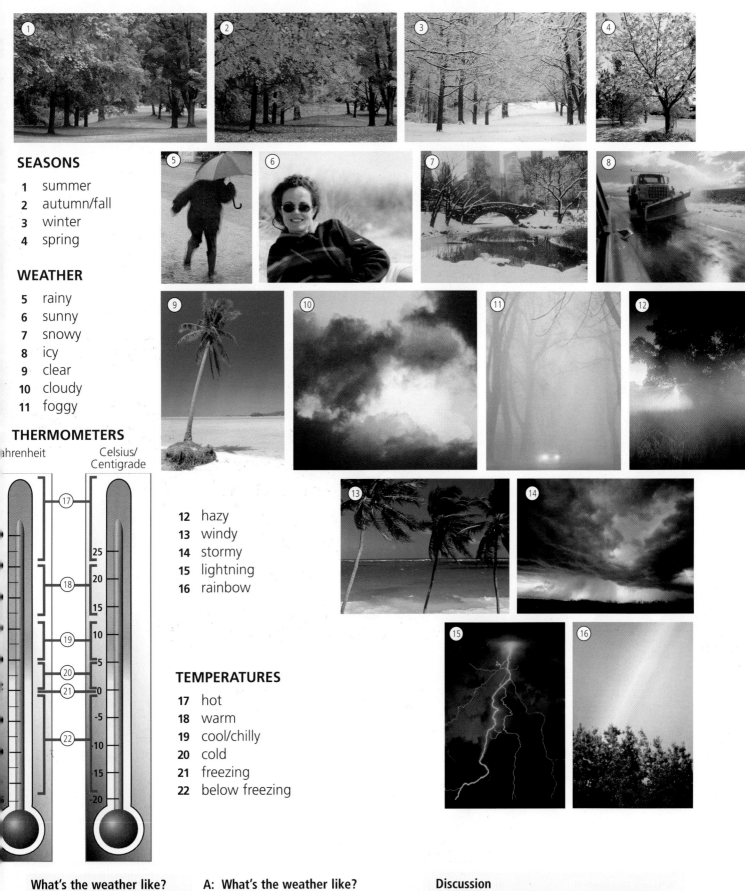

SEASONS

1 summer
2 autumn/fall
3 winter
4 spring

WEATHER

5 rainy
6 sunny
7 snowy
8 icy
9 clear
10 cloudy
11 foggy

THERMOMETERS

ahrenheit Celsius/
 Centigrade

12 hazy
13 windy
14 stormy
15 lightning
16 rainbow

TEMPERATURES

17 hot
18 warm
19 cool/chilly
20 cold
21 freezing
22 below freezing

What's the weather like?
It's foggy.

What's the weather like?
It's cloudy and cool.

A: **What's the weather like?**
B: It's and

A: **What's the weather like?**
B: It's

Discussion

1 What's your favorite season? Why?
2 What's your favorite kind of weather? Why?

A

1 Sun
2 solar system

A THE PLANETS

3 Mercury
4 Venus
5 Earth
6 Mars
7 Jupiter
8 Saturn
9 Uranus
10 Neptune
11 Pluto

12 orbit
13 star
14 constellation
15 comet
16 satellite
17 galaxy

B THE MOON

18 crescent moon
19 half moon
20 full moon
21 new moon

C SPACE TRAVEL

22 fuel tank
23 booster rocket
24 space shuttle
25 launch pad
26 astronaut
27 space suit
28 flag
29 lunar module
30 lunar vehicle

Where's Uranus?
It's between Saturn and Neptune.

Where's Mercury?
It's next to the Sun.

A: **Where's Jupiter?**
B: It's between and
........................ .

A: **Where's Pluto?**
B: It's next to

Discussion
1 Do you know the names of any constellations?
2 Have you ever seen a comet?
3 Which planets have humans explored?

A HARDWARE

1 scanner
2 personal computer/PC
3 CD-ROM drive
4 floppy disk drive/A drive
5 hard disk drive/C drive
6 monitor
7 screen
8 keyboard
9 printer
10 mouse pad
11 mouse
12 floppy disk/diskette
13 laptop
14 CD-ROM

B SOFTWARE

15 spreadsheet
16 window
17 icon
18 document
19 toolbar
20 cursor

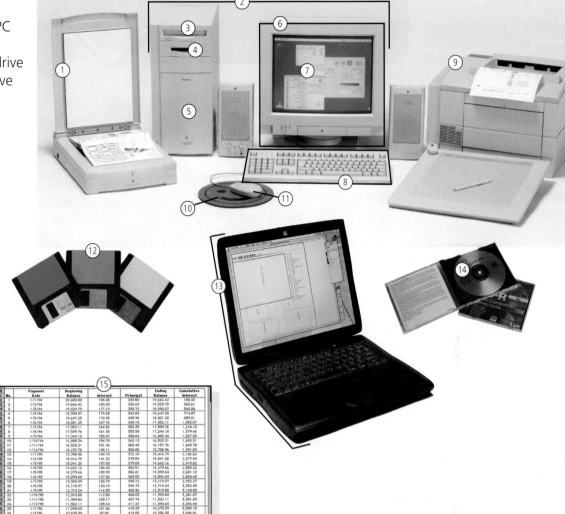

What's this called?
It's a laptop.

What's this called?
It's an icon.

A: **What's this called?**
B: It's a(n)

Discussion

1 Do you use a computer at home or work?
2 What can people do on a computer?

1 DVD player
2 DVD

3 video cassette
4 remote control
5 video cassette recorder/VCR

6 television/TV
7 TV screen

8 games console
9 video games

10 clock radio

11 stereo system/hi-fi
12 compact disc/CD player
13 compact disc/CD
14 tape deck/cassette deck
15 tape/cassette
16 radio
17 tuner
18 speaker
19 computer
20 personal cassette player/Walkman™
21 headphones

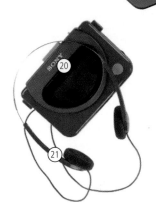

1 cell phone/cellular phone/mobile (phone)
2 charger
3 telephone/phone
4 answering machine
5 cordless phone
6 base
7 keypad
8 handset
9 adapter plug
10 (pocket) calculator
11 pager
12 electronic personal organizer/ PDA

13 flash
14 film
15 camera
16 lens
17 Polaroid™ camera
18 digital camera
19 video camera
20 slide projector
21 slide
22 battery
23 flashlight
24 light bulb

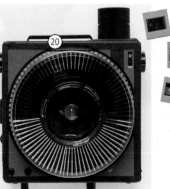

Which is more useful – a Polaroid camera or a digital camera?
I think a digital camera is more useful.

Which is more useful – a VCR or a DVD player?
I think a VCR is more useful.

A: **Which is more useful – a(n)**
.................................. **or a(n)**
.. ?
B: I think a(n)
is more useful.

Discussion
1 Which of these things do you have?
2 Which of these things would you like to have?

FEELINGS

1 sad
2 nervous
3 confused
4 angry/mad
5 excited
6 surprised
7 bored
8 happy
9 scared/afraid
10 suspicious

Is she happy?
Yes, she is./No, she isn't. She's bored

Does she look confused?
Yes, he does./No, he doesn't. He looks scared

A: **Is he/she** .. ?
B: Yes, he/she is./No, he/she isn't.

A: **Does he/she look** ?
B: Yes, he/she does./No, he/she doesn't.

Discussion

When do you feel:

1 nervous?
2 angry?
3 happy?

OPPOSITES

1 neat
2 messy

3 dry
4 wet

5 tight
6 loose

7 heavy
8 light

9 open
10 closed

11 short
12 long

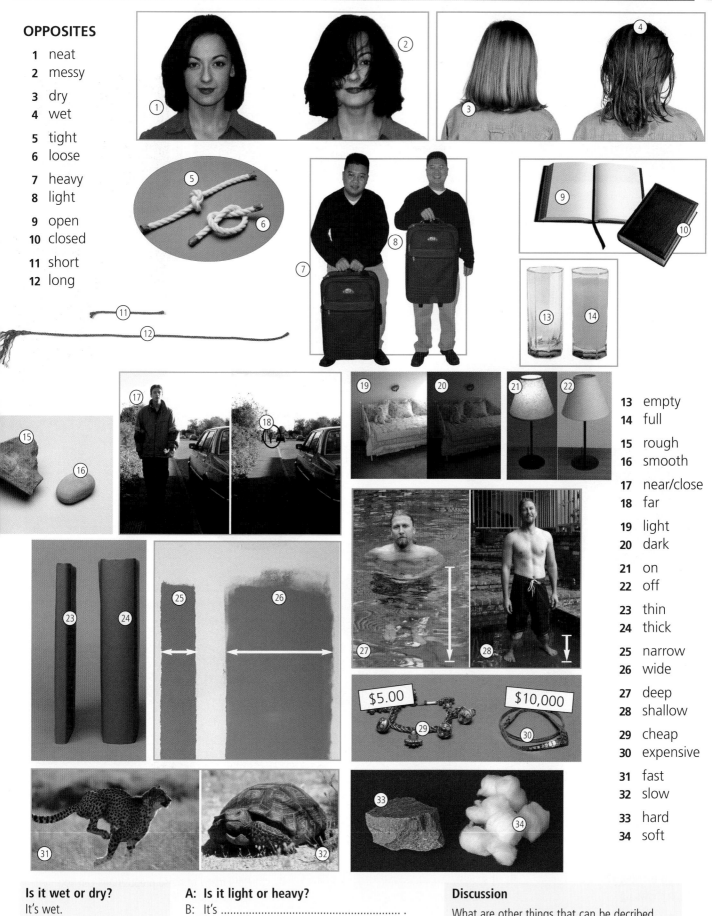

13 empty
14 full

15 rough
16 smooth

17 near/close
18 far

19 light
20 dark

21 on
22 off

23 thin
24 thick

25 narrow
26 wide

27 deep
28 shallow

29 cheap
30 expensive

31 fast
32 slow

33 hard
34 soft

Is it wet or dry?
It's wet.

Is he far or near?
He's near.

A: Is it light or heavy?
B: It's

A: Is it/he or ?
B: It's/He's

Discussion
What are other things that can be decribed with these adjectives?

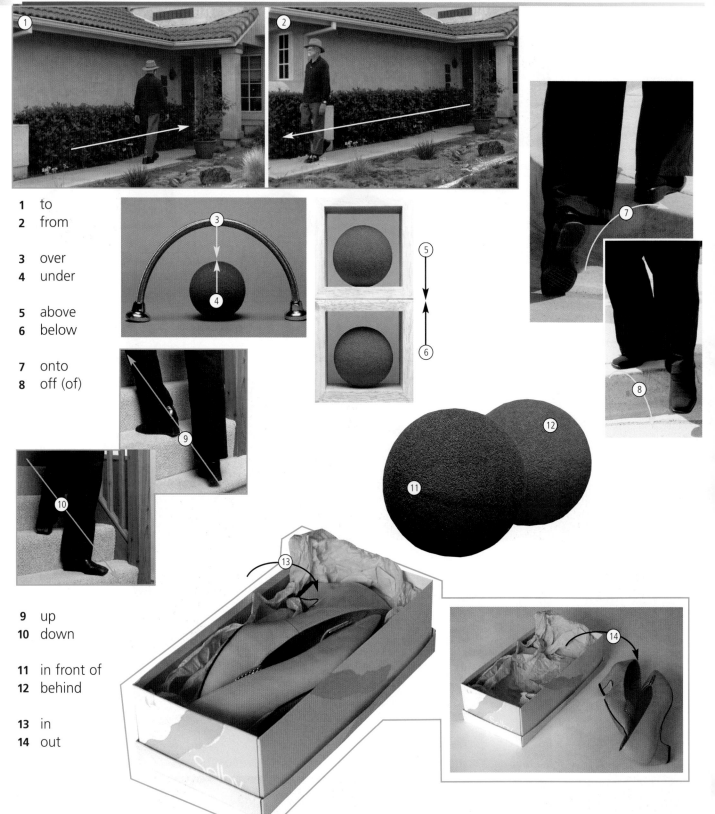

1 to
2 from

3 over
4 under

5 above
6 below

7 onto
8 off (of)

9 up
10 down

11 in front of
12 behind

13 in
14 out

Does this picture show up or down?
It shows up.

Does this show in front of or behind?
Behind.

A: **Does this show to or from?**
B: It shows

Discussion
How many of these prepositions can you demonstrate?

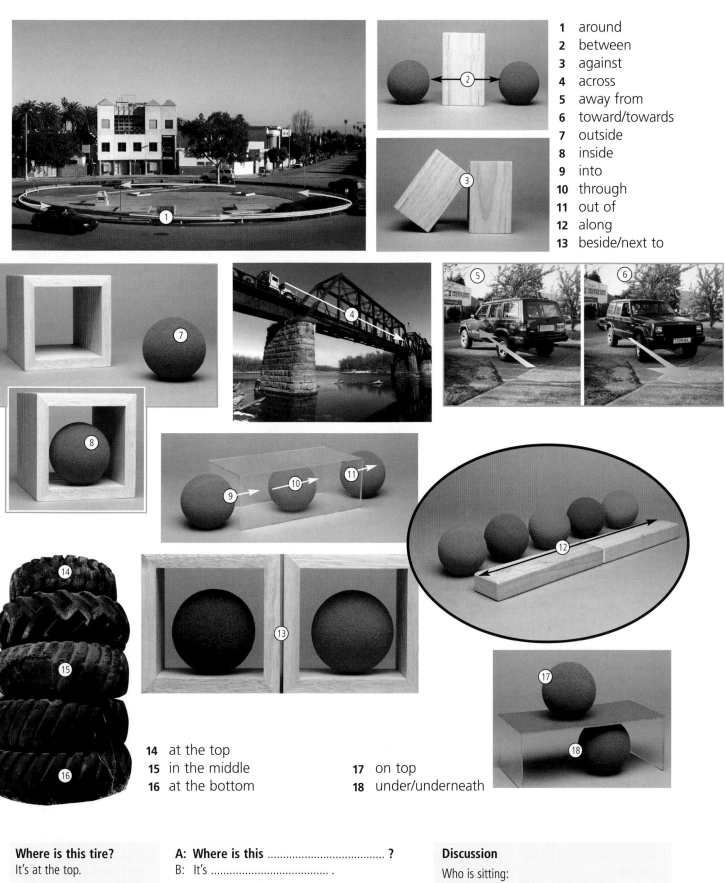

1 around
2 between
3 against
4 across
5 away from
6 toward/towards
7 outside
8 inside
9 into
10 through
11 out of
12 along
13 beside/next to

14 at the top
15 in the middle
16 at the bottom
17 on top
18 under/underneath

Where is this tire?
It's at the top.

Where is this ball?
It's outside the box.

A: **Where is this** ?
B: It's

Discussion

Who is sitting:
1 next to you?
2 across from you?
2 in the middle of the room?

above /ə'bʌv/ **115**

accelerator /ək'sɛlə,reɪţə/ **73**

accessories /ək'sɛsəriz/ **55**

accident /'æksədənt/ **85**

accident victim /'æksədənt ,vɪktɪm/ **85**

accordion /ə'kɔrdiən/ **96**

accountant /ə'kauntənt **29**

a cold /ə 'koʊld/ **44**

across /ə'krɔs/ **116**

actor /'æktə/ **93**

actress /'æktrɪs/ **93**

acute angle /ə,kyut 'æŋgəl/ **5**

adapter plug /ə'dæptə ,plʌg/ **111**

add /æd/ **69**

address /'ædrɛs/ **82**

adhesive bandage /əd,hisɪv 'bændɪdʒ/ **45**

adhesive tape /əd'hisɪv ,teɪp/ **45**

A drive /'eɪ draɪv/ **109**

adult /ə'dʌlt/ **9**

adult education classes /ə,dʌlt ɛdʒə'keɪʃən **56**

aerobics class /ə'roʊbɪks ,klæs/ **92**

afraid /ə'freɪd/ **113**

aftershave /'æftə,ʃeɪv/ **43**

against /ə'gɛnst/ **116**

air bed /'ɛr bɛd/ **97**

air filter /'ɛr,fɪltə/ **72**

airline desk /'ɛrlaɪn ,dɛsk/ **76**

airmail letter /,ɛrmeɪl 'lɛţə/ **82**

airplane /'ɛrpleɪn/ **77**

airport /'ɛrpɔrt/ **76, 77**

air tank /'ɛr tæŋk/ **90**

air traffic controller /,ɛr træfɪk kən'troʊlə/ **77**

aisle /aɪl/ **63, 93**

aisle seat /'aɪl sit/ **77**

Alabama /,ælə'bæmə/ **8**

alarm clock /ə'lɑrm ,klɑk/ **17**

Alaska /ə'læskə/ **8**

album /'ælbəm/ **94**

Albuquerque /'ælbə,kəki/ **8**

algebra /'ældʒəbrə/ **59**

Alka Seltzer™ /'ælkə ,sɛltsə/ **44**

alligator /'ælə,geɪţə/ **102**

along /ə'lɔŋ/ **116**

aluminum foil /ə,lumənəm 'fɔɪl/ **64**

ambulance /'æmbyələns/ **85**

American cheese /ə,mɛrɪkən 'tʃiz/ **65**

amethyst /'æməθɪst/ **55**

amplifier /'æmplə,faɪə/ **96**

amusement park /ə'myuzmənt ,park/ **99**

analog watch /,ænl-ag 'watʃ/ **7**

anchor /'æŋkə/ **29, 78**

anesthetist /ə'nɛsθə,tɪst/ **47**

angelfish /'eɪndʒəl fɪʃ/ **103**

angler /'æŋglə/ **98**

angry /,æŋgri/ **113**

ankle /'æŋkəl/ **37**

ankle socks /'æŋkəl ,saks/ **50**

answering machine /'ænsə-ɪŋ mə,ʃin/ **111**

answer the phone /,ænsə ðə 'foʊn/ **31**

ant /ænt/ **105**

antacid /,ænt'æsɪd/ **44**

antlers /'æntlə-z/ **102**

apartment building /ə'part ̚mənt ,bɪldɪŋ/ **13**

apex /'eɪpɛks/ **5**

Appalachian Mountains /,æpəleɪtʃən 'maʊt ̚nz/ **8**

appetizers /'æpə,taɪzə-z/ **66**

apple /'æpəl/ **62**

application form /æplɪ'keɪʃən ,fɔrm/ **26**

April /'eɪprəl/ **6**

aquarium /ə'kwɛriəm/ **100**

architect /'arkə,tɛkt/ **29**

Arizona /,ærɪ'zoʊnə/ **8**

Arkansas /'arkən,sɔ/ **8**

arm arm **37**

armchair /'armtʃɛr/ **18**

armrest /'armrɛst/ **77**

around /ə'raʊnd/ **116**

arrivals and departures board /ə,raɪvəlz ən dɪ'partʃə-z ,bɔrd/ **71**

art /art/ **59**

artery /'arţəri/ **38**

artichoke /'arţɪ,tʃoʊk/ **61**

artist /'arţɪst/ **29**

arts and crafts /,arts ən 'kræfts/ **94**

asparagus /ə'spærəgəs/ **61**

aspirin /'æsprɪn/ **44**

astronaut /'æstrə,nɔt/ **108**

astronomy /ə'stranəmi/ **94**

Atlanta /ət'læntə/ **8**

Atlantic Ocean /ət,læntɪk 'oʊʃən/ **8**

atlas /'æt ̚ləs/ **60**

ATM card /,eɪ ti 'ɛm ,kard/ **79**

ATM /,eɪ ti 'ɛm/ **79**

at the bottom of /ət ðə 'baţəm əv/ **116**

at the top of /ət ðə 'tap əv/ **116**

attend a meeting /ə,tɛnd ə 'miţɪŋ/ **31**

attic /'æţɪk/ **24**

attorney /ə'tə-ni/ **36**

audience /'ɔdiəns/ **93**

August /'ɔgəst/ **6**

Augusta /ɔ'gʌstə /

aunt /ænt/ **11**

Austin /'ɔstɪn/ **8**

author /'ɔθə/ **60**

autumn /'ɔţəm/ **107**

away from /ə'weɪ frəm/ **116**

ax /æks/ **32**

axe /æks/ **32**

baby /'beɪbi/ **9**

baby bottle /'beɪbi ,baţl/ **20**

baby carriage /'beɪbi ,kærɪdʒ/ **20, 57**

baby carrier /'beɪbi ,kæriə/ **20**

baby clothes /'beɪbi ,kloʊz/ **20**

baby wipes /'beɪbi ,waɪps/ **20**

back /bæk/ **37**

backache /'bækeɪk/ **44**

backboard /'bækbɔrd/ **87**

backbone /'bækboʊn/ **38**

backgammon /'bæk,gæmən/ **95**

backhoe /'bækhoʊ/ **34**

backpack /'bækpæk/ **98**

backside /'bæksaɪd/ **37**

back teeth /,bæk 'tiθ/ **48**

bacon /'beɪkən/ **65**

badminton /'bæd,mɪnt ̚n/ **88**

badminton player /'bædmɪnt ̚n ,pleɪə/ **88**

badminton racket /'bædmɪnt ̚n ,rækɪt/ **88**

bag /bæg/ **68**

bagel /'beɪgəl/ **65, 70**

baggage /'bægɪdʒ/ **76**

baggage carousel /'bægɪdʒ kærə,sɛl/ **76**

baggage cart /'bægɪdʒ ,kart/ **76, 77**

baggage claim area /,bægɪdʒ 'kleɪm ,ɛriə/ **76**

bagger /'bægə/ **27**

baggy /'bægi/ **52**

bake /beɪk/ **69**

baked beans /,beɪkt 'binz/ **63**

baked potato /,beɪkt pə'teɪţoʊ/ **66**

baker /'beɪkə/ **27**

bakery /'beɪkəri/ **65**

baking /'beɪkɪŋ/ **94**

balance beam /'bæləns ,bim/ **89**

balcony /'bælkəni/ **13**

bald /bɔld/ **39**

bailiff /'beɪlɪf/ **36**

ballerina /,bælə'rinə/ **93**

ballet /bæ'leɪ/ **93**

ballet dancer /bæ'leɪ ,dænsə/ **93**

ballet shoe /bæ'leɪ ,ʃu/ **93**

ballooning /bə'lunɪŋ/ **98**

ballpoint pen /,bɔlpɔɪnt 'pɛn/ **30, 58, 83**

banana /bə'nænə/ **62**

band /bænd/ **93**

Band-Aid™ /'bændeɪd/ **45**

bangs /bæŋz/ **39**

bank /bæŋk/ **79**

bank officer /'bæŋk ,ɔfəsə/ **79**

bank statement /'bæŋk ,steɪt ̚mənt/ **79**

bank teller /'bæŋk ,tɛlə/ **29, 79**

bannister /'bænɪstə/ **24**

bar /bar/ **35**

barbecue /'barbɪ,kyu/ **22, 69**

barrette /bə'rɛt/ **55**

barrier /'bæriə/ **75**

base /beɪs/ **5, 43, 86, 111**

baseball /'beɪsbɔl/ **86**

baseball cap /'beɪsbɔl ,kæp/ **51**

baseline /'beɪslaɪn/ **88**

basement /'beɪsmənt/ **24**

basket /'bæskɪt/ **87, 100**

basketball /'bæskɪt ̚bɔl/ **87**

basketball player /'bæskɪt ̚bɔl ,pleɪə/ **87**

bass /beɪs/ **103**

bass guitar /,beɪs gɪ'tar/ **96**

bassoon /bə'sun/ **96**

bat /bæt/ **86**

bath mat /'bæθ mæt/ **16**

bath towel /'bæθ ,taʊəl/ **16**

bathing cap /'beɪðɪŋ ,kæp/ **90**

bathing suit /'beɪðɪŋ ,sut/ **51, 97**

bathrobe /'bæθroʊb/ **49**

bathroom /'bæθrum/ **16, 35**

bathtub /'bæθtʌb/ **16**

baton /bə'tan/ **93**

batter /'bæţə/ **86**

battery /'bæţəri/ **72, 111**

beach ball /'bitʃ bɔl/ **97**

beach chair /'bitʃ tʃɛr/ **97**

beach towel /'bitʃ ,taʊəl/ **97**

beach umbrella /'bitʃ ʌm,brɛlə/ **97**

beach /bitʃ/ **97, 106**

beak /bik/ **104**

beaker /'bikə/ **58**

bear /bɛr/ **102**

beard /bɪrd/ **39**

beat /bit/ **69**

beautician /byu'tɪʃən/ **42**

beauty salon /'byuţi sə,lan/ **42**

bedroom /'bɛdrum/ **17**

bedskirt /'bɛdskə-t/ **17**

bedspread /'bɛdsprɛd/ **17**

bee /bi/ **105**

beehive /'bihaɪv/ **105**

beer /bɪr/ **64**

behind /bɪ'haɪnd/ **115**

beige /beɪʒ/ **53**

bellhop /'bɛlhap/ **35**

below /bɪ'loʊ/ **115**

below freezing /bɪ,loʊ 'frizɪŋ/ **107**

belt /bɛlt/ **55**

bend over /ˌbɛnd 'oʊvɚ/ **92**
beside /bɪ'saɪd/ **116**
between /bɪ'twin/ **116**
bib /bɪb/ **20**
bicycle /'baɪsɪkəl/ **72, 89**
bike /baɪk/ **89**
bikini /bɪ'kini/ **97**
bill /bɪl/ **104**
billboard /'bɪlbɔrd/ **81**
billy goat /'bɪli ˌgoʊt/ **101**
binoculars /bɪ'nɑkyəlɚz/ **94**
biology /baɪ'ɑlədʒi/ **59**
bird /bɚd/ **104**
birdie /'bɚdi/ **88**
bird-watching /'bɚd ˌwɑtʃɪŋ/ **94**
Birmingham /'bɚmɪŋˌhæm/ **8**
Bismarck /'bɪzmɑrk/ **8**
black eye /ˌblæk 'aɪ/ **45**
black hair /ˌblæk 'hɛr/ **39**
black /blæk/ **53**
blackbelt /'blækbɛlt/ **88**
blackboard /'blækbɔrd/ **56**
blade /bleɪd/ **91**
blazer /'bleɪzɚ/ **50**
blender /'blɛndɚ/ **15**
blond hair /ˌblɑnd 'hɛr/ **39**
blood /blʌd/ **45**
blood pressure gauge /'blʌd ˌprɛʃɚ ˌgeɪdʒ/ **46**
blouse /blaʊs/ **50**
blueberry /'blu ˌbɛri/ **62**
bluejay /'bludʒeɪ/ **104**
blush /blʌʃ/ **43**
boarding pass /'bɔrdɪŋ ˌpæs/ **76**
boat /boʊt/ **90, 98**
bobsled /'bɑbslɛd/ **91**
bobsledding /'bɑbˌslɛdɪŋ/ **91**
body /'bɑdi/ **37**
boil /bɔɪl/ **69**
Boise /'bɔɪzi/ **8**
book /bʊk/ **18, 57, 60, 83**
bookcase /'bʊk-keɪs/ **18**
book of stamps /ˌbʊk əv 'stæmps/ **82**
bookstore /'bʊkstɔr/ **84**
booster rocket /'bustɚ ˌrɑkɪt/ **108**
boots /buts/ **49**
bored /bɔrd/ **113**
Boston /'bɔstən/ **8**
botanical garden /bə'tænɪkəl ˌgɑrdn/ **99**
bottle /'bɑtl/ **68**
bottle opener /'bɑtl ˌoʊpənɚ/ **15**
bottled water /ˌbɑtld 'wɔtɚ/ **66**
bounce /baʊns/ **92**
bow /boʊ/ **83, 96**
bow tie /'boʊ taɪ/ **51**
bowl /boʊl/ **19**
bowler /'boʊlɚ/ **88**
bowling /'boʊlɪŋ/ **88**

bowling ball /'boʊlɪŋ ˌbɔl/ **88**
box /bɑks/ **68**
box cutter /'bɑks ˌkʌtɚ/ **32**
boxer /'bɑksɚ/ **87**
boxer shorts /'bɑksɚ ˌʃɔrts/ **51**
boxing /'bɑksɪŋ/ **87**
boxing glove /'bɑksɪŋ ˌglʌv/ **87**
boxing ring /'bɑksɪŋ ˌrɪŋ/ **87**
boxing trunks /'bɑksɪŋ ˌtrʌŋks/ **87**
box of tissues /ˌbɑks əv 'tɪʃuz/ **16**
boy /bɔɪ/ **9**
bra /brɑ/ **50**
bracelet /'breɪslɪt/ **55**
braces /'breɪsɪz/ **48**
braid /breɪd/ **39**
brain /breɪn/ **38**
brake /breɪk/ **73**
brake light /'breɪk laɪt/ **73**
brass /bræs/ **96**
brazil nut /brə'zɪl ˌnʌt/ **62**
break /breɪk/ **41, 69**
breakfast /'brɛkfəst/ **70**
breastbone /'brɛstboʊn/ **38**
brick /brɪk/ **34**
bricklayer /'brɪkˌleɪɚ/ **27**
bridge /brɪdʒ/ **75, 81**
briefcase /'brifkeɪs/ **55**
briefs /brifs/ **51**
broccoli /'brɑkəli/ **61**
broken leg /ˌbroʊkən 'lɛg/ **44**
broken zipper /ˌbroʊkən 'zɪpɚ/ **54**
brooch /broʊtʃ/ **55**
brook /brʊk/ **106**
broom /brum/ **21**
brother /'brʌðɚ/ **10**
brother-in-law /'brʌðɚ ɪn ˌlɔ/ **11**
brown /braʊn/ **53**
brown hair /ˌbraʊn 'hɛr/ **39**
bruise /bruz/ **45**
brush /brʌʃ/ **21, 43, 94**
brush your hair /ˌbrʌʃ yɚ 'hɛr/ **12**
brush your teeth /ˌbrʌʃ yɚ 'tiθ/ **12**
brussel sprouts /'brʌsəl ˌspraʊts/ **61**
bucket /'bʌkɪt/ **21, 97**
buckle /'bʌkəl/ **52, 55**
Buffalo /'bʌfəˌloʊ/ **8**
bug bite /'bʌg baɪt/ **45**
building blocks /'bɪldɪŋ ˌblɑks/ **57**
bull /bʊl/ **101**
bulletin board /'bʊlətⁿ bɔrd/ **56**
bump /bʌmp/ **45**
bumper /'bʌmpɚ/ **73**

bunsen burner /'bʌnsən ˌbɚnɚ/ **58**
burner /'bɚnɚ/ **14**
bus /bʌs/ **71, 80**
bus driver /'bʌs ˌdraɪvɚ/ **71**
bush /bʊʃ/ **22**
business studies /'bɪznɪs/ **59**
bus lane /'bʌs leɪn/ **80**
bus shelter /'bʌs ˌʃɛltɚ/ **80**
bus stop /'bʌs stɑp/ **71, 80**
butcher /'bʊtʃɚ/ **27**
butter /'bʌtɚ/ **63, 70**
butterfly /'bʌtɚˌflaɪ/ **105**
buttocks /'bʌtəks/ **37**
button /'bʌtⁿn/ **52**
buttonhole /'bʌtⁿnˌhoʊl/ **52**

cabbage /'kæbɪdʒ/ **61**
cabin /'kæbɪn/ **77**
cabin cruiser /'kæbɪn ˌkruzɚ/ **78**
cabinet /'kæbənɪt/ **14**
cable /'keɪbəl/ **78**
cactus /'kæktəs/ **106**
cafeteria /ˌkæfə'tɪriə/ **58**
cage /keɪdʒ/ **100**
calculator /'kælkyəˌleɪtɚ/ **58, 111**
calendar /'kæləndɚ/ **6**
calf /kæf/ **37, 101**
California /ˌkælɪ'fɔrnyə/ **8**
calling card /'kɔlɪŋ ˌkɑrd/ **85**
call number /'kɔl ˌnʌmbɚ/ **60**
camel /'kæməl/ **102**
camera /'kæmrə/ **94, 111**
camper /'kæmpɚ/ **98**
campfire /'kæmpfaɪɚ/ **98**
campground /'kæmpgraʊnd/ **98**
camping /'kæmpɪŋ/ **98**
camping stove /'kæmpɪŋ ˌstoʊv/ **98**
campsite /'kæmpsaɪt/ **98**
can /kæn/ **68**
Canada /'kænədə/ **8**
candy /'kændi/ **83**
candy store /'kændi ˌstɔr/ **84**
canned food /ˌkænd 'fud/ **63**
canoe /kə'nu/ **90**
canoeing /kə'nuɪŋ/ **90**
canoeist /kə'nuɪst/ **90**
can opener /'kæn ˌoʊpənɚ/ **15**
cap /kæp/ **49**
cape /keɪp/ **42**
captain /'kæptən/ **77**
car /kɑr/ **72, 98**
card store /'kɑrd stɔr/ **84**
card /kɑrd/ **82**
cardigan /'kɑrdəgən/ **49**
cardiologist /ˌkɑrdi'ɑlədʒɪst/ **46**
cards /kɑrdz/ **95**
cargo ship /'kɑrgoʊ ˌʃɪp/ **78**
cargo /'kɑrgoʊ/ **78**

carpenter /'kɑrpəntɚ/ **27**
carpet /'kɑrpɪt/ **17**
carrots /'kærəts/ **61**
carry /'kæri/ **40**
carry-on bag /'kæri ɑn ˌbæg/ **76**
car seat /'kɑr sit/ **20**
Carson City /ˌkɑrsən 'sɪti/ **8**
cart /kɑrt/ **60**
carton /'kɑrtⁿn/ **68**
cash /kæʃ/ **79**
cash drawer /'kæʃ drɔr/ **79**
cashew /'kæʃu/ **62**
cashier /kæ'ʃɪr/ **63**
cash machine /'kæʃ məˌʃin/ **79**
cassette /kə'sɛt/ **110**
cassette deck /kə'sɛt ˌdɛk/ **110**
cassette player /kə'sɛt ˌpleɪɚ/ **56, 73**
cast /kæst/ **47**
casual wear /'kæʒuəl ˌwɛr/ **50, 51**
cat /kæt/ **100**
catch /kætʃ/ **92**
catcher /'kætʃɚ/ **86**
caterpillar /'kætɚˌpɪlɚ/ **105**
catsup /'kætʃəp/ **64**
cauliflower /'kɔliˌflaʊɚ/ **61**
cave /keɪv/ **106**
CD /ˌsi 'di/ **110**
CD player /ˌsi 'di ˌpleɪɚ/ **56, 73, 110**
C drive /'si draɪv/ **109**
CD-ROM /ˌsi di 'rɑm/ **109**
CD-ROM drive /ˌsi di 'rɑm ˌdraɪv/ **109**
ceiling /'silɪŋ/ **24**
celery /'sɛləri/ **61**
cellar /'sɛlɚ/ **24**
cello /'tʃɛloʊ/ **96**
cell phone /'sɛl foʊn/ **111**
cellular phone /ˌsɛlyəlɚ 'foʊn/ **111**
cement /sɪ'mɛnt/ **34**
cement mixer /sɪ'mɛnt ˌmɪksɚ/ **34**
center /'sɛntɚ/ **5**
cents /sɛnts/ **79**
cereal /'sɪriəl/ **64, 70**
chain /tʃeɪn/ **55**
chair /tʃɛr/ **19**
chair lift /'tʃɛr lɪft/ **91**
chalk /tʃɔk/ **56**
chalkboard /'tʃɔkbɔrd/ **56**
champagne /ʃæm'peɪn/ **66**
chandelier /ˌʃændə'lɪr/ **19**
change purse /'tʃeɪndʒ pɚs/ **55**
changing pad /'tʃeɪndʒɪŋ ˌpæd/ **20**
charger /'tʃɑrdʒɚ/ **111**
Charleston /'tʃɑrlstən/ **8**
Charlotte /'ʃɑrlət/ **8**

cheap /tʃip/ **114**
check /tʃɛk/ **79**
checkbook /'tʃɛkbʊk/ **79**
checked /tʃɛkt/ **53**
checkerboard /'tʃɛkɚˌbɔrd/ **95**
checkers /'tʃɛkɚz/ **95**
checking in /ˌtʃɛkɪŋ 'ɪn/ **35**
checking out /ˌtʃɛkɪŋ 'aʊt/ **35**
check-out area /'tʃɛkaʊt̮ ˌɛriə/ **63**
check-out counter /'tʃɛkaʊt̚ ˌkaʊntɚ/ **63**
checkout desk 'tʃɛk-aʊt̚ ˌdɛsk/ **60**
cheddar cheese /ˌtʃɛdɚ 'tʃiz/ **65**
cheek /tʃik/ **38**
cheese /tʃiz/ **63**
cheesecake /'tʃizkeɪk/ **66**
cheetah /'tʃit̮ə/ **102**
chef /ʃɛf/ **27**
chemistry /'kɛməstri/ **59**
cherry /'tʃɛri/ **62**
chess /tʃɛs/ **95**
chessboard /'tʃɛsbɔrd/ **95**
chessman /'tʃɛsmæn/ **95**
chesspiece /'tʃɛspis/ **95**
chest /tʃɛst/ **37**
chest of drawers /ˌtʃɛst əv 'drɔrz/ **17**
chewing gum /'tʃuɪŋ ˌgʌm/ **83**
Cheyenne /ʃaɪ'yæn/ **8**
Chicago /ʃɪ'kagoʊ/ **8**
chick /tʃɪk/ **101**
chicken /'tʃɪkən/ **65, 101**
child /tʃaɪld/ **9**
children /'tʃɪldrən/ **10**
children's section /'tʃɪldrənz ˌsɛkʃən/ **60**
chilly /'tʃɪli/ **107**
chimney /'tʃɪmni/ **13**
chin /tʃɪn/ **37**
chipmunk /'tʃɪpmʌŋk/ **105**
chocolate cake /ˌtʃaklɪt 'keɪk/ **66**
chocolate /'tʃaklɪt/ **83**
chop /tʃap/ **69**
chorus /'kɔrəs/ **93**
Christmas Day /ˌkrɪsməs 'deɪ/ **6**
Cincinnati /ˌsɪnsɪ'næt̮i/ **8**
circle /'sɚkəl/ **5**
circumference /sɚ'kʌmfrəns/ **5**
city /'sɪt̮i/ **80**
clam /klæm/ **103**
clap /klæp/ **40**
clarinet /ˌklærə'nɛt/ **96**
classical concert /ˌklæsɪkəl 'kansɚt/ **93**
classifieds /'klæsɪˌfaɪdz/ **26**
classroom /'klæsrum/ **56**
claw /klɔ/ **103, 104**

cleaning fluid /'klinɪŋ ˌfluɪd/ **48**
clear /klɪr/ **107**
Cleveland /'klivlənd/ **8**
cliff /klɪf/ **106**
climber /'klaɪmɚ/ **89**
clippers /'klɪpɚz/ **23**
clock /klak/ **7**
clock radio /ˌklak 'reɪdioʊ/ **110**
close /kloʊs/ **113**
closed /kloʊzd/ **114**
closet /'klazɪt/ **17**
clothesline /'kloʊzlaɪn/ **21**
clothespin /'kloʊzpɪn/ **21**
clothes rack /'kloʊz ræk/ **21**
clothing store /'kloʊðɪŋ ˌstɔr/ **84**
cloudy /'klaʊdi/ **107**
clutch /klʌtʃ/ **73**
clutch bag /'klʌtʃ bæg/ **55**
coastline /'koʊstlaɪn/ **106**
coat /koʊt/ **49**
cockatoo /'kakəˌtu/ **104**
cockpit /'kakˌpɪt/ **77**
cockroach /'kak-roʊtʃ/ **105**
cocoa /'koʊkoʊ/ **64**
coconut /'koʊkəˌnʌt/ **62**
coffee /'kɔfi/ **64, 66, 70**
coffee maker /'kɔfi ˌmeɪkɚ/ **15**
coffee table /'kɔfi ˌteɪbəl/ **18**
coin /kɔɪn/ **94**
coin collecting /'kɔɪn kəˌlɛktɪŋ/ **94**
coinslot /'kɔɪnslat/ **85**
colander /'kaləndɚ/ **15**
cold /koʊld/ **107**
cold medicine /'koʊld ˌmɛdəsən/ **44**
cold water faucet /ˌkoʊld 'wɔt̮ɚ ˌfɔsɪt/ **16**
coleslaw /'koʊlslɔ/ **65**
collar /'kalɚ/ **52**
collection /kə'lɛkʃən/ **82**
college /'kalɪdʒ/ **56**
cologne /kə'loʊn/ **43**
Colorado /ˌkalə'radoʊ/ **8**
colored pen /ˌkʌlɚd 'pɛn/ **83**
coloring book /'kʌlərɪŋ ˌbʊk/ **57, 83**
colors /'kʌlɚz/ **53**
comb your hair /ˌkoʊm yɚ 'hɛr/ **12**
comb /koʊm/ **42, 43**
comet /'kamɪt/ **108**
comforter /'kʌmfɚt̮ɚ/ **17**
compact disc /ˌkampækt 'dɪsk/ **110**
compact disc player /ˌkampækt 'dɪsk ˌpleɪɚ/ **110**
compartment /kəm'part̚mənt/ **77**
compass /'kʌmpəs/ **58**

compost /'kampoʊst/ **23**
computer /kəm'pyut̮ɚ/ **56, 60, 109, 110**
computer games /kəm'pyut̮ɚ ˌgeɪmz/ **95**
computer lab /kəm'pyut̮ɚ ˌlæb/ **58**
computer technician /kəm'pyut̮ɚ tɛkˌnɪʃən/ **29**
Concord /'kaŋkɚd/ **8**
condiments /'kandəmənts/ **64**
conduct a meeting /kənˌdʌkt ə 'mit̮ɪŋ/ **31**
conductor /kən'dʌktɚ/ **93**
confectionery /kən'fɛkʃəˌnɛri/ **83**
conference room /'kanfrəns ˌrum/ **35**
confused /kən'fyuzd/ **113**
Connecticut /kə'nɛt̮ɪkət/ **8**
constellation /ˌkanstə'leɪʃən/ **108**
construction site /kən'strʌkʃən ˌsaɪt/ **34**
construction worker /kən'strʌkʃən ˌwɚkɚ/ **34**
consultant /kən'sʌltənt/ **47**
contact lenses /ˌkantækt 'lɛnzɪz/ **48**
container /kən'teɪnɚ/ **68**
control tower /kən'troʊl ˌtaʊɚ/ **77**
convertible /kən'vɚt̮əbəl/ **72**
conveyer belt /kən'veɪyɚ bɛlt/ **33, 63**
cook /kʊk/ **27**
cookbook /'kʊkbʊk/ **14**
cookies /'kʊkiz/ **64**
cookie sheet /'kʊki ˌʃit/ **15**
cooking /'kʊkɪŋ/ **69**
cool /kul/ **107**
cooler /'kulɚ/ **97**
copilot /'koʊˌpaɪlət/ **77**
cordless phone /ˌkɔrdlɪs 'foʊn/ **111**
corn /kɔrn/ **63**
corner /'kɔrnɚ/ **5**
corn on the cob /ˌkɔrn ɔn ðə 'kab/ **61**
cosmetics /kaz'mɛtɪks/ **43**
cotton /'kat̚n/ **54**
couch /kaʊtʃ/ **18**
cough /kɔf/ **44**
cough syrup /'kɔf ˌsɚəp/ **44**
counselor /'kaʊnsəlɚ/ **46**
counter /'kaʊntɚ/ **82**
counter top 'kaʊntɚ ˌtap **14**
country /'kʌntri/ **98**
countryside /'kʌntriˌsaɪd/ **98**
couple /'kʌpəl/ **9**
court /kɔrt/ **87, 88**

court reporter /ˌkɔrt rɪ'pɔrt̮ɚ/ **36**
courtroom /'kɔrt̚rum/ **36**
cousins /'kʌzənz/ **11**
cover letter /'kʌvɚ ˌlɛt̮ɚ/ **26**
cow /kaʊ/ **101**
crab /kræb/ **65, 103**
craft fair /'kræft fɛr/ **99**
crane /kreɪn/ **34, 78, 104**
crayon /'kreɪən/ **57**
cream /krim/ **45, 53**
cream cheese /ˌkrim 'tʃiz/ **70**
credit card /'krɛdɪt ˌkard/ **79**
crescent moon /ˌkrɛsənt 'mun/ **108**
crest /krɛst/ **104**
crewneck sweater /ˌkrunɛk 'swɛt̮ɚ/ **49**
crib /krɪb/ **20**
crime /kraɪm/ **36**
crocodile /'krakəˌdaɪl/ **102**
croissant /krwa'sant/ **70**
cross-country skiing /ˌkrɔs kʌntri 'ski-ɪŋ/ **91**
crosswalk /'krɔswɔk/ **74, 80**
crow /kroʊ/ **104**
crowd /kraʊd/ **86**
cruise ship /'kruz ʃɪp/ **78**
crush /krʌʃ/ **69**
crutches /'krʌtʃɪz/ **47**
cry /kraɪ/ **40**
cube /kyub/ **5**
cucumbers /'kyuˌkʌmbɚz/ **61**
cuff /kʌf/ **52**
cuff link /'kʌf lɪŋk/ **55**
cup /kʌp/ **16, 19, 68**
cupboard /'kʌbɚd/ **14**
cupcake /'kʌpkeɪk/ **65**
curb /kɚb/ **80**
curly hair /ˌkɚli 'hɛr/ **39**
cursor /'kɚsɚ/ **109**
curtains /'kɚt̚nz/ **17**
cushion /'kʊʃən/ **18**
customer /'kʌstəmɚ/ **63, 79, 82**
customs /'kʌstəmz/ **76**
customs officer /'kʌstəmz ˌɔfəsɚ/ **76**
cut /kʌt/ **41, 42, 45**
cutlery /'kʌtləri/ **19**
cutting board /ˌkʌt̮ɪŋ bɔrd/ **15**
cycling /'saɪklɪŋ/ **89**
cyclist /'saɪklɪst/ **89**
cylinder /'sɪləndɚ/ **5**
cylinder block /'sɪləndɚ ˌblak/ **72**
cymbal /'sɪmbəl/ **96**

daffodil /'dæfəˌdɪl/ **22**
Dallas /'dæləs/ **8**
daily planner /ˌdeɪli 'plænɚ/ **55**
daily routine /ˌdeɪli ru'tin/ **12**

dairy products /'dɛri ˌprɑdʌkts/ **63**

daisy /'deɪzi/ **22**

dance /dæns/ **40**

dark /dɑrk/ **114**

dark blue /ˌdɑrk 'blu/ **53**

dark green /ˌdɑrk 'grin/ **53**

dark hair /ˌdɑrk 'hɛr/ **39**

dashboard /'dæʃbɔrd/ **73**

date /deɪt/ **62**

datebook /'deɪtˌbʊk/ **30**

daughter /'dɔt̬ɚ/ **10**

daughter-in-law /'dɔt̬ɚ ɪn ˌlɔ/ **11**

days of the week /ˌdeɪz əv ðə 'wik/ **6**

debit card /'dɛbɪt ˌkɑrd/ **79**

December /dɪ'sɛmbɚ/ **6**

deck /dɛk/ **78**

deep /dip/ **114**

deer /dɪr/ **102**

defense attorney /dɪ'fɛns əˌtɚni/ **36**

defendant dɪ'fɛndənt **36**

Delaware /'dɛləˌwɛr/ **8**

delicatessen /ˌdɛlɪkə'tɛsən/ **65**

delivery /dɪ'lɪvri/ **82**

denim /'dɛnəm/ **54**

dental assistant /'dɛntl əˌsɪstənt/ **48**

dental care /'dɛntl ˌkɛr/ **48**

dental floss /'dɛntl ˌflɔs/ **48**

dental hygienist /ˌdɛntl haɪ'dʒɪnɪst/ **48**

dentist /'dɛntɪst/ **28, 48**

Denver /'dɛnvɚ/ **8**

department store /dɪ'pɑrtˌmənt ˌstɔr/ **80**

departure lounge /dɪ'pɑrtʃɚ ˌlaʊndʒ/ **76**

depth /dɛpθ/ **5**

desert /'dɛzɚt/ **106**

designer /dɪ'zaɪnɚ/ **29**

desk /dɛsk/ **18, 30, 56**

desk calendar /'dɛsk ˌkæləndɚ/ **30**

desk clerk /'dɛsk klɚk/ **35**

desk lamp /'dɛsk læmp/ **30**

dessert /dɪ'zɚt/ **66**

dessert cart /dɪ'zɚt ˌkɑrt/ **66**

Detroit /dɪ'trɔɪt/ **8**

diagonal /daɪ'ægənəl/ **5**

diameter /daɪ'æmət̬ɚ/ **5**

diamond /'daɪmənd/ **55**

diaper /'daɪpɚ/ **20**

diary /'daɪəri/ **30**

dice /daɪs/ **95**

dictionary /'dɪkʃəˌnɛri/ **60**

digital camera /ˌdɪdʒɪtl 'kæmrə/ **111**

digital watch /ˌdɪdʒɪtl 'wɑtʃ/ **7**

dig the soil /ˌdɪg ðə 'sɔɪl/ **23**

dime /daɪm/ **79**

dining room /'daɪnɪŋ ˌrum/ **19**

dining room table /ˌdaɪnɪŋ rum 'teɪbəl/ **19**

dip /dɪp/ **65**

dish /dɪʃ/ **19**

dishwasher /'dɪʃˌwɑʃɚ/ **14**

dishwashing liquid /'dɪʃwɑʃɪŋ ˌlɪkwɪd/ **14**

diskette /dɪ'skɛt/ **109**

distributor /dɪ'strɪbyət̬ɚ/ **72**

diver /'daɪvɚ/ **90**

divided by /də'vaɪdɪd baɪ/ **4**

divider /də'vaɪdɚ/ **74**

diving board /'daɪvɪŋ ˌbɔrd/ **90**

diving /'daɪvɪŋ/ **90**

divorced /də'vɔrst/ **9**

dock /dɑk/ **78**

doctor /'dɑktɚ/ **28, 46**

doctor's office /'dɑktɚz ˌɔfɪs/ **46**

document /'dɑkyəmənt/ **109**

dog /dɔg/ **100**

doghouse /'dɔghaʊs/ **100**

do homework /ˌdu 'hoʊmwɚk/ **25**

doll /dɑl/ **57**

dollar bill /ˌdɑlɚ 'bɪl/ **79**

dollar coin /'dɑlɚ ˌkɔɪn/ **79**

dolly /'dɑli/ **33**

dolphin /'dɑlfɪn/ **103**

do not enter sign /ˌdu nɑt 'ɛntɚ ˌsaɪn/ **75**

donkey /'dɑŋki/ **101**

don't walk sign /ˌdoʊnt 'wɔk ˌsaɪn/ **80**

door /dɔr/ **73**

doorbell /'dɔrbɛl/ **13**

doorknob /'dɔrnɑb/ **13**

do push-ups /ˌdu 'pʊʃʌps/ **92**

do sit-ups /ˌdu 'sɪt̬ʌps/ **92**

do the laundry /ˌdu ðə 'lɔndri/ **25**

double bass /ˌdʌbəl 'beɪs/ **96**

double bed /ˌdʌbəl 'bɛd/ **17**

double room /ˌdʌbəl 'rum/ **35**

double yellow line /ˌdʌbəl ˌyɛloʊ 'laɪn/ **80**

doughnut /'doʊnʌt/ **67**

down /daʊn/ **115**

downhill skiing /ˌdaʊnhɪl 'ski-ɪŋ/ **91**

dragonfly /'drægənˌflaɪ/ **105**

drainpipe /'dreɪnpaɪp/ **13**

drama /'drɑmə/ **59**

drape /dreɪp/ **18**

draw /drɔ/ **41**

drawer /drɔr/ **17**

dress /drɛs/ **50**

dresser /'drɛsɚ/ **17**

dressing table /'drɛsɪŋ ˌteɪbəl/ **17**

dressmaker /'drɛsˌmeɪkɚ/ **54**

drill /drɪl/ **48**

drill bit /'drɪl bɪt/ **32**

drinks /drɪŋks/ **64, 66**

driveway /'draɪvweɪ/ **13**

drugstore /'drʌgstɔr/ **83, 84**

drum /drʌm/ **96**

drum kit /'drʌm kɪt/ **96**

drummer /'drʌmɚ/ **93**

dry /draɪ/ **114**

dry goods /'draɪ gʊdz/ **64**

dry your face /ˌdraɪ yɚ 'feɪs/ **12**

dry yourself /'draɪ yɚˌsɛlf/ **12**

duck /dʌk/ **101**

duckling /'dʌklɪŋ/ **101**

dump truck /'dʌmp trʌk/ **34**

duplex /'duplɛks/ **13**

dust /dʌst/ **25**

dustcloth /'dʌstklɔθ/ **21**

dustpan /'dʌstpæn/ **21**

dust ruffle /'dʌst ˌrʌfəl/ **17**

duty-free shop /ˌduti 'fri ˌʃɑp/ **76**

DVD /ˌdi vi 'di/ **110**

DVD player /ˌdi vi 'di ˌpleɪɚ/ **110**

eagle /'igəl/ **104**

ear /ɪr/ **37**

ear protectors /'ɪr prəˌtɛktɚz/ **34**

earring /'ɪrɪŋ/ **55**

Earth /ɚθ/ **108**

easel /'izəl/ **57**

east /ist/ **8**

East Coast /ˌist 'koʊst/ **8**

Easter /'istɚ/ **6**

eat breakfast /ˌit 'brɛkfəst/ **12**

edge /ɛdʒ/ **5**

eel /il/ **103**

egg /ɛg/ **63, 104**

egg beaters /'ɛg ˌbit̬ɚz/ **15**

eggplant /'ɛgplænt/ **61**

eight /eɪt/ **4**

eighteen /ˌeɪ'tin/ **4**

eighty /'eɪt̬i/ **4**

elbow /'ɛlboʊ/ **37**

elbow pads /'ɛlboʊ ˌpædz/ **89**

electric drill /ɪˌlɛktrɪk 'drɪl/ **32**

electric guitar /ɪˌlɛktrɪk gɪ'tɑr/ **96**

electrician /ɪˌlɛk'trɪʃən/ **27**

electric mixer /ɪˌlɛktrɪk 'mɪksɚ/ **15**

electric shaver /ɪˌlɛktrɪk 'ʃeɪvɚ/ **43**

electronic personal organizer /ɪlɛkˌtrɑnɪk ˌpɚsənəl 'ɔrgənaɪzɚ/

electronics store /ɪlɛk'trɑnɪks ˌstɔr/ **84**

elementary school /ɛlə'mɛntri ˌskul/ **56**

elephant /'ɛləfənt/ **102**

elevator /'ɛləˌveɪt̬ɚ/ **35**

eleven /ɪ'lɛvən/ **4**

ellipse /ɪ'lɪps/ **5**

El Paso /ɛl 'pæsoʊ/ **8**

embroidery /ɪm'brɔɪdɚi/ **94**

emerald /'ɛmərəld/ **55**

emergencies /ɪ'mɚdʒənsiz/ **85**

emergency number /ɪ'mɚdʒənsi ˌnʌmbɚ/ **85**

emery board /'ɛmri ˌbɔrd/ **43**

empty /'ɛmpti/ **68, 114**

encyclopedia /ɪnˌsaɪklə'pidiə/ **60**

engine /'ɛndʒɪn/ **71, 72**

English literature /ˌɪŋglɪʃ 'lɪt̬ərətʃɚ/ **59**

ENT specialist /ˌi ɛn 'ti ˌspɛʃəlɪst/ **46**

entertainment /ˌɛntɚ'teɪnmənt/ **93**

envelope /'ɛnvəˌloʊp/ **82**

equals /'ikwəlz/ **4**

eraser /ɪ'reɪsɚ/ **30, 58, 83**

escalator /'ɛskəˌleɪt̬ɚ/ **71, 84**

evening /'ivnɪŋ/ **7**

evening gown /'ivnɪŋ ˌgaʊn/ **50**

evidence /'ɛvədəns/ **36**

examination table /ɪgzæmə'neɪʃən ˌteɪbəl/ **46**

excavation site /ˌɛkskə'veɪʃən ˌsaɪt/ **34**

excited /ɪk'saɪt̬ɪd/ **113**

exercise bike /'ɛksɚsaɪz ˌbaɪk/ **92**

exhaust pipe /ɪg'zɔst ˌpaɪp/ **73**

exhibition /ˌɛksə'bɪʃən/ **99**

ex-husband /ˌɛks 'hʌzbənd/ **10**

expensive /ɪk'spɛnsɪv/ **114**

ex-wife /ˌɛks 'waɪf/ **10**

eye /aɪ/ **37**

eyebrow /'aɪbraʊ/ **37, 38**

eyebrow pencil /'aɪbraʊ ˌpɛnsəl/ **43**

eye care /'aɪ kɛr/ **48**

eye chart /'aɪ tʃɑrt/ **48**

eye drops /'aɪ drɑps/ **48**

eyeglass case /'aɪglæs ˌkeɪs/ **48**

eyelash /'aɪlæʃ/ **38**

eyelid /'aɪˌlɪd/ **38**

eyeliner /'aɪˌlaɪnɚ/ **43**

eye shadow /'aɪ ˌʃædoʊ/ **43**

fabric /'fæbrɪk/ **54**

fabric store /'fæbrɪk ˌstɔr/ **84**

face /feɪs/ **5, 7, 37**

facial /'feɪʃəl/ **42**

factory /'fæktəri/ **33**

factory worker /'fæktəri ˌwɚkɚ/ **29**

fairground /'fɛrgraʊnd/ **99**

falcon /'fælkən/ **104**

fall /fɔl/ **40, 107**

ground beef /ˌgraʊnd 'bif/ **65**
groundhog /'graʊndhɑg/ **105**
groundsheet /'graʊnd‚ʃit/ **98**
guard /gɑrd/ **86**
guest /gɛst/ **35**
Gulf of Mexico /ˌgʌlf əv 'mɛksɪkoʊ/ **8**
guinea pig /'gɪni ‚pɪg/ **100**
guitarist /gɪ'tɑrɪst/ **93**
gum /gʌm/ **48**
gurney /'gɚni/ **47**
gutter /'gʌtɚ/ **13, 80, 88**
gym /dʒɪm/ **58, 59, 92**
gymnast /'dʒɪmnəst/ **89**
gymnastics /dʒɪm'næstɪks/ **89**
gynecologist /ˌgaɪnə'kɑlədʒɪst/ **46**

hair /hɛr/ **37**
hairbrush /'hɛrbrʌʃ/ **42**
hairdresser /'hɛr‚drɛsɚ/ **29, 42**
hairdresser's chair /'hɛrdrɛsɚz ‚tʃɛr/ **42**
hairdryer /'hɛr‚draɪɚ/ **42, 43**
hairstyling /'hɛr‚staɪlɪŋ/ **43**
half full /‚hæf 'fʊl/ **68**
half moon /‚hæf 'mun/ **108**
Halloween /ˌhælə'win/ **6**
hallway /'hɔlweɪ/ **24**
ham /hæm/ **65**
hamburger /'hæm‚bɚgɚ/ **67**
hammer /'hæmɚ/ **32**
hamper /'hæmpɚ/ **16**
hamster /'hæmstɚ/ **100**
hand /hænd/ **37**
handbag /'hændbæg/ **55**
handcuffs /'hændkʌfs/ **36**
handkerchief /'hæŋkɚtʃɪf/ **55**
handle /'hændl/ **15, 17**
hand mirror /'hænd ‚mɪrɚ/ **42**
handrail /'hændreɪl/ **80**
handset /'hændsɛt/ **111**
hand towel /'hænd ‚taʊəl/ **16**
hangar /'hæŋɚ/ **21, 77**
happy /'hæpi/ **113**
hard /hɑrd/ **114**
hard disk drive /‚hɑrd 'dɪsk ‚draɪv/ **109**
hard hat /'hɑrd hæt/ **34**
hardware /'hɑrdwɛr/ **109**
harmonica /hɑr'mɑnɪkə/ **96**
harness /'hɑrnɪs/ **89**
hat /hæt/ **49**
hatchback /'hætʃbæk/ **72**
have a cup of coffee /‚hæv ə ‚kʌp əv 'kɔfi/ **12**
Hawaii /hə'waɪ-i/ **8**
hazelnut /'heɪzəl‚nʌt/ **62**
hazy /'heɪzi/ **107**
head /hɛd/ **37**
headache /'hɛdeɪk/ **44**

headboard /'hɛdbɔrd/ **17**
headlight /'hɛdlaɪt/ **73**
headphones /'hɛdfoʊnz/ **58, 110**
headrest /'hɛdrɛst/ **73**
heart /hɑrt/ **38**
heavy /'hɛvi/ **39, 114**
hedge /hɛdʒ/ **22**
heel /hil/ **37, 52**
height /haɪt/ **5**
height chart /'haɪt tʃɑrt/ **46**
Helena /'hɛlənə/ **8**
helicopter /'hɛli‚kɑptɚ/ **77**
helmet /'hɛlmɪt/ **86, 89, 91**
hemline /'hɛmlaɪn/ **52**
herbs /ɚbz/ **64**
hi-fi /‚haɪ 'faɪ/ **110**
high chair /'haɪ tʃɛr/ **20**
high-rise building /‚haɪ raɪz 'bɪldɪŋ/ **81**
high school /'haɪ skul/ **56**
highway /'haɪweɪ/ **74**
hiker /'haɪkɚ/ **98**
hiking /'haɪkɪŋ/ **98**
hill /hɪl/ **106**
hip /hɪp/ **37**
hip-bone /'hɪp boʊn/ **38**
hippopotamus /ˌhɪpə'pɑtəməs/ **102**
historic battlefield /hɪ‚stɔrɪk 'bætl̩fild/ **99**
hobby /'hɑbi/ **94**
hold /hoʊld/ **41**
hole /hoʊl/ **89**
hole puncher /'hoʊl ‚pʌntʃɚ/ **30**
holidays /'hɑlə‚deɪz/ **6**
home activities /hoʊm/ **12**
home economics /‚hoʊm ɛkə'nɑmɪks/ **59**
home plate /‚hoʊm 'pleɪt/ **86**
honey /'hʌni/ **63**
honeycomb /'hʌni‚koʊm/ **105**
honeydew melon /'hʌnidu ‚mɛlən/ **62**
hood /hʊd/ **52, 73**
hook /hʊk/ **32, 34**
hook and eye /‚hʊk ən 'aɪ/ **54**
hoop /hup/ **87**
hop /hɑp/ **92**
horn /hɔrn/ **102**
hors d'oeuvres /ɔr 'dɚvz/ **66**
horse /hɔrs/ **89, 98, 101**
horseback riding /'hɔrsbæk ‚raɪdɪŋ/ **89, 98**
horse racing /'hɔrs ‚reɪsɪŋ/ **87**
hose /hoʊz/ **23, 72, 85**
hospital ward /'hɑspɪtl̩ ‚wɔrd/ **47**
hot /hɑt/ **107**
hot-air balloon /‚hɑt 'ɛr bə‚lun/ **98**

hot cereal /ˌhɑt 'sɪriəl/ **70**
hotdog /'hɑtdɔg/ **67**
hotel /hoʊ'tɛl/ **35**
hot water faucet /‚hɑt 'wɔṭɚ ‚fɔsɪt/ **16**
hour hand /'aʊɚ hænd/ **7**
house /haʊs/ **13**
household products /‚haʊshoʊld 'prɑdʌkts/ **64**
housekeeper /'haʊs‚kipɚ/ **35**
housework /'haʊswɚk/ **25**
Houston /'hyustən/ **8**
hubcap /'hʌbkæp/ **73**
hug /hʌg/ **40**
hummingbird /'hʌmɪŋ‚bɚd/ **104**
hump /hʌmp/ **102**
hurt /hɚt/ **45**
husband /'hʌzbənd/ **10**
hutch /hʌtʃ/ **100**
hyacinth /'haɪə‚sɪnθ/ **22**
hypotenuse /haɪ'pɑt⌐n-us/ **5**

ice /aɪs/ **91**
ice cream /'aɪs krim/ **66, 67**
ice cream cone /'aɪs krim ‚koʊn/ **67**
ice skate /'aɪs skeɪt/ **91**
icon /'aɪkɑn/ **109**
icy /'aɪsi/ **107**
Idaho /'aɪdə‚hoʊ/ **8**
Illinois /ˌɪlə'nɔɪ/ **8**
immigration and naturalization /ˌɪmə‚greɪʃən ən nætʃrələ'zeɪʃən/ **76**
immigration officer /ˌɪmə'greɪʃən ‚ɔfəsɚ/ **76**
in /ɪn/ **115**
in box /'ɪn bɑks/ **30**
Independence Day/Fourth of July /ɪndə'pɛndəns ‚deɪ, ‚fɔrθ əv dʒə'laɪ/ **6**
index file /'ɪndɛks ‚faɪl/ **30**
Indiana /ˌɪndi'ænə/ **8**
Indianapolis /ˌɪndiə'næpəlɪs/ **8**
individual sports /ɪndə'vɪdʒuəl ‚spɔrts/ **88**
infield /'ɪnfild/ **86**
information desk /ɪnfɚ'meɪʃən ‚dɛsk/ **60**
in front of /ɪn 'frʌnt əv/ **115**
in-laws /'ɪn lɔz/ **11**
in-line skate /‚ɪn laɪn 'skeɪt/ **89**
inmate /'ɪnmeɪt/ **36**
insect bite /'ɪnsɛkt ‚baɪt/ **45**
insect repellent /'ɪnsɛkt rɪ'pɛlənt/ **45**
insect /'ɪnsɛkt/ **105**
inside /ɪn'saɪd/ **116**
instrument panel /'ɪnstrəmənt ‚pænl/ **77**
intercom /'ɪntɚ‚kɑm/ **13, 20**

intersection /'ɪntɚ‚sɛkʃən/ **74**
interstate highway sign /ˌɪntɚsteɪt 'haɪweɪ ‚saɪn/ **75**
interviewer /'ɪntɚ‚vyuɚ/ **26**
in the middle of /ɪn ðə 'mɪdl əv/ **116**
into /'ɪntu/ **116**
intravenous drip /ˌɪntrəvinəs 'drɪp/ **85**
Iowa /'aɪəwə/ **8**
iron /'aɪɚn/ **21, 25**
ironing board /'aɪɚnɪŋ ‚bɔrd/ **21**
iron-on tape /‚aɪɚn ɑn 'teɪp/ **54**
island /'aɪlənd/ **106**
isosceles triangle /aɪ‚sɑsəliz 'traɪæŋgəl/ **5**

jacket /'dʒækɪt/ **49, 50, 51**
jackhammer /'dʒæk‚hæmɚ/ **34**
Jackson /'dʒæksən/ **8**
Jacksonville /'dʒæksənvɪl/ **8**
jail /dʒeɪl/ **36**
jam /dʒæm/ **63, 70**
January /'dʒænyu‚ɛri/ **6**
jar /dʒɑr/ **68**
jeans /dʒinz/ **50, 51**
jelly /'dʒɛli/ **63, 70**
jellyfish /'dʒɛli‚fɪʃ/ **103**
jet /dʒɛt/ **77**
jewelry /'dʒuəlri/ **55**
jigsaw puzzle /'dʒɪgsɔ ‚pʌzəl/ **57**
job announcement board /'dʒɑb ə‚naʊnsmənt⌐ ‚bɔrd/ **26**
job candidate /'dʒɑb ‚kændədɪt/ **26**
job interview /'dʒɑb ‚ɪntɚvyu/ **26**
jockey /'dʒɑki/ **87**
jockey shorts /'dʒɑki ‚ʃɔrts/ **51**
jogger /'dʒɑgɚ/ **89**
journalist /'dʒɚnl-ɪst/ **29**
judge /dʒʌdʒ/ **28, 36**
judo /'dʒudoʊ/ **88**
juice /dʒus/ **64**
July /dʒʊ'laɪ/ **6**
jump rope /'dʒʌmp roʊp/ **92**
June /dʒun/ **6**
jungle gym /ˌdʒʌŋgəl 'dʒɪm/ **57**
junior high school /ˌdʒunyɚ 'haɪ skul/ **56**
Jupiter /'dʒupɪṭɚ/ **108**
jury /'dʒʊri/ **36**

kangaroo /ˌkæŋgə'ru/ **102**
Kansas /'kænzəs/ **8**
Kansas City /ˌkænzəs 'sɪṭi/ **8**
karate /kə'rɑṭi/ **88**
Kentucky /kən'tʌki/ **8**
ketchup /'kɛtʃəp/ **64**

kettle /ˈkɛt̮l/ **15**
key ring /ˈki rɪŋ/ **55**
keyboard /ˈkibɔrd/ **58, 96, 109**
keypad /ˈkipæd/ **111**
kick /kɪk/ **92**
kid /kɪd/ **101**
kidney /ˈkɪdni/ **38**
killer whale /ˌkɪlɚ ˈweɪl/ **103**
kindergarten /ˈkɪndɚˌgɑrt̚n/ **56**
kiss /kɪs/ **40**
kitchen /ˈkɪtʃən/ **14**
kitchen equipment /ˈkɪtʃən ɪˌkwɪp̚mənt/ **15**
kite /kaɪt/ **57**
kitten /ˈkɪt̚n/ **100**
knead /nid/ **69**
knee /ni/ **37**
kneecap /ˈnikæp/ **38**
kneel /nil/ **92**
knife /naɪf/ **15, 19**
knitting /ˈnɪt̮ɪŋ/ **54, 94**
knitting needle /ˈnɪt̮ɪŋ ˌnidl/ **54, 94**
knocker /ˈnɑkɚ/ **13**
koala bear /koʊˈɑlə ˌbɛr/ **102**

ladder /ˈlædɚ/ **34, 85**
ladle /ˈleɪdl/ **15**
ladybug /ˈleɪdiˌbʌg/ **105**
lake /leɪk/ **98, 106**
Lake Erie /ˌleɪk ˈɪri/ **8**
Lake Huron /ˌleɪk ˈhyʊrɑn/ **8**
Lake Michigan /ˌleɪk ˈmɪʃɪgən/ **8**
Lake Ontario /ˌleɪk ɑnˈtɛrioʊ/ **8**
Lake Superior /ˌleɪk səˈpɪriɚ/ **8**
lamb /læm/ **101**
lamb chops /ˈlæm ˌtʃɑps/ **65**
lamp /læmp/ **17, 18, 48**
lampshade /ˈlæmpʃeɪd/ **18**
landing /ˈlændɪŋ/ **77**
landscape features /ˈlændskeɪp/ **106**
lane /leɪn/ **74, 88**
language lab /ˈlæŋgwɪdʒ ˌlæb/ **58**
languages /ˈlæŋgwɪdʒɪz/ **59**
lapel /ləˈpɛl/ **52**
laptop /ˈlæptɑp/ **109**
large intestine /ˌlɑrdʒ ɪnˈtɛstɪn/ **38**
lasagna /ləˈzɑnyə/ **66**
Las Vegas /lɑs ˈveɪgəs/ **8**
laugh /læf/ **40**
launch pad /ˈlɔntʃ pæd/ **108**
laundry basket /ˈlɔndri ˌbæskɪt/ **16, 21**
laundry detergent /ˈlɔndri dɪˌtɚdʒənt/ **21**
lawn /lɔn/ **22**
lawn mower /ˈlɔn ˌmoʊɚ/ **23**
lawyer /ˈlɔyɚ/ **28**

leather /ˈlɛðɚ/ **54**
lecturer /ˈlɛktʃərɚ/ **28**
leeks /liks/ **61**
leg /lɛg/ **37**
leg of lamb /ˌlɛg əv ˈlæm/ **65**
lemon /ˈlɛmən/ **62**
length /lɛŋkθ/ **5**
lens /lɛnz/ **48, 111**
leopard /ˈlɛpɚd/ **102**
letter /ˈlɛt̮ɚ/ **82**
letter carrier /ˈlɛt̮ɚ ˌkæriɚ/ **82**
lettuce /ˈlɛt̮ɪs/ **61**
level /ˈlɛvəl/ **34**
librarian /laɪˈbrɛriən/ **60**
library /ˈlaɪˌbrɛri/ **60**
library card /ˈlaɪbrɛri ˌkɑrd/ **60**
license plate /ˈlaɪsəns ˌpleɪt/ **73**
lid /lɪd/ **15**
lie down /ˌlaɪ ˈdaʊn/ **40**
lifeboat /ˈlaɪfboʊt/ **78**
lifeguard /ˈlaɪfgɑrd/ **97**
life jacket /ˈlaɪf ˌdʒækɪt/ **77, 78**
lift /lɪft/ **92**
light /laɪt/ **114**
light bulb /ˈlaɪt̚ ˌbʌlb/ **111**
light hair /ˌlaɪt ˈhɛr/ **39**
lighthouse /ˈlaɪthaʊs/ **78**
lightning /ˈlaɪt̚nɪŋ/ **107**
lime /laɪm/ **62**
line /laɪn/ **99**
linen /ˈlɪnən/ **54**
lines /laɪnz/ **5**
lion /ˈlaɪən/ **102**
lips /lɪps/ **37**
lipstick /ˈlɪpˌstɪk/ **43**
listen to the radio /ˌlɪsən tə ðə ˈreɪdioʊ/ **12**
Little Rock /ˈlɪt̮l ˌrɑk/ **8**
liver ˈlɪvɚ **38, 65**
living room /ˈlɪvɪŋ ˌrum/ **18**
lizard /ˈlɪzɚd/ **102**
llama /ˈlɑmə/ **102**
loading dock /ˈloʊdɪŋ ˌdɑk/ **33**
load the dishwasher /ˌloʊd ðə ˈdɪʃwɑʃɚ/ **25**
loaf /loʊf/ **68**
lobby /ˈlɑbi/ **35**
lobster /ˈlɑbstɚ/ **65, 103**
lollipop /ˈlɑliˌpɑp/ **83**
long /lɔŋ/ **114**
long hair /ˌlɔŋ ˈhɛr/ **39**
long-sleeved /ˌlɔŋ ˈslivd/ **52**
loose /lus/ **52, 114**
Los Angeles /lɔs ˈændʒəlɪs/ **8**
Louisiana /luˌiziˈænə/ **8**
Louisville /ˈluivɪl/ **8**
lounge chair /ˈlaʊndʒ tʃɛr/ **22**
luggage /ˈlʌgɪdʒ/ **76**
luggage carousel /ˈlʌgɪdʒ ˌkærəˌsɛl/ **76**
luggage cart /ˈlʌgɪdʒ ˌkɑrt/ **76**

luggage compartment /ˈlʌgɪdʒ kəmˌpɑrt̚mənt/ **71**
lunar module /ˌlunɚ ˈmɑdʒul/ **108**
lunar vehicle /ˌlunɚ ˈviɪkəl/ **108**
lunchmeat /ˈlʌntʃmit/ **65**
lung /lʌŋ/ **38**

machine /məˈʃin/ **33**
mad /mæd/ **113**
magazine /ˌmægəˈzin/ **60, 83**
magnifying glass /ˈmægnəfaɪˌɪŋ ˌglæs/ **94**
maid /meɪd/ **35**
mail /meɪl/ **82**
mailbox /ˈmeɪlbɑks/ **13, 82**
mail carrier /ˈmeɪl ˌkæriɚ/ **28, 82**
mail truck /ˈmeɪl trʌk/ **82**
mail van /ˈmeɪl væn/ **82**
main course /ˌmeɪn ˈkɔrs/ **66**
Maine /meɪn/ **8**
make a sandwich /ˌmeɪk ə ˈsændwɪtʃ/ **25**
make breakfast /ˌmeɪk ˈbrɛkfəst/ **25**
make dinner /ˌmeɪk ˈdɪnɚ/ **25**
make lunch /ˌmeɪk ˈlʌntʃ/ **25**
make the bed /ˌmeɪk ðə ˈbɛd/ **25**
make-up /ˈmeɪkʌp/ **43**
make-up bag /ˈmeɪkʌp ˌbæg/ **55**
mall /mɔl/ **84**
man /mæn/ **9**
mane /meɪn/ **102**
manhole /ˈmænhoʊl/ **81**
manhole cover /ˈmænhoʊl ˌkʌvɚ/ **81**
manicure /ˈmænɪˌkyʊr/ **43**
mantelpiece /ˈmænt̮lˌpis/ **18**
March /mɑrtʃ/ **6**
margarine /ˈmɑrdʒərɪn/ **63**
marina /məˈrinə/ **78**
married ˈmærid **9**
married couple /ˌmærid ˈkʌpəl/ **10**
Mars /mɑrz/ **108**
martial arts /ˈmɑrʃəl/ **88**
Maryland /ˈmɛrələnd/ **8**
mascara /mæˈskærə/ **43**
mask /mæsk/ **47, 86, 90**
Massachusetts /ˌmæsəˈtʃusɪts/ **8**
massage /məˈsɑʒ/ **42**
mast /mæst/ **90**
mat /mæt/ **58, 88, 92**
matches /ˈmætʃɪz/ **83**
math /mæθ/ **59**
mattress /ˈmætrɪs/ **17**
May /meɪ/ **6**
mayonnaise /ˈmeɪəˌneɪz/ **64**
meadow /ˈmɛdoʊ/ **106**
measure /ˈmɛʒɚ/ **69**

measuring cup /ˈmɛʒərɪŋ ˌkʌp/ **15**
measuring spoons /ˈmɛʒərɪŋ spunz/ **15**
meat /mit/ **65**
mechanic /mɪˈkænɪk/ **27**
medical care /ˈmɛdɪkəl ˌkɛr/ **46**
medical records /ˌmɛdɪkəl ˈrɛkɚdz/ **46**
medical specialist /ˌmɛdɪkəl ˈspɛʃəlɪst/ **46**
medicine cabinet /ˈmɛdəsən ˌkæbɪnɪt/ **16**
Memorial Day /məˈmɔriəl ˌdeɪ/ **6**
Memphis /ˈmɛmfɪs/ **8**
menu /ˈmɛnyu/ **66**
Mercury /ˈmɚkyəri/ **108**
messy /ˈmɛsi/ **114**
metal /ˈmɛt̮l/ **55**
metal detector /ˈmɛt̮l dɪˌtɛktɚ/ **76**
meter /ˈmit̮ɚ/ **82**
Mexico /ˈmɛksɪˌkoʊ/ **8**
Miami /maɪˈæmi/ **8**
Michigan /ˈmɪʃɪgən/ **8**
microphone /ˈmaɪkrəˌfoʊn/ **96**
microwave oven /ˌmaɪkrəweɪv ˈʌvən/ **14**
Mid-Atlantic /ˌmɪd ətˈlæntɪk/ **8**
midday /mɪdˈdeɪ/ **7**
middle school /ˈmɪdl ˌskull/ **56**
middle seat /ˈmɪdl ˌsit/ **77**
midnight /ˈmɪdnaɪt/ **7**
Midwest /ˌmɪdˈwɛst/ **8**
milk /mɪlk/ **63, 66, 70**
milkshake /ˈmɪlkʃeɪk/ **67**
Milwaukee /mɪlˈwɔki/ **8**
mineral water /ˈmɪnərəl ˌwɔt̮ɚ/ **64**
minivan /ˈminiˌvæn/ **72**
Minneapolis /ˌminiˈæpəlɪs/ **8**
Minnesota /ˌmɪnəˈsoʊt̮ə/ **8**
mints /mɪnts/ **83**
minus /ˈmaɪnəs/ **4**
minute hand /ˈmɪnɪt ˌhænd/ **7**
mirror /ˈmɪrɚ/ **16, 17, 19, 48**
missing button /ˌmɪsɪŋ ˈbʌt̚n/ **54**
Mississippi /ˌmɪsəˈsɪpi/ **8**
Missouri /mɪˈzuri/ **8**
mitt /mɪt/ **86**
mix /mɪks/ **69**
mixing bowl /ˈmɪksɪŋ ˌboʊl/ **15**
mobile phone /ˌmoʊbəl ˈfoʊn/ **111**
model /ˈmɑdl/ **29**
moisturizer /ˈmɔɪstʃəˌraɪzɚ/ **43**
mole /moʊl/ **105**
Monday /ˈmʌndi/ **6**
money /ˈmʌni/ **79**

passenger car /'pæsəndʒɚ ˌkɑr/ 71

passport /'pæspɔrt/ 76

pasta /'pɑstə/ 64

path /pæθ/ 98

patient /'peɪʃənt/ 46, 47, 48

patio /'pæṭiˌoʊ/ 22

patio chair /'pæṭioʊ ˌtʃɛr/ 22

patio table /'pæṭioʊ ˌteɪbəl/ 22

pattern /'pæṭɚn/ 53, 54

patterned /'pæṭɚnd/ 53

paws /pɔz/ 100

pay phone /'peɪ foʊn/ 85

PC /ˌpi 'si/ 30, 109

PDA /ˌpi di 'eɪ/ 111

peacock /'pikɑk/ 104

peak /pik/ 106

peanut /'pinʌt/ 62

peanut butter /'pinət ˌbʌṭɚ/ 63

pear /pɛr/ 62

pearls /pɚlz/ 55

peas /piz/ 61

pecan /pə'kɑn/ 62

pedal /'pɛdl/ 72

pedestrian /pə'dɛstriən/ 80

pedestrian crossing /pə'dɛstriən ˌkrɔsɪŋ/ 75

pediatrician /ˌpidiə'trɪʃən/ 46

peel /pil/ 69

peeler /'pilɚ/ 15

pelican /'pɛlɪkən/ 104

pelvis /'pɛlvɪs/ 38

pencil /'pɛnsəl/ 30, 58, 83

pencil holder /'pɛnsəl ˌhoʊldɚ/ 30

pencil sharpener /'pɛnsəl ˌʃɑrpənɚ/ 58

penguin /'pɛŋgwɪn/ 104

Pennsylvania /ˌpɛnsəl'veɪnyə/ 8

penny /'pɛni/ 79

pepper /'pɛpɚ/ 64

pepper shaker /'pɛpɚ ˌʃeɪkɚ/ 19

percussion /pɚ'kʌʃən/ 96

performing arts /pɚˌfɔrmɪŋ 'ɑrts/ 59

perfume /'pɚfyum/ 43

periodical /ˌpɪri'ɑdɪkəl/ 83

periodical section /pɪri'ɑdɪkəl ˌsɛkʃən/ 60

perpendicular /ˌpɚpən'dɪkyəlɚ/ 5

personal cassette player /ˌpɚsənəl kə'sɛt ˌpleɪɚ/ 110

personal computer /ˌpɚsənəl kəm'pyuṭɚ/ 30, 109

personal data /ˌpɚsənəl 'deɪṭə/ 9

pets /pɛts/ 100

petticoat /'pɛṭiˌkoʊt/ 50

pharmacist /'fɑrməsɪst/ 28

pharmacy /'fɑrməsi/ 44, 84

Philadelphia /ˌfɪlə'dɛlfyə/ 8

Phoenix /'finɪks/ 8

phone /foʊn/ 111

photocopier /'foʊṭəˌkɑpiɚ/ 30, 60

photocopy a letter /ˌfoʊṭəkɑpiə 'lɛṭɚ/ 31

photographer /fə'tɑgrəfɚ/ 29

photography /fə'tɑgrəfi/ 94

physical descriptions /ˌfɪzɪkəl dɪ'skrɪpʃənz/ 39

physical education /ˌfɪzɪkəl ɛdʒə'keɪʃən/ 59

physical therapist /ˌfɪzɪkəl 'θɛrəpɪst/ 46

physician /fɪ'zɪʃən/ 46

physics /'fɪzɪks/ 59

physiotherapist /ˌfɪzioʊ'θɛrəpɪst/ 46

piano /pi'ænoʊ/ 96

piccolo /'pɪkəˌloʊ/ 96

pickaxe /'pɪkæks/ 34

pick up /ˌpɪk 'ʌp/ 41

pick up the children /ˌpɪk ʌp ðə 'tʃɪldrən/ 25

picnic /'pɪknɪk/ 98

picnic table /'pɪknɪk ˌteɪbəl/ 98

picture /'pɪktʃɚ/ 18

picture frame /'pɪktʃɚ ˌfreɪm/ 18

pie /paɪ/ 66

pier /pɪr/ 97

Pierre /pyɛr/ 8

pig /pɪg/ 101

pigeon /'pɪdʒən/ 104

piglet /'pɪglɪt/ 101

pillow /'pɪloʊ/ 17

pillowcase /'pɪloʊˌkeɪs/ 17

pills /pɪlz/ 44

pilot /'paɪlət/ 77

pin /pɪn/ 54, 88

pincushion /'pɪnˌkuʃən/ 54

pineapple /'paɪnˌæpəl/ 62

pine cone /'paɪn koʊn/ 106

pine tree /'paɪn tri/ 106

ping pong /'pɪŋ pɑŋ/ 88

ping pong ball /'pɪŋ pɑŋ ˌbɔl/ 88

ping pong player /'pɪŋ pɑŋ ˌpleɪɚ/ 88

ping pong table /'pɪŋ pɑŋ ˌteɪbəl/ 88

pink /pɪŋk/ 53

pint /paɪnt/ 68

pipette /paɪ'pɛt/ 58

pita bread /'piṭə ˌbrɛd/ 65

pitcher /'pɪtʃɚ/ 19, 86

pitcher's mound /'pɪtʃɚz ˌmaʊnd/ 86

pizza /'pitsə/ 66

place mat /'pleɪs mæt/ 19

places to live /ˌpleɪsɪz tə 'lɪv/ 13

plaid /plæd/ 53

plane /pleɪn/ 32

planets /'plænɪts/ 108

plant /plænt/ 18

planter /'plænṭɚ/ 18, 23

plant flowers /ˌplænt 'flaʊɚz/ 23

plastic wrap /'plæstɪk ˌræp/ 64

plate /pleɪt/ 19

platform /'plætˌfɔrm/ 71

playground /'pleɪgraʊnd/ 57

playing an instrument /ˌpleɪ-ɪŋ ən 'ɪnstrəmənt/ 94

pliers /'plaɪɚz/ 32

plug /plʌg/ 21

plum /plʌm/ 62

plumber /'plʌmɚ/ 27

plus /plʌs/ 4

Pluto /'pluṭoʊ/ 108

pocket /'pɑkɪt/ 52

point /pɔɪnt/ 40

polar bear /'poʊlɚ ˌbɛr/ 102

Polaroid™ camera /ˌpoʊlərɔɪd 'kæmrə/ 111

pole /poʊl/ 91

police car /pə'lis ˌkɑr/ 85

police officer /pə'lis ˌɔfəsɚ/ 28, 36, 85

police station /pə'lis ˌsteɪʃən/ 85

polka-dotted /'poʊkə ˌdɑṭɪd/ 53

polyester /'pɑliˌɛstɚ/ 54

pond /pɑnd/ 106

pony tail /'poʊni ˌteɪl/ 39

porch /pɔrtʃ/ 13

pork chops /'pɔrk tʃɑps/ 65

porter /'pɔrṭɚ/ 76

Portland /'pɔrtˌlənd/ 8

postal clerk /'poʊstl ˌklɚk/ 82

postcard /'poʊstkɑrd/ 82

poster /'poʊstɚ/ 56

postmark /'poʊstmɑrk/ 82

post office /'poʊst ˌɔfɪs/ 82

pot /'pɑt/ 15

pot holder /'pɑt ˌhoʊldɚ/ 15

pot roast /'pɑt ˌroʊst/ 65

potato chips /pə'teɪṭə ˌtʃɪps/ 67, 83

potatoes /pə'teɪṭoʊz/ 61

potato salad /pəˌteɪṭoʊ 'sæləd/ 65

potter's wheel /'pɑṭɚz ˌwil/ 94

pottery /'pɑṭəri/ 94

potty chair /'pɑṭi ˌtʃɛr/ 20

pouch /paʊtʃ/ 102

pound /paʊnd/ 68

pour /pɔr/ 41, 69

power drill /'paʊɚ ˌdrɪl/ 32

power saw /'paʊɚ ˌsɔ/ 32

pre-school /'priskʊl/ 56

prescription /prɪ'skrɪpʃən/ 46

press /prɛs/ 41

print a copy /ˌprɪnt ə 'kɑpi/ 31

printer /'prɪnṭɚ/ 109

prison /'prɪzən/ 36

prison officer /'prɪzən ˌɔfəsɚ/ 36

private transportation /ˌpraɪvɪt trænspɚ'teɪʃən/ 72

professor /prə'fɛsɚ/ 28

promenade /ˌprɑmə'neɪd/ 97

prosecuting /'prɑsəˌkyuṭɪŋ/ 36

protractor /proʊ'træktɚ/ 58

prune /prun/ 62

public transportation /ˌpʌblɪk trænspɚ'teɪʃən/ 71

pull /pʊl/ 40

pumpkin /'pʌmpkɪn/ 61

pumps /pʌmps/ 49

pupil /'pyupəl/ 38

puppy /'pʌpi/ 100

purple /'pɚpəl/ 53

purse /pɚs/ 55

push /pʊʃ/ 40

put down /ˌpʊt 'daʊn/ 41

put on make-up /ˌpʊt ɔn 'meɪkʌp/ 12

quantities /'kwɑnṭɪṭiz/ 68

quart /kwɔrt/ 68

quarter /'kwɔrṭɚ/ 79

quarter full /ˌkwɔrṭɚ 'fʊl/ 68

quilt /kwɪlt/ 17

quilting /'kwɪltɪŋ/ 94

rabbit /'ræbɪt/ 100, 101

raccoon /ræ'kun/ 102

racehorse /'reɪshɔrs/ 87

radio /'reɪdiˌoʊ/ 73, 110

radius /'reɪdiəs/ 5

railroad crossing sign /'reɪlroʊd ˌkrɔsɪŋ ˌsaɪn/ 75

railway station /'reɪlweɪ ˌsteɪʃən/ 71

rainbow /'reɪnboʊ/ 107

raincoat /'reɪnkoʊt/ 49

rain hat /'reɪn hæt/ 49

rainy /'reɪni/ 107

raisin /'reɪzən/ 62

rake /reɪk/ 23

rake the leaves /ˌreɪk ðə 'livz/ 23

ram /ræm/ 101

ranch house /'ræntʃ haʊs/ 13

rash /ræʃ/ 45

raspberry /'ræzˌbɛri/ 62

rat /ræt/ 105

razor /'reɪzɚ/ 16, 43

razor blade /'reɪzɚ ˌbleɪd/ 43

reach /ritʃ/ 92

read /rid/ 41

read the paper /ˌrid ðə 'peɪpɚ/ 12

WORDLIST

twelve o'clock /ˌtwɛlv əˈklɑk/ **7**
twenty percent /ˌtwɛnti pɚˈsɛnt/ **4**
twenty /ˌtwɛnti/ **4**
twenty-one /ˌtwɛnti ˈwʌn/ **4**
twin bed /ˌtwɪn ˈbɛd/ **17**
two /tu/ **4**

umbrella /ʌmˈbrɛlə/ **22, 49**
umpire /ˈʌmpaɪɚ/ **86**
uncle /ˈʌŋkəl/ **11**
under /ˈʌndɚ/ **115, 116**
underneath /ˌʌndɚˈniθ/ **116**
undershirt /ˈʌndɚˌʃɚt/ **51**
underwear /ˈʌndɚˌwɛr/ **50, 51**
United States /yʊˌnaɪtɪd ˈsteɪts/ **8**
university /ˌyunəˈvɚsəti/ **56**
up /ʌp/ **115**
upper arm /ˈʌpɚ ˈɑrm/ **37**
Uranus /yʊˈreɪnəs/ **108**
Utah /ˈyutɑ/ **8**
utility room /yuˈtɪləti ˌrum/ **21**

vacuum cleaner /ˈvækyum ˌklinɚ/ **21**
vacuum the house /ˌvækyum ðə ˈhaʊs/ **25**
Valentine's Day /ˈvæləntaɪnz ˌdeɪ/ **6**
valley /ˈvæli/ **106**
van /væn/ **72, 98**
vase /veɪz/ **18**
VCR /ˌvi si ˈɑr/ **110**
vegetable garden /ˈvɛdʒtəbəl ˌgɑrdn/ **22**
vegetables /ˈvɛdʒtəbəlz/ **61, 66**
vehicle /ˈviɪkəl/ **72**
vein /veɪn/ **38**
Velcro™ /ˈvɛlkroʊ/ **54**
Venus /ˈvinəs/ **108**
Vermont /vɚˈmɑnt/ **8**
vest /vɛst/ **51**
veterinarian /ˌvɛtərəˈnɛriən/ **28**
video camera /ˈvɪdioʊ ˌkæmrə/ **111**
video cassette /ˈvɪdioʊ kəˌsɛt/ **110**
video cassette recorder /ˌvɪdioʊ kəˌsɛt rɪˈkɔrdɚ/ **56, 110**
video games /ˈvɪdioʊ ˌgeɪmz/ **95, 110**
video store /ˈvɪdioʊ ˌstɔr/ **84**
vinegar /ˈvɪnɪgɚ/ **64**
viola /viˈoʊlə/ **96**
violin /ˌvaɪəˈlɪn/ **96**

Virginia /vɚˈdʒɪnyə/ **8**
vise /vaɪs/ **32**
V-neck sweater /ˌvi nɛk ˈswɛtɚ/ **49**
vocalist /ˈvoʊkəlɪst/ **93**
vocational school /voʊˈkeɪʃənl ˌskul/ **56**
volleyball /ˈvɑliˌbɔl/ **87**
volleyball player /ˈvɑlibɔl ˌpleɪɚ/ **87**

waist /weɪst/ **37**
waistband /ˈweɪstbænd/ **52**
waiter /ˈweɪtɚ/ **27, 66**
waiting room /ˈweɪtɪŋ ˌrum/ **47**
waitress /ˈweɪtrɪs/ **27**
wake up /ˌweɪk ˈʌp/ **12**
walk /wɑk/ **92**
walkie-talkie /ˌwɑki ˈtɔki/ **34**
walking /ˈwɑkɪŋ/ **98**
Walkman™ /ˈwɑkmən/ **110**
walk sign /ˈwɑk saɪn/ **80**
walk the dog /ˌwɑk ðə ˈdɔg/ **25**
walkway /ˈwɑkweɪ/ **13**
wall /wɔl/ **24**
wall unit /ˈwɔl ˌyunɪt/ **18**
wallet /ˈwɑlɪt/ **55**
wallpaper /ˈwɔlˌpeɪpɚ/ **17**
walnut /ˈwɔlnʌt/ **62**
walrus /ˈwɔlrəs/ **103**
warehouse /ˈwɛrhaʊs/ **33**
warm /wɔrm/ **107**
warm-up suit /ˈwɔrm ʌp ˌsut/ **51**
wash /wɑʃ/ **42, 69**
wash cloth /ˈwɑʃ klɔθ/ **16**
washing machine /ˈwɑʃɪŋ məˌʃin/ **21**
Washington /ˈwɑʃɪŋtən/ **8**
Washington D.C. /ˈwɑʃɪŋtən ˌdi ˈsi/ **8**
wash the dishes /ˌwɑʃ ðə ˈdɪʃɪz/ **25**
wash your face /wɑʃ yɚ ˈfeɪs/ **12**
wasp /wɑsp/ **105**
wastepaper basket /ˈweɪstpeɪpɚ ˌbæskɪt/ **30**
watch /wɑtʃ/ **7, 55**
water buffalo /ˈwɔtɚ ˌbʌfəloʊ/ **102**
watercress /ˈwɔtɚˌkrɛs/ **61**
waterfall /ˈwɔtɚˌfɔl/ **106**
watering can /ˈwɔtɚɪŋ ˌkæn/ **23**
watermelon /ˈwɔtɚˌmɛlən/ **62**
water ski /ˈwɔtɚ ˌski/ **90**

water-skier /ˈwɔtɚ ˌskiɚ/ **90**
water sports /ˈwɔtɚ ˌspɔrts/ **90**
water the plants /ˌwɔtɚ ðə ˈplænts/ **23**
water transportation /ˈwɔtɚ trænspɚˌteɪʃən/ **78**
wave /weɪv/ **40, 97**
wavy hair /ˌweɪvi ˈhɛr/ **39**
weather /ˈwɛðɚ/ **107**
Wednesday /ˈwɛnzdi/ **6**
weigh /weɪ/ **69**
weights /weɪts/ **92**
west /wɛst/ **8**
West Coast /ˌwɛst ˈkoʊst/ **8**
West Virginia /ˌwɛst vɚˈdʒɪnyə/ **8**
wet /wɛt/ **114**
wheel /wil/ **72**
wheelbarrow /ˈwilˌbæroʊ/ **23, 34**
wheelchair /ˈwil-tʃɛr/ **47**
whipped cream /ˌwɪpt ˈkrim/ **66**
whisk /wɪsk/ **15**
whiskers /ˈwɪskɚz/ **100**
white /waɪt/ **53**
whiteboard /ˈwaɪtbɔrd/ **56**
whiteboard marker /ˈwaɪtbɔrd ˌmarkɚ/ **56**
white bread /ˌwaɪt ˈbrɛd/ **65**
white out™ /ˈwaɪt aʊt/ **30, 83**
white wine /ˌwaɪt ˈwaɪn/ **64, 66**
whole trout /ˌhoʊl ˈtraʊt/ **65**
whole wheat bread /ˌhoʊl ˈwit ˌbrɛd/ **65**
wide /waɪd/ **52, 114**
widow /ˈwɪdoʊ/ **9**
widower /ˈwɪdoʊɚ/ **9**
width /wɪdθ/ **5**
wife /waɪf/ **10**
wild animals /ˌwaɪld ˈænəməlz/ **102**
window cleaner /ˈwɪndoʊ ˌklinɚ/ **27, 64**
window frame /ˈwɪndoʊ ˌfreɪm/ **24**
window pane /ˈwɪndoʊ ˌpeɪn/ **24**
window seat /ˈwɪndoʊ ˌsit/ **77**
window /ˈwɪndoʊ/ **13, 18, 24, 77, 109**
windshield /ˈwɪndʃild/ **73**
windshield wiper /ˈwɪndʃild ˌwaɪpɚ/ **73**
windsurfer /ˈwɪndˌsɚfɚ/ **90**

windsurfing /ˈwɪndˌsɚfɪŋ/ **90**
windy /ˈwɪndi/ **107**
wine glass /ˈwaɪn glæs/ **19**
wine list /ˈwaɪn lɪst/ **66**
wing /wɪŋ/ **77, 104**
winter /ˈwɪntɚ/ **107**
winter sports /ˌwɪntɚ ˈspɔrts/ **91**
Wisconsin /wɪsˈkɑnsɪn/ **8**
withdrawal slip /wɪθˈdrɔəl ˌslɪp/ **79**
witness /ˈwɪtnɪs/ **36**
wok /wɑk/ **15**
wolf /wʊlf/ **102**
woman /ˈwʊmən/ **9**
woodchuck /ˈwʊdtʃʌk/ **105**
woods /wʊdz/ **106**
woodwinds /ˈwʊdwɪndz/ **96**
woodworking /ˈwʊdˌwɚkɪŋ/ **94**
wool /wʊl/ **54**
workbench /ˈwɚkbɛntʃ/ **32**
worker /ˈwɚkɚ/ **33**
work on a computer /ˌwɚk ɔn ə kəmˈpyutɚ/ **31**
workshop /ˈwɚkʃɑp/ **32**
work station /ˈwɚk ˌsteɪʃən/ **33**
wrapping paper /ˈræpɪŋ ˌpeɪpɚ/ **83**
wrench /rɛntʃ/ **32**
wrestler /ˈrɛslɚ/ **88**
wrestling /ˈrɛslɪŋ/ **88**
wrist /rɪst/ **37**
write /raɪt/ **41**
Wyoming /waɪˈoʊmɪŋ/ **8**

X-ray /ˈɛks reɪ/ **46**
X-ray machine /ˈɛks reɪ məˌʃin/ **76**
xylophone /ˈzaɪləˌfoʊn/ **96**

yacht /yɑt/ **78**
yard /yɑrd/ **13, 22**
yard line /ˈyɑrd laɪn/ **86**
yarn /yɑrn/ **54**
yellow /ˈyɛloʊ/ **53**
yellow light /ˌyɛloʊ ˈlaɪt/ **74**
yield sign /ˈyild saɪn/ **75**
yoghurt /ˈyoʊgɚt/ **63**
yogurt /ˈyoʊgɚt/ **63**

zebra /ˈzibrə/ **102**
zip code /ˈzɪp koʊd/ **82**
zipper /ˈzɪpɚ/ **52**
zoo /zu/ **99**
zucchini /zuˈkini/ **61**

1 NUMBERS, TIME, HOLIDAYS

1.1 **Write these words out in the correct order**

third fifth first fourth second

1. _____ 2. _____ 3. _____ 4. _____ 5. _____

1.2 **What shapes are these objects? Put them in the correct column.**

| dice | calculator | tire | plate | egg |
| watermelon | baseball | door | clock | flag |

Oval	**Circle**	**Rectangle**
_____	_____	_____
_____	_____	_____
	_____	_____
	_____	_____

1.3 **When do these holidays happen? Draw a line from the holiday to its month.**

Father's Day November

Thanksgiving May

Valentine's Day July

Christmas Day June

Memorial Day October

Halloween December

Independence Day February

1.4 **Circle the time you would do the activity.**

1. Eat breakfast 7:30 a.m. 7:30 p.m.

2. Go to the store 2:00 a.m. 2:00 p.m.

3. Mow the lawn 4:00 a.m. 4:00 p.m.

4. Eat lunch noon midnight

5. Go to sleep 11 o'clock 11 o'clock
 in the morning in the evening

EXERCISES

2 PEOPLE

1.1 What do you do in the morning? Put the verbs in order.

get up	dry yourself	1. _____	4. _____
take a shower	get dressed	2. _____	5. _____
wake up	go to work	3. _____	6. _____

2.2 Use the information about Brad Pitt to complete the application form.

Brad Pitt 12/18/1963 994-9872

1106 Hollywood Drive, Los Angeles, CA Actor Male

98554 Married American

Jennifer Aniston No children Shawnee, Oklahoma

1. First name _____

2. Last name _____

3. Sex _____

4. Occupation _____

5. Address _____

6. Zip code _____

7. Telephone number _____

8. Nationality _____

9. Date of birth _____

10. Place of birth _____

11. Marital status _____

12. Husband's/wife's name _____

13. Number of children _____

2.3 Put the male and female equivalents in the correct column.

granddaughter, sister, nephew, half-sister, father, aunt, grandmother, mother-in-law, stepfather, stepson

	Male	Female	Male	Female
Example	widower	widow		
1.	brother	_____	6. _____	stepdaughter
2.	_____	mother	7. father-in-law	_____
3.	uncle	_____	8. half-brother	_____
4.	grandfather	_____	9. grandson	_____
5.	_____	niece	10. stepmother	_____

2.4 Marital status. Write these words out correctly.

1. insleg _____

2. riedram _____

3. idwwo _____

4. mrreiedar _____

5. vdecroid _____

3 HOUSING

3.1 **Where in your house are these objects? Draw a line to link the objects to the correct rooms.**

toilet		dresser
oven	kitchen	coffee table
laundry basket	bathroom	sofa/couch
armchair	dining room	dining table
headboard	living room	napkin
quilt	bedroom	spice rack
microwave		

3.2 **Choose the part of the house where we normally do these things.**

dining room, bedroom (2), bathroom (2), kitchen (2), yard (2)

Example We usually watch the television in the <u>living room</u>.

1. We usually sleep in the _____
2. We eat our meals in the _____
3. We wash our hair in the _____
4. We cook a barbecue in the _____
5. We brush our teeth in the _____

6. We make dinner in the _____
7. We sit in the sun in the _____
8. We wash the dishes in the _____
9. We make the beds in the _____

3.3 Write the name of the part of the house where you would find these items and cross out the object that is in the wrong place.

oven	closet	toilet	armchair	lawn
freezer	dressing table	toothbrush	razor	shed
dishwasher	alarm clock	tile	magazine rack	bush
sink	bath tub	mirror	sofa	swing
fridge	lamp	quilt	bookcase	crib
~~swing~~	mattress	sink	coffee table	fence
				hedge

Example kitchen 1. _____ 2. _____ 3. _____ 4. _____

3.4 **Complete the words. All these things go on the dining room table.**

1. f_rk
2. sp_on
3. w_ne glas_
4. plat_
5. nap_in

6. kn_fe
7. t_bl_spoo_
8. s_lt
9. p_pper
10. t_asp_on

EXERCISES

4 WORK

4.1 Match the place of work to the job.

hospital, court, studio, restaurant, school, university, kitchen, office, bank

1. secretary _____

2. nurse _____

3. teacher _____

4. professor _____

5. judge _____

6. photographer _____

7. bank teller _____

8. cook _____

9. waiter _____

4.2 Fill in the verbs to complete the word. All of the verbs are activities in the office.

		O					a meeting
		F			papers		
send a		F					
		I			a letter		
		C			a letter		
		E			an e-mail		

4.3 Match the pictures and the words. Put the correct number next to the word.

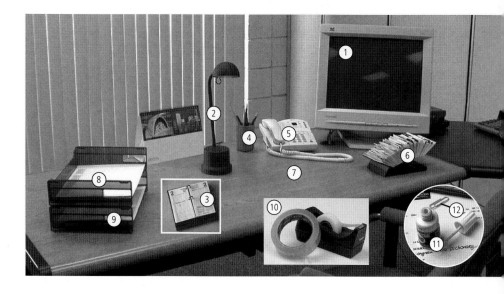

pencil holder ☐ white out™ ☐ telephone ☐ ☐

in box ☐ Rolodex ☐ lamp ☐ ☐

paper clip ☐ PC ☐ desk calendar ☐ ☐

out box ☐ tape ☐ desk ☐ ☐

5 THE BODY

5.1 **Fill in the blanks to complete the physical description.**
Each dash represents a letter.

This man has _ _ _ _ _ _ _ _ _ _ hair. He has _ _ _ eyes and a _ _ _ _ nose.

He has _ _ _ _ eyelashes and thick _ _ _ _ _ _ _ _ . His mouth is _ _ _ _ _ and

his _ _ _ _ are small too. He has a _ _ _ _ beard and a _ _ _ _ _ _ _ _ .

5.2 **Write the verbs of movement under the correct picture.**

to frown, to cry, to push, to pull, to sit, to talk, to sing, to hug, to shake hands, to wave

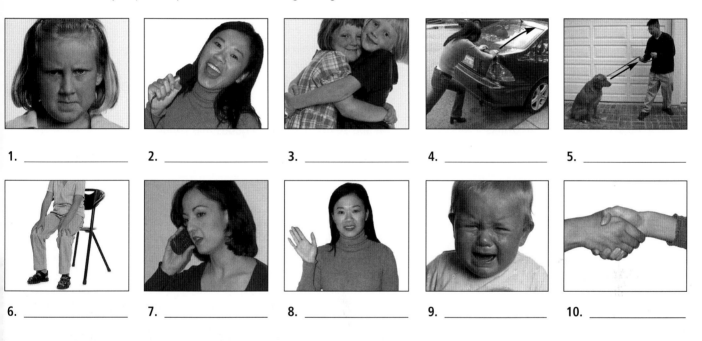

1. _____ 2. _____ 3. _____ 4. _____ 5. _____

6. _____ 7. _____ 8. _____ 9. _____ 10. _____

5.3 **Match the opposites. Draw a line to connect them.**

1. tall **2.** dark hair **3.** heavy **4.** straight hair **5.** short hair

a) thin **b)** long hair **c)** short **d)** blond hair **e)** curly hair

5.4 **Put these words in the correct box according to where they are on our bodies.**

thigh, nose, wrist, hip, waist, palm, ankle, calf, knee, elbow, stomach, ears, forehead, kneecap, cheek, fingers, thumb, back, mouth, lips

Head/Face	Arm/Hand	Leg	Body

EXERCISES

6 FOOD

6.1 Complete the restaurant dialogue with the words below.

apple pie, shrimp cocktail, roast beef, baked potato, bottled water

WAITER	Hello, sir. What would you like to eat?	WAITER	Would you like dessert?
CUSTOMER	For an appetizer I would like _____.	CUSTOMER	Yes. Can I have _____ please?
WAITER	And for the main course?	WAITER	And to drink?
CUSTOMER	I would like _____ and a _____ .	CUSTOMER	I would like _____ .

6.2 Put these words in the correct boxes.

chicken, orange juice, pepper, oil, bacon, ground beef, pork chops, sugar, cereal, vinegar, shrimp, liver, salt, pasta, rice, lobster, crab, cookies, beer, mineral water

Meat	Drinks	Fish and seafood	Dry goods and condiments	
_____	_____	_____	_____	_____
_____	_____	_____	_____	_____
_____	_____	_____	_____	_____
_____			_____	_____
_____			_____	

6.3 Food word soup
Look at these pictures. Find the words for these foods in the word soup.

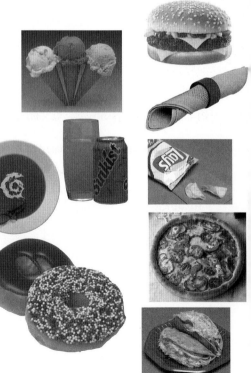

D	O	U	G	H	N	U	T	G	E	W	O
I	Y	S	M	Q	H	N	A	B	N	D	W
S	S	O	U	P	M	U	C	T	A	U	N
E	O	G	L	I	O	C	O	H	P	R	K
C	R	D	P	Z	C	K	W	P	I	C	M
R	A	V	A	Z	T	B	O	V	K	P	G
E	D	F	N	A	K	E	A	M	J	E	S
A	Q	S	U	R	N	A	P	K	I	N	E
M	H	A	M	B	U	R	G	E	R	T	R

7 TRANSPORTATION

7.1 Use the words in the box to finish the sentences below.

engine, train station, passenger, platform, track, luggage compartment, bus stop, timetable

1. You should never walk on the _____

2. You wait for the train on the _____

3. You can leave your bags in a _____

4. You wait for a bus at the _____

5. To know what time the train leaves, look at the _____

6. When you ride on a train, you are a _____

7. The car that pulls the train is the _____

8. The train arrives in the _____

7.2 Number the words.

roof rack ☐ bumper ☐ hood ☐ trunk ☐ exhaust pipe ☐

side mirror ☐ headlight ☐ gas cap ☐ tire ☐ door ☐

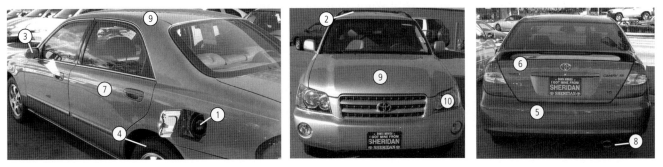

7.3 Find the missing letters to make a new word.

Word	Missing letter	Word	Missing letter	Word	Missing letter
1. –icket	t	4. custo–s	_____	7. p–ssport	_____
2. b–llhop	_____	5. su–tcase	_____	8. –uggage cart	_____
3. baggage claim a–ea	_____	6. boardi–g pass	_____	**New word** _ _ _ _ _ _ _ _ _ _ _ _ _ _	

7.4 Put these vehicles in the correct category.

sedan, yacht, hatchback, cabin cruiser, rowboat, four-wheel drive, helicopter, convertible, oil tanker, cruise ship, station wagon, ferry, jet plane

Air	Land	Sea

8 COMMUNITY

8.1 Put the words in the correct boxes.

coin slot, fire hydrant, stretcher, drip, ladder, hose, smoke, phonecard, ambulance, receiver, oxygen mask, fire extinguisher, paramedic

Fire station	Ambulance service	Phone booth

8.2 Draw a line to connect the place with what you can buy there.

1.	optician	**a)**	stamp
2.	pharmacy	**b)**	radio
3.	candystore	**c)**	medicine
4.	sports store	**d)**	sunglasses
5.	music store	**e)**	tennis racket
6.	electronics store	**f)**	CD or cassette tape
7.	post office	**g)**	chocolate bar

8.3 Label the following items in the boxes provided.

letter, address, envelope, postmark, zip code, postcard, stamp

1

2

3

4

5

6

7

9 SPORTS

9.1 Match the words to their sports type.

speed skating basketball

surfing | water sports | baseball

sailing | individual sports | downhill skiing

golf | winter sports | rowing

tennis | team sports | figure skating

football diving

9.2 Baseball word soup. Find 8 words connected with baseball.

J	S	C	M	O	Z	P	A	C	H
D	T	N	A	F	M	I	T	T	D
B	A	S	E	T	W	T	B	Q	I
O	D	T	P	E	C	C	I	G	N
T	I	O	L	V	M	H	B	Y	F
G	U	M	P	I	R	E	E	R	I
N	M	C	L	S	A	R	Y	R	E
K	X	H	J	D	K	U	F	J	L
E	I	O	U	T	F	I	E	L	D

9.3 Answer these questions about sports equipment.

1.	Do football players wear boxing trunks?	No, they don't.
2.	Do wrestlers wear snorkels?	
3.	Do boxers wear trunks?	
4.	Do bowlers wear mitts?	
5.	Do volleyball players wear goggles?	
6.	Do boxers wear goggles?	
7.	Do cyclists wear helmets?	
8.	Do roller-skaters wear helmets?	
9.	Do swimmers wear gloves?	
10.	Do scuba divers wear shoulder pads?	

EXERCISES

10 ENTERTAINMENT

10.1 **Match each hobby to one piece of equipment.**

photography knitting needles telescope painting

knitting potter's wheel binoculars astronomy

pottery brush camera bird-watching

10.2 **Put the words in the correct box.**

pier swimsuit

surfboard cooler

float seashell

beach towel wave

sea shovel

bucket sunglasses

Things you take to the beach	Things you find at the beach

10.3 **Find the missing letters to make a new word.**

Word	Missing letter	Word	Missing letter	Word	Missing letter
1. ba–kpack	c	**4.** sign–ost		**7.** sleepin– bag	
2. p–th		**5.** camps–te			
3. fisher–an		**6.** hiki–g		**New word** _ _ _ _ _ _ _ _ _ _	

10.4 **What games are these? Unscramble the letters.**

1. sches _____

2. ecid _____

3. omteucpr_____ games

4. nomamgkacb _____

5. kcreshce_____

6. rdsca _____

10.5 **Match the place to go with what you would see there.**

a) actor, b) ballerina, c) orchestra, d) plants, e) roller coaster, f) crafts, g) wild animals

1. zoo _____ **3.** botanical garden _____ **5.** craft fair _____ **7.** amusement park _____

2. ballet _____ **4.** theater _____ **6.** concert _____

10.6 **Cross out the instrument that doesn't belong in the group.**

Strings	Woodwind	Brass
piano	flute	trombone
guitar	clarinet	saxophone
violin	saxophone	French horn
drum	recorder	trumpet
double bass	cymbal	tuba

11 ANIMALS

11.1 Circle the animals that are kept in a cage.

gerbils	tropical fish	cat
parakeet	hamster	dog
goldfish	guinea pig	kitten

11.2 Match the animal with the name of its baby. Write the matching letter on the line.

a. calf b. foal c. gosling d. chick e. piglet f. lamb g. kid

1. horse _____

2. goose_____

3. sheep_____

4. pig _____

5. cow _____

6. goat_____

11.3 Complete the names of the wild animals.

1. el_phant

2. g_raffe

3. ze_ra

4. tige_

5. ka_garoo

6. _onkey

7. c_eetah

8. ll_ma

9. li_ard

10. racco_n

11.4 Put the animals into the correct category.

chipmunk, shrimp, wasp, flamingo, skunk, mosquito, bass, eagle, ostrich, swan, trout, mole, walrus, bluejay, ant, lobster, groundhog, fly, dolphin, octopus, shark

birds	sea animals	insects	fish	small animals
_____	_____	_____	_____	_____
_____	_____	_____	_____	_____
_____	_____	_____	_____	_____
_____	_____	_____		_____
_____	_____			

EXERCISES

12 THE ENVIRONMENT

12.1 Write the weather for each of these places.

Example: In San Francisco, it is foggy.

1. In Washington D.C., it is_____

2. In Miami, it is_____

3. In Los Angeles, it is _____

4. In New York, it is _____

12.2 Find the words for the pictures in the word soup.

```
H  N  H  V  B  X  G  O  S  E  N  Y  M  U  Y
W  I  J  V  E  O  C  M  K  S  E  Y  E  B  M
E  X  L  I  A  L  I  A  O  L  N  I  A  A  W
L  K  N  L  C  P  L  N  L  U  J  I  D  J  C
D  L  Y  K  H  K  V  A  Z  H  N  P  O  P  R
K  A  A  T  S  X  V  G  Y  J  K  T  W  P  M
I  E  M  W  A  T  E  R  F  A  L  L  A  E  P
P  T  X  O  G  O  M  C  A  V  E  E  R  I  H
S  L  C  B  S  T  P  A  E  Q  F  M  V  T  N
W  X  T  R  H  L  T  R  E  E  G  I  F  A  M
Y  R  D  E  S  E  R  T  C  S  E  G  Y  P  B
I  B  D  U  H  Z  Z  P  F  N  H  P  I  O  N
G  U  W  S  J  O  R  O  L  Q  P  I  N  N  Q
H  K  F  D  H  C  J  E  V  T  U  X  S  D  B
H  Q  L  P  U  X  O  T  B  B  J  S  J  Y  T
```

12.3 Write the names of the planets in the correct order from the nearest to the furthest from the sun.

Mercury	Saturn	Pluto
Earth	Venus	Neptune
Jupiter	Mars	Uranus

1. _____ **4.** _____ **7.** _____

2. _____ **5.** _____ **8.** _____

3. _____ **6.** _____ **9.** _____

1 NUMBERS, TIME, HOLIDAYS

1.1
1. first
2. second
3. third
4. fourth
5. fifth

1.2

Oval	Rectangle
egg	flag
watermelon	door

Circle	calculator
clock	
plate	
tire	
baseball	

1.3
Father's Day – June
Thanksgiving – November
Valentine's Day – February
Christmas – December
Memorial Day – May
Halloween – October
Independence Day – July

1.4
1. 7:30 a.m.
2. 2:00 p.m.
3. 4:00 p.m.
4. noon
5. 11 o'clock in the evening

2 PEOPLE

2.1
1. wake up
2. get up
3. take a shower
4. dry yourself
5. get dressed
6. go to work

2.2
1. Brad
2. Pitt
3. Male
4. Actor
5. 1106 Hollywood Drive, Los Angeles, CA
6. 98554
7. 994-9872
8. American
9. 12/18/1963
10. Shawnee, Oklahoma
11. Married
12. Jennifer Aniston
13. No children

2.3
1. sister
2. father
3. aunt
4. grandmother
5. nephew
6. stepson
7. mother-in-law
8. half-sister
9. granddaughter
10. stepfather

2.4
1. single
2. married
3. widow
4. remarried
5. divorced

3 HOUSING

3.1

Kitchen
oven
microwave
spice rack

Bathroom
laundry basket
toilet

Dining Room
chandelier
napkin

Living Room
armchair
coffee table
sofa/couch

Bedroom
headboard
quilt
dresser

3.2
1. bedroom
2. dining room
3. bathroom
4. yard
5. bathroom
6. kitchen
7. yard
8. kitchen
9. bedroom

3.3
1. Bedroom/bathtub
2. Bathroom/quilt
3. Living room/razor
4. Yard/crib

3.4
1. fork
2. spoon
3. wine glass
4. plate
5. napkin
6. knife
7. tablespoon
8. salt
9. pepper
10. teaspoon

4 WORK

4.1
1. office
2. hospital
3. school
4. university
5. court
6. studio
7. bank
8. kitchen
9. restaurant

4.2
conduct a meeting
file papers
send a fax
sign a letter
photocopy a letter
send an e-mail

4.3
pencil holder 4
in box 8
paper clip 12
out box 9
white out™ 11
Rolodex 6
PC 1
tape 10
telephone 5
lamp 2
desk calendar 3
desk 7

5 THE BODY

5.1
This man has **short black** hair. He has **big** eyes and a **long** nose. He has **long** eyelashes and thick **eyebrows**. His mouth is **small** and his **ears** are small too. He has a **long** beard and a **mustache**.

5.2
1. to frown
2. to sing
3. to hug
4. to push
5. to pull
6. to sit
7. to talk
8. to wave
9. to cry
10. to shake hands

5.3
1c, 2d, 3a, 4e, 5b

5.4

Head/Face	Leg
nose	thigh
ears	hip
forehead	ankle
cheek	calf
mouth	knee
lips	kneecap

Arm/Hand	Body
wrist	waist
palm	stomach
elbow	back
fingers	
thumb	

6 FOOD

6.1
Hello, sir. What would you like to eat?
For an appetizer I would like **shrimp cocktail**.
And for the main course?
I would like **roast beef and a baked potato**.
Would you like dessert?
Yes. Can I have **apple pie** please?
And to drink?
I would like **bottled water.**

6.2

Meat	Drinks
chicken	orange juice
bacon	beer
ground beef	mineral water
pork chops	
liver	

Fish and seafood
shrimp
lobster
crab

Dry goods and condiments
pepper
oil
sugar
cereal
vinegar
salt
pasta
rice
cookies

6.3

Across
DOUGHNUT
SOUP
NAPKIN
HAMBURGER

Down
ICE CREAM
PIZZA
TACO

Diagonal
SODA
CHIPS

7 TRANSPORT

7.1
1. track
2. platform
3. luggage compartment

4. bus stop
5. timetable
6. passenger
7. engine
8. train station

7.2
1. gas cap
2. roof rack
3. side mirror
4. tire
5. bumper
6. trunk
7. door
8. exhaust pipe
9. hood
10. headlight

7.3
1. ticket
2. bellhop
3. baggage claim area
4. customs
5. suitcase
6. boarding pass
7. passport
8. luggage cart
Spells the word: t-e-r-m-i-n-a-l

7.4
Air
helicopter
jet plane
Land
sedan
hatchback
four-wheel drive
convertible
station wagon
Sea
yacht
cabin cruiser
rowboat
oil tanker
cruise ship
ferry

8 COMMUNITY
7.1
Fire station
fire hydrant
ladder
hose
smoke
fire extinguisher
Ambulance service
stretcher
drip
ambulance
oxygen mask
paramedic
Phone booth
coinslot

phonecard
receiver

8.2
1d, 2c, 3g, 4e, 5f, 6b, 7a

8.3
1. postmark
2. letter
3. zip code
4. address
5. envelope
6. postcard
7. stamp

9 SPORTS
9.1
Water sports
surfing
sailing
rowing
diving
Individual sports
golf
tennis
Winter sports
speed skating
downhill skiing
figure skating
Team sports
football
basketball
baseball

9.2
Across
MITT
BASE
UMPIRE
OUTFIELD
Down
STADIUM
PITCHER
INFIELD
Diagonal
CATCHER

9.3
2. No, they don't.
3. Yes, they do.
4. No, they don't.
5. No, they don't.
6. No, they don't.
7. Yes they do.
8. Yes they do.
9. No, they don't.
10. No, they don't.

10 ENTERTAINMENT
10.1
photography/camera
knitting/knitting needles
pottery/potter's wheel

painting/brush
astronomy/telescope
bird-watching/binoculars

10.2
Things you take …
surfboard, float, beach towel,
bucket, swimsuit, cooler, shovel
sunglasses
Things you find …
pier, sea, seashell, wave

10.3
1. backpack
2. path
3. fisherman
4. signpost
5. campsite
6. hiking
7. sleeping bag
Spells the word:
c-a-m-p-i-n-g

10.4
1. chess
2. dice
3. computer games
4. backgammon
5. checkers
6. cards

10.5
1g, 2b, 3d, 4a, 5f, 6c, 7e

10.6
Strings – drum
Woodwind- cymbal
Brass- saxophone

11 ANIMALS
11.1
Animals that are kept in a cage:
gerbils
parakeet
hamster
guinea pig

11.2
1b, 2c, 3f, 4e, 5a, 6g

11.3
1. elephant
2. giraffe
3. zebra
4. tiger
5. kangaroo
6. monkey
7. cheetah
8. llama
9. lizard
10. raccoon

11.4
birds
flamingo
eagle

ostrich
swan
bluejay
sea animals
shrimp
walrus
lobster
dolphin
octopus
insects
wasp
mosquito
ant
fly
fish
bass
trout
shark
small animals
chipmunk
skunk
mole
groundhog

12 ENVIRONMENT
12.1
1. In Washington D.C., it is cloudy and rainy.
2. In Miami, it is cloudy.
3. In Los Angeles, it is sunny.
4. In New York, it is cloudy and snowy.

12.2
Across
WATERFALL (9)
CAVE (2)
DESERT (4)
TREE (1)
Down
BEACH (10)
MEADOW (5)
POND (11)
Diagonal
HILL (12)
DAM (3)
LAKE (8)
MOUNTAIN (7)
PEAK (6)
VALLEY (13)

12.3
1. Mercury
2. Venus
3. Earth
4. Mars
5. Jupiter
6. Saturn
7. Uranus
8. Neptune
9. Pluto

ACKNOWLEDGEMENTS

Director
Della Summers

Editorial Director
Adam Gadsby

Senior Publisher
Laurence Delacroix

Editor
Jennifer Sagala

ELT Consultant and photobrief
Tamara Colloff-Bennett

Design and photography
Hart McLeod and Susan G. Holtz

Production
Clive McKeough

Conversation activities
Liz Sharman

Exercises
Russell Stannard

Pronunciation Editor
Rebecca Dauer

Pearson Education Limited
Edinburgh Gate
Harlow
Essex CM20 2JE
England
and Associated Companies throughout the world

Visit our website: http://www.longman.com/dictionaries

© Pearson Education Limited, 2003
All rights reserved; no part of this publication may be reproduced, stored in a retrieval system,
or transmitted in any form or by any means, electronic, mechanical, photocopying, recording
or otherwise, without the prior written permission of the Publishers.

First published 2003
004 006 007 005 003

Words that the editors have reason to believe constitute trademarks have been described as such.
However, neither the presence nor the absence of such a description should be regarded as affecting
the legal status of any trademark.

ISBN 0 582 451035 (Paperback edition)

British Library Cataloguing-in-Publication Data
A catalogue record for this book is available from the British Library.

Library of Congress Cataloging-in-Publication Data
A catalog record for this book has been applied for.

Set in Frutiger by Hart McLeod, Cambridge
Printed in China
GCC/02